ESKIMO MASKS: ART AND CEREMONY

ESKIMO MASKS

ART AND CEREMONY

DOROTHY JEAN RAY

Photographs by Alfred A. Blaker

UNIVERSITY OF WASHINGTON PRESS

SEATTLE AND LONDON

Preface

IN THIS BOOK WE PRESENT THE ESTHETIC AND CERE-
monial aspects of Eskimo masks both pictorially and analytically.
The photographs are the work of Alfred A. Blaker, and the text is
by Dorothy Jean Ray. As principal photographer for the Scientific Pho-
tographic Laboratory, University of California at Berkeley, Blaker
became interested in the broadly representative collection of well-
preserved masks in the Lowie Museum of the university. Ray had been
concerned with the implications of Eskimo mask making and its sig-
nificance as a consequence of an ongoing study of Eskimo art. It was
the stimulus of Blaker's photographic efforts, however, which led her
to embark upon the actual task of assembling and analyzing the ethno-
graphic data. Originally it was felt that the photographic content should
be limited to the unit collection at the Lowie Museum in view of the
diversity and quality of masks represented there. However, in the course
of analysis it became clear that the addition of a few types not present
in the Lowie Collection would be desirable as counterpart for the text.
The desired range was achieved by presenting additional examples from
only a few collections and printed sources, but the textual discussion is
based upon the analysis of collections from many further museums, as
enumerated in the discussion of the specific masks. The entire Lowie
Museum collection is illustrated here. The text is divided into two
parts: first, an analysis and synthesis of all aspects of Eskimo life rela-
tive to masks, particularly an interpretation of the mask in ceremonial
and religious life; and, second, a descriptive catalogue of each mask
illustrated.

We are grateful to the following persons who were exceedingly helpful during the course of this project: William R. Bascom, director of the Lowie Museum, who courteously made specimens available for photography; Albert B. Elsasser, postgraduate research archeologist of the museum, who devoted long after-work hours to the photography; and Robert F. Heizer, professor of anthropology at the University of California, for generous advice and assistance.

Luyse Kollnhofer, curator of ethnology of the Burke Memorial Washington State Museum, kindly lent her aid during the study and photography of the masks illustrated from that museum.

Charles E. Borden of the University of British Columbia unselfishly devoted time to reading portions of the manuscript and provided valuable comments. Robert Greengo of the University of Washington, David Sanger and William E. Taylor, Jr., of the National Museum of Canada, and James W. VanStone, University of Toronto, furnished critical unpublished information.

In *Artists of the Tundra and the Sea,* Ray expressed thanks to the personnel of the numerous museums where research for the study of ivory carving was undertaken during 1954. At this time it is a privilege to extend thanks, once again, to the personnel of those museums, where an introductory study of Eskimo masks was made.

Grateful thanks are also extended to the persons whose cooperation made possible the 1964 phase of the research: R. Rolland Armstrong, president of Sheldon Jackson Junior College, Sitka; Helen Dirtadian, librarian, E. L. Keithahn, curator, and Mrs. Anne Sosnkowski, assistant curator of the Alaska Historical Library and Museum, Juneau; George I. Quimby, Field Museum, Chicago.

Librarians at the University of Washington were exceptionally helpful during preparation of the manuscript, particularly Richard Berner, curator of manuscripts; Robert D. Monroe, chief, Special Collections Division; Ernestine Brown, Pacific Northwest Collection librarian; and Mrs. Ruth Kirk, interlibrary loan librarian.

Textual information is also based on field research in Alaska,

as discussed more fully in the section on the individual masks. Principal informants in 1955 were Mike Kazingnuk and Aloysius Pikongonna; in 1964, Benjamin Atchak, Louisa and Mischa Charles, Frank Degnan, Margaret (Mrs. Eric) Johnsson, John E. Kakaruk, Robert Mayokok, Alec Myomick, Frank Moses, William Oquilluk, Tony Pushruk, and Paul Tiulana; and in 1966, James A. Killigivuk.

DOROTHY JEAN RAY
Seattle, Washington

Contents

PART I

A Vision Becomes a Mask

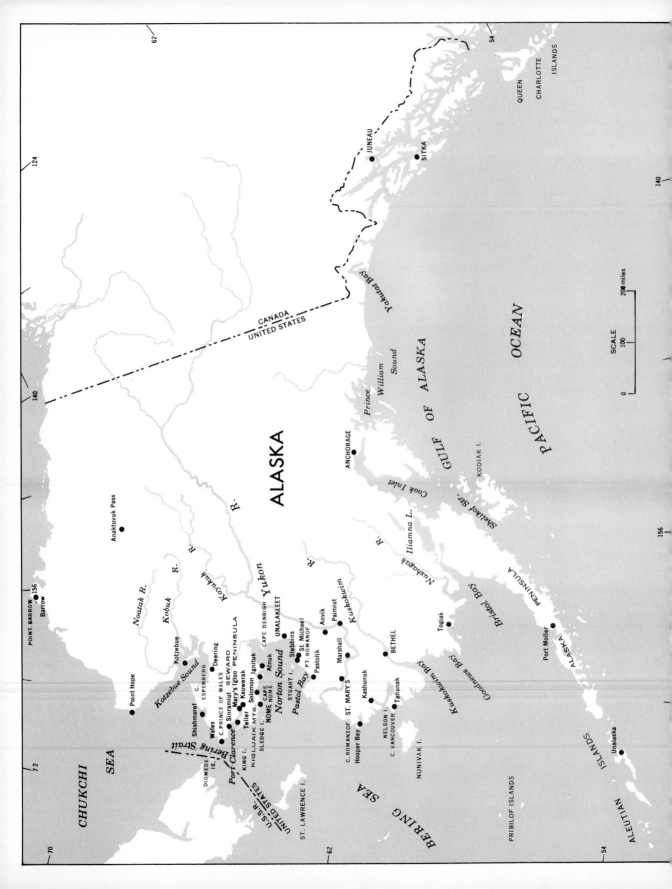

ONE

Introduction

ESKIMO MASKS OF NINETEENTH-CENTURY ALASKA EX-
hibit one of the broadest imaginative vistas in primitive art. They
range from simple facial forms to surrealistic creations, and from
delicate objects that covered only the eyes and nose to huge slabs of
wood that shielded the entire body. These pieces of sculpture attained
an exceptional degree of artistic achievement, yet they have suffered
virtual neglect compared with the attention shown the Eskimos' other
fine artistic achievements. Perhaps part of the blame can be ascribed
to the circumstances of history, for after 1900 masks disappeared as a
living force in Eskimo culture.

Life had changed swiftly for the Alaskan Eskimo by that time.
Between 1896 and 1900 the gold rush sent wave after wave of prospec-
tors, speculators, and gay ladies washing over St. Michael, the Yukon
River, and Seward Peninsula. During the summer of 1900, thirty thousand
persons—more than the native population of all Alaska—tramped the
seacoast near Nome looking for gold. This human inundation inevitably
affected the Eskimo and his arts. The acquisitive Yankee not only
snapped up every Eskimo object in sight as a souvenir—even a broken
sled runner—but demanded more. The curio trade, already off to a suc-
cessful run with sales of ivory pipes and needle cases at several Bering
Sea trading posts, became a bustling industry. Many objects once fash-
ioned for pleasure were now made for money.

When other civilized customs came without end, traditional Es-
kimo ways succumbed, and masks, with their indivisible relationship
with old beliefs, fell before the relentless campaign of a new religion.

1

Most missionaries frowned on them as heathen images of witchcraft, and by the latter 1700's in the Aleutian Islands, if reports can be believed, Russian priests had destroyed all masks they could find.

Mask making was in full swing when the Russians established trading posts north of the 62nd Parallel at St. Michael in 1833 and on the Kuskokwim River at Kolmakov in 1841. Masks from those areas escaped the Aleutian destruction because their missionaries and administrators, according to first-hand observers like W. H. Dall, were concerned more with spirits of the bottle than with those of the soul, and thus their neglect of the Eskimos' spiritual salvation may well have preserved an art form that had been extinguished farther south.

The majority of Eskimo masks in American museums were collected between 1877 and 1900, although a few were sent to European museums before the 1870's. The date 1877 heralded the arrival in St. Michael of Edward William Nelson, the first serious American collector of Alaskan ethnological objects. Nelson remained until 1881, and his indefatigable collecting, adjunct to his Signal Corps duties, was to make the United States National Museum one of the great depositories of Eskimo materials. Few persons exhibited Nelson's care in collecting masks, which were often deposited without specific provenience, and were tagged from the vague limbo of "Alaska" or "Eskimo Alaska." Furthermore, information left by most old mask collectors was fragmentary and often erroneous, resulting from poor reporting and failure to learn the well-kept secrets of a mask. The meaning of a mask and its inseparable vision, story, and dance were lost forever. Thus it is not surprising that published photographs of masks sometimes are accompanied by captions consisting of pure fabrication.

The making of wooden masks by Eskimos was confined almost exclusively to Alaska, where ceremonialism reached its highest development. Skin masks were used to some extent in all Eskimo areas east of Alaska, but they were generally employed to amuse or frighten children, or in connection with sexual play (Speck 1935; Boas 1888: Fig. 535).

Greenland Eskimos sometimes used wooden masks in connection with shamanistic activities (Thalbitzer 1914:636).

Describing the physical aspects of a mask is merely a start toward reaching an understanding of its complicated conception and use. A mask may appear to be a work of art by today's standards, yet its beauty was only a small component of its total meaning to the nineteenth-century Eskimo for whom it encased a multiplicity of significant relationships, embracing nearly the whole of Eskimo ritualism. Thus the treatment of masks as physical objects is merely a counterpart to the functional aspects of religion and ceremonialism. Attention to ceremonialism is biased toward the Alaskan Eskimo, because only in Alaska did masks play a significant role in the ritualistic elaboration of Eskimo religion. However, the basic aspects of Eskimo religion reflected in the making and use of masks are common throughout the Eskimo world.

Despite the paucity of information about masks from old sources, a few of the older Eskimos in 1964 still remembered something about them. It is hoped that their recollections, together with fragments culled from the writings of a few observant twentieth-century anthropologists, and my interpretations of their place in religion and the culture, will make meaningful a part of Eskimo life no longer alive, but exemplified in the accompanying photographs.

In this book, masks are discussed mainly in relation to a specific village, island, or river. Nevertheless, terminology for large general areas is necessarily used. These are: Southern Alaska (Pacific Eskimos: Prince William Sound Eskimos, including the Chugach and Kodiak Eskimos); Aleutian Islands (Aleuts); Bering Sea (inhabitants of the Yukon-Kuskokwim drainage, and the area south to the Aleutians and north to Norton Sound including Nunivak Island); and Northern Alaska (people north of Norton Sound including Sledge Island, King Island, and Big and Little Diomede islands). Bering Strait refers only to the Seward Peninsula area and the islands to the west.

TWO

The Shaman and the Mask

IN 1842 LIEUTENANT L. A. ZAGOSKIN OF THE RUSSIAN
Navy was a guest at a festival in a lower Yukon River village of
Alaska. Under the blue-gray dome of merging sky and snow, the
settlement lay deserted, but inside the *kazgi* (or ceremonial house) sev-
eral hundred Eskimos, the entire population of two villages, waited
feverishly for the first dances of a week-long festival.

Zagoskin, smothering among the chattering men and women, the
heavy odors of seal oil and dried fish, and the dead, suffocating air,
felt faint and ready to leave at the slightest excuse, but the people them-
selves were oblivious to everything except their anticipation of the
things they loved above all—the dancing, the singing, and the drama
of the performances. They had come to hear new and old songs; to see
new and old dances. To sing was to breathe, and to dance was to live.

Though the half-buried *kazgi* of turf and driftwood was huge by
Eskimo standards—more than sixty feet square—it was difficult to find
space among the hundreds of spectators for the performers. Accord-
ingly, a cleared space at one end of the room had been reserved for a
stage, and a bench draped with grass mats served as the dancers' dress-
ing room. The orchestra—four men with large tambourine drums—
sat on top of the bench.

Naked men, bodies glistening with sweat, sat in the choice seats,
three tiers of planks placed around three sides of the room; women,
children, infants, and less fortunate males were packed together tightly
on the floor. All waited intently in the flickering patchwork light of sev-
eral seal oil lamps for the dancing to begin.

The drummers tuned their drums, the people gossiped, and the children whispered. All at once, two ragged, dirty old men rushed out from behind the dressing room taunting each other and mocking and teasing the audience: "Why have you come here?" "You won't see anything you haven't seen before!" "The songs have been stolen!" Suddenly their bantering stopped, for a dancer, naked except for a gaudily decorated crow mask, had swung to the stage by a rope from the roof.

As he hit the wooden floor, the drummers struck a crashing note, falling immediately into a steady, monotonous beat as prelude for a chorus that had assembled during the old men's antics. The chorus then announced the story of a shaman, or medicine man, who had failed as a hunter, and the dancer began to enact the deeds of that unfortunate man. Beside him, four women—two on either side—danced in their best fur clothing and gayest beads, bells, and copper ornaments, augmenting his gestures with their own graceful sweeping movements and waving carved wooden objects trimmed with long caribou hair.

The masked dancer was the center of attention as he created in pantomime not only the hunter and his dilemmas, but the crow that had been the cause of all his blighted hopes. The dancer cawed and shrieked, talked and mumbled, unfolding the reasons why any shaman might be a poor hunter. In this case, the audience was led to believe that the crow, and not the shaman, was at fault because he constantly frustrated the latter's attempts to carry on the normal pursuits of a hunter. The dancer first discovered that the crow had frightened away caribou by its raucous shrieks. Then, inspecting his ptarmigan and fishing nets, he found them pecked full of holes. At last, discouraged by constant failure in all aspects of hunting—in the water, on the wing, and on land—he fell into animated conversation with the spirit of the crow. With the chorus singing a soft background, the dancer-hunter finally struck a pose and threw a question to the air.

"Who are you?" he asked. "Who are you?"

And the spirit of the crow answered, "This is your share of trouble!" (Zagoskin 1847:229).

Zagoskin's description of a masked dance was the first from the Yukon-Kuskokwim area where a dazzling variety of masks was made. The fortunate Zagoskin saw the ceremonies and the use of masks at their height, but his understanding of their meaning was less than ours of today when only vestiges remain in museum cases or between the covers of a book.

No mask existed as a carving in itself, but as part of an integrated complex of story, song, and dance in religious and secular activities. Eskimo mask art was, for the most part, religious art, derived both from the spirits and for the spirits by the shaman. Many categories of spirits were recognized throughout the Eskimo world, but each spirit, though conceptually similar among several groups, was interpreted differently as a mask. Stylistic interpretations of the various spirits usually were consistent within one group, however, and though the shaman was allowed the greatest latitude in a unique vision, its physical embodiment, the mask, conformed to an areal style. Thus it is possible to place the provenience of almost any mask by inspecting it and comparing it with others.

Religious masks were worn in dances of various festivals and in nondoctoring performances of the shaman; rarely, in festivities commemorating the dead. The festivals (including the whaling and the caribou ceremonies of the northern Eskimos) honored spirits of animals or birds important as food or connected with hunting in some magical or religious way. Because dances were performed to influence the animal's spirit and therefore its subsequent behavior, it was important not only to make the masks beautiful and exciting, but to select the best dancers to wear them. Men generally wore the face masks, and women, the so-called finger masks.

Masks, taken as a whole, represented the complete range of Alaskan Eskimo cosmology, consisting of good and bad mythological beings that created man, his livelihood, and his ceremonies or, conversely, tried to destroy them; of deities, especially sun and moon, which controlled certain aspects of men's lives; and of an array of spirits that

Plate I. *A large mask, possibly from Nushagak; the sticks at the top are stylized human bodies*

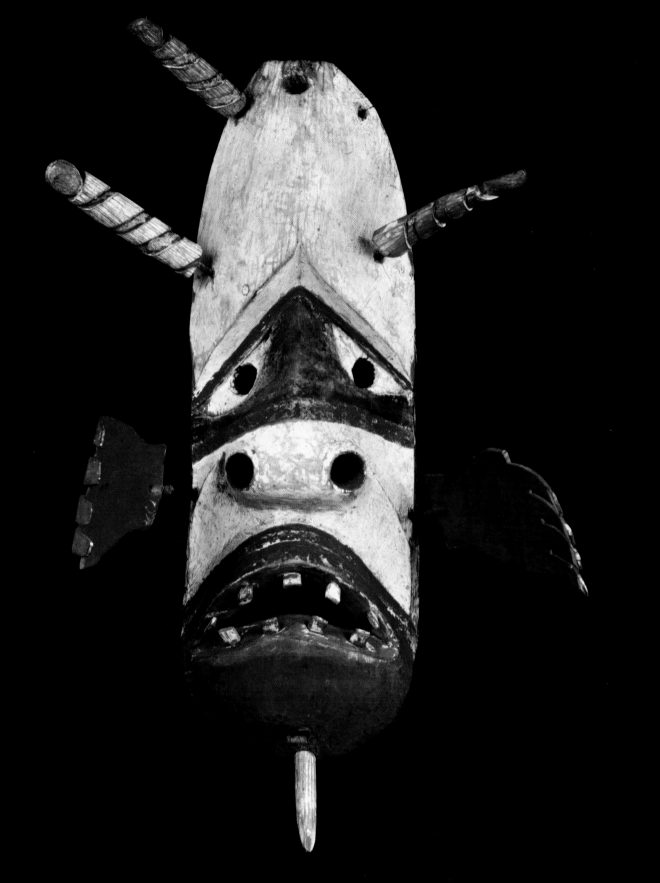

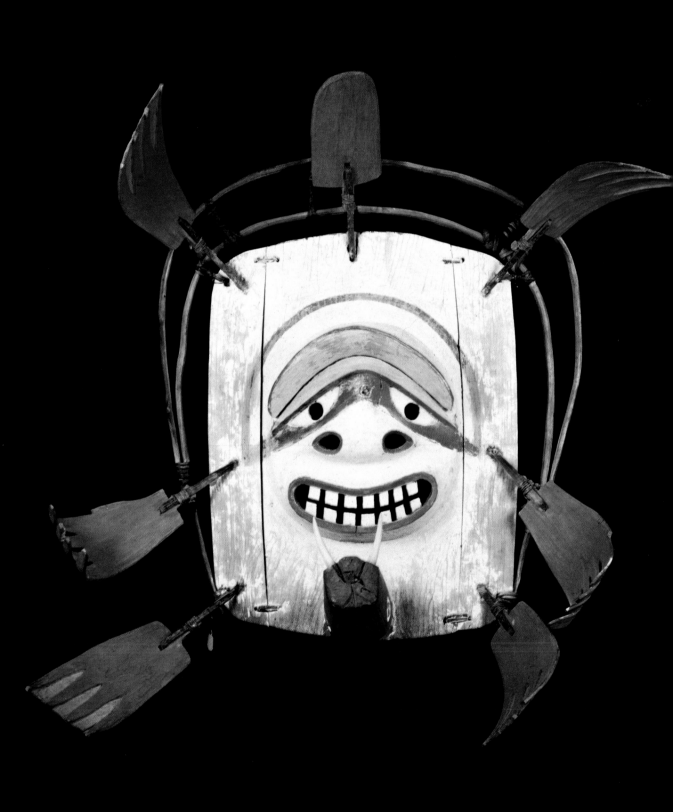

could be manipulated for various purposes. Most religious masks belong to this last category, which can be subdivided further into masks that represent spirits of animals and inanimate objects, guardian spirits and shaman's tutelaries (helping spirits), and records of shamans' journeys to the spiritual world. (Secular masks, which were in the minority, are discussed later in conjunction with their use in festivals.)

The person most essential to the people for an understanding of their cosmology was the shaman. He not only was a doctor who diagnosed illnesses and prescribed for the sick with the help of his powerful tutelaries, but was interpreter for vast, unknown forces that controlled the food supply. He was also the main architect for the dances that served as liaison between the spirits and the people.

Any man was entitled to see spirits and mythological creatures, but the shaman saw them most successfully and most frequently. Furthermore, he had unique visionary experiences ordinarily denied a layman. A shaman was a man or woman who had displayed atypical or psychotic behavior as a child. These early leanings, encouraged by others and augmented by instruction in spiritual and magical practices, were channeled into the acceptable role of shaman. A person could, however, become a shaman later in life as the result of a unique experience or exceptional circumstances.

The practicing shaman was aided by a number of personal and stage properties. For example, he always summoned his tutelaries in a dimly lighted room to the accompaniment of his own drumming and chanting while wearing a hooded intestine parka that rustled with the slightest movement. When properly shaken and twisted, this indispensable frock created a torrent of noise to accompany (and cover up) the shaman's conversation with a spirit.

At other times, with or without the parka, the shaman performed incredible sleight-of-hand tricks or disappeared, supposedly to visit the spirit world. The cleverest shamans were known to survive such terrible tests as being burned alive, thrown into the sea beneath the ice bound hand and foot, or speared through the stomach. They not only survived

Plate II. *A mask that probably represents the spirits of some sea mammal and the shaman who possessed that spirit*

the tests, but emerged without a mark—no singed hair, wet clothing, or hole in the stomach.

The shaman could also change into an animal. He could kill another shaman merely by staring at him. He could make fish run in a barren stream, and he could swallow a bucketful of flint points without getting indigestion. These performances were believed by the people because generally they were conducted for the common welfare to discover the cause of current misfortune, such as poor seal hunting or an epidemic of illness. How much skepticism actually confronted the shamans' performances can never be measured because it was to everybody's advantage to keep in their good graces. It is small wonder that a Little Diomede informant said "an *angutkuk* [shaman] was greater than Houdini." This informant had attended a half dozen Christian churches, but could not bring himself to abandon his faith in the genuine Eskimo medicine man.

The shamans were also seers of the future. A famous Sledge Island man predicted the coming of the first European ship to the island, and another shaman with great prognostic powers, a blind man from Kauwerak, a Seward Peninsula village, could see into the future merely by looking into the bottom of a bucket. He used his bucket also for remarkable journeys, once going all the way to San Francisco and back, which he described to his admiring audience. To prove his powers he permitted his friends to look into the bucket, and they, too, saw men and women walking on the beach at Cape Nome and ships sailing around San Francisco Bay (Ray field notes).

At Point Hope, Knud Rasmussen was told that shamans had been particularly active in the past with the coming of autumn and darkness. Then the people could see "fire-ball after fire-ball rushing through the sky," but, "now that we are Christians, we never see them," one man added (1952:131).

The shaman, during his trances and flights to the spirit world, was in a position to see all of the spiritual and mythological beings of Eskimo belief. The making of masks was one of his ways of interpreting

these beings, and utilizing them in various performances for the maintenance of the proper balance between spirits and human beings was another. Thus, the masks symbolized not only a specific spirit and its characteristic powers, but also the intricate relationship between the shaman (or the dancers) and a spirit who could control food, weather, or life itself. In other words, the mask was the symbol for the balance of life, as, for example, at Point Hope, where the wolverine mask represented protection for the shaman, and the wolf mask, hunting prowess for all the people.

To the Eskimo, every animal and object—a seal, a hill, and even driftwood—was capable of possessing a spirit, one of whose various guises was a human being, a little person. The generic term for a spirit, *inua* in the northern Eskimo language, and *yua* in the Bering Sea language, meant "its human being" or "its person" and was the possessive case for person, *inuk* or *yuk*. Because the spirit resembled a human being, it was represented on a mask by a human face or a part of one. The largest proportion of masks depicted an animal's spirit or "person," and consequently were called spirit masks.

The linguistic aspects of the word for spirit are discussed here because many of the masks in museums were collected and designated variously as soul, spirit, *yua,* or *inua (inva)* masks, but no clear-cut distinction ever emerged about these words relative to masks. The words *inua* and *yua* were mistakenly believed by E. W. Nelson to mean different things; that is, *inua* to mean the individual soul of animate objects, and *yua* the soul of inanimate objects. "Yu-ă" to him was only the "spirit of the elements, places and things" (1899:429, 443). This distinction was subsequently followed by several writers (Collins 1962:21; Riley 1955:9; Weyer 1962:299). Edward M. Weyer also said, "in the region of the Bering Strait the word for the soul in the broad sense is yu-ă a variant of *inua"* (*ibid.* The word for soul, however, is *inuchia,* from *inuk,* in the north, and *yuchia,* from *yuk,* in the south). The difference between *inua* and *yua* was linguistic, not conceptual (as Nelson understood it to be), for the soul was immortal and the spirit (*inua*) was not. Inanimate ob-

jects did not have a soul. The two words belong to two different languages, but have the same meaning.

The mixing of two languages, the Malemiut (a northern or Inupiaq dialect) and Unaluk (a southern or Yupik dialect) in the St. Michael area brought both words into use in a unique way. Colloquially the Unalit of St. Michael used the northern possessive term, *inua*, to refer to the carved form of the spirit, and *yua*, their own possessive term, to mean its "person" or spirit. Thus, their colloquialism *inua yua*, used to mean "image's person," was actually a hybrid linguistic form meaning "its person its person." This was not understood by non-Eskimo observers, who thought the word *inua* was a part of the southern language, and not a borrowed form. Thus, the terms *inua, yua,* or spirit, applied to masks, mean the same thing.

The spirit in a mask was not the individual spirit of the individual animal, but the vital force representing a chain or continuum of all the individual spirits of that genus which had lived, were living, or were to live. Therefore, when a human face or a representative part of it such as a mouth or an eye was placed on a seal spirit mask, it did not represent an individual seal, but an abstraction of the entire genus of the seal's spirit. On the other hand, masks were sometimes made merely to imitate the animal for secular dances, or to portray a mythological creator-being such as the raven or the eagle. In that case, the animal represented was intended to be the specific, individual animal, not the general spirit. However, if a realistic animal or bird mask had the slightest suggestion of an extra eye, mouth, or nose, or had one eye shaped differently from the other, it then represented the spirit of the genus or category of object represented.

Spirit masks were worn in dances of the bladder festivals and general hunting festivals, like the Messenger Feast, where the hunters sought the animal's favor. The Bladder Festival, as it is known now, had a greater concern with animal spirit relationships than the Messenger Feast, which also incorporated trading, romance, and homage to mythological personages. It undoubtedly had developed after the old

bladder festivals were well established, possibly as a result of increasing trade and transportation facilities.

Malevolent beings, *tungat,* were separate entities, not in any way connected with the spirits of objects or living creatures. These beings, however, were sometimes utilized by shamans as tutelaries, and from this came one of the Eskimo names for shaman, *tungalik,* or "demon intermediary." This word was used most frequently in the Yupik-speaking, or southern, area of Alaska, but by the end of the nineteenth century it was employed in almost all of western Alaska interchangeably with the common northern term, *angutkuk,* or "man of many tricks." According to Birket-Smith the Chugach shaman was called KaLa•lik, or "one who has Spirits" (1953:126).

The shaman interpreted the mask's physical shape either from his own vision or from traditional forms and delegated a good carver to carry out his design. The majority of masks were made in this way, but under certain circumstances a carver could make any mask without a shaman's guidance except that of the shaman's personal guardian spirit or spiritual experience. A layman usually carved his own guardian spirit mask, which he wore when dancing with other persons and their guardian spirit masks (Ray 1966; Ray field notes. On Nunivak Island, masks of shamans' experiences were worn in the same way in the Messenger Feast also; Lantis 1946:192).

Although it was customary to hire an expert for the job, a shaman could, if he wished, make his own mask. The northern shaman carved his own more often than his southern counterpart. (This subject is dealt with more completely in the section about mask making.) Shamans' masks of personal tutelaries were usually made after they had been encountered in visions. Although the masks could represent inimical beings, they more often were animal spirits whose positive and helpful powers the shaman wished to enlist, or successful spirits that once had belonged to a famed man no longer living. A fantasy-prone shaman might collect a half dozen or more masks during his lifetime for his personal use.

Several folktales relate spiritual experiences wherein men learned to make masks before their initial public performances as shamans. One tale relates how a Little Diomede hunter, married to a King Island woman, carved his first masks. The hunter, Manina, was taken beneath the sea where he met the chief spirit, who bade him perform many difficult and unusual chores during the course of two winters. At one juncture Manina, bound hand and foot, was put adrift into the sea; another time he was beheaded. The second autumn, after he had survived the final tests, the chief spirit told him:

"You must make masks just like us and one like yourself. This is the last thing for you to do, and this dance to be held will be all in fun. Bring the masks and a woman's decorated parka to the men's house [kazgi]. Then cut off your fingers with an adze and throw them to the dogs."

All summer Manina was busy making masks, and he also made one to represent his first spirit-power, before the King Island spirits had come to him and before he was a medicine-man. This spirit, Kangina, was but half a person from head to heels, and the other spirits feared him [Curtis 1930:124–26].

A Point Hope shaman, Umigluk, obtained his first power and made his first masks under similar circumstances. His experiences began as he ran swiftly from his summer camp to the village of Tigara. On the way he saw a boat descending from the moon, and in the boat he recognized another speedy runner, a shaman who had died recently. The shaman disappeared from view, and another man, Anguluk, wearing fancy new clothes and with only one big eye instead of two, appeared in the boat and danced for Umigluk. The shaman then reappeared and told Umigluk that he had come to take him away, but could not do so because he was unclean from beluga (white whale) hunting. Umigluk went home but was nervous and upset for four days afterward because he had been possessed by Anguluk's spirit.

That autumn his vision of Anguluk established him securely as a shaman. The people urged him to demonstrate his vision and power, so he trained eight men to make eight masks with a protruding forehead and one long slit eye like Anguluk's. He also taught them to sing eight

different songs that he had learned in his trance and to dance the way Anguluk had danced in the boat (Rainey 1947:276–77. In 1891 Sheldon Jackson collected one of these masks which is illustrated in Pl. 54).

Another man, Unguktunguk, from Little Diomede Island obtained his power mysteriously. The people only knew

... that after drifting to sea on an ice-floe and returning with a frozen heel, he became a medicine-man.

One time he made two sets of masks and brought them into the men's house, where were all the people. After men put on the masks and danced, Unguktunguk ordered a large piece of ice with a hole in it to be placed over the entrance hole. His seal-power took possession of him, and he went under the piece of ice. He came up to the hole three times, blowing like a seal. When he rose a fourth time, the chief dancer harpooned Unguktunguk through the head. He bled profusely, and all present saw the weapon with attached line through his head. He then disappeared below the entrance hole, and men pulled in the line with the harpoon on the end. Soon Unguktunguk, his seal-spirit gone, reappeared as well as before [Curtis 1930:133].

This tale, obtained by E. W. Curtis in 1927, is so much like an actual performance witnessed by W. T. Lopp at Cape Prince of Wales in December, 1892, that it undoubtedly refers to the same event. Lopp's account consists of hastily written diary notes, summarized as follows:

The roof of one of the *kazgis* at Cape Prince of Wales was decorated with wooden effigies of whales, walrus, birds, seals, and boats. Also suspended from the roof was an old-fashioned whaling spear, eight feet long, which Oomaligzuk, one of the shamans, licked with his tongue. A whaling crew of eight young men with wooden masks danced round in a circle at the beginning of the ceremony. Whale vertebrae were brought in. Oomaligzuk then went down into the floor entrance, hands tied, representing a seal. He "blows around, comes up several times." The spirits caused him to talk the Siberian language beneath his intestine parka. The men speared him several times, but did not succeed in pinning him. Oomaligzuk then came up, hands still tied, and gave the spearmen further instructions in how to succeed in catching him. On the fourth try, they speared him.

"Spear quivered," Lopp wrote, "and was drawn down through the hole . . . end thong made fast to timber." After that other shamans performed and everybody sang for a half hour before Oomaligzuk was drawn up on the instructions of another shaman. The ivory spearhead was in the lower part of his chest, his back was bleeding, and blood oozed from his mouth. He went down into the hole again, and when he reappeared the thong and spearhead fell from him. He fell over, but "responded to their Ki-ki." When he arose, he spit blood; he pressed his breast, and blood ran out below his belt. He represented the seal spirit, whose blood was gushing out. Oomaligzuk then drank from finger bowls and washed his breast with water. Then the masked dancers performed again. Lopp was told that Oomaligzuk was only "a small doctor" (Diary 1892).

Sometimes a mask did not result from spectacular events. For example, E. W. Nelson illustrated the head, neck, and beak of a sandhill crane, 30 inches long (see Pl. 59, No. 1). The top of the head was excavated so that the light of a small lamp could shine through the eyes. The maker was a shaman "who claimed that once, when he was alone upon the tundra, he saw a sand-hill crane standing at a distance looking at him; as he approached, the feathers on the bird's breast parted, revealing the face of the bird's *inua* . . . (Nelson 1899:402).

Spirit masks obtained through visions did not enable the shaman to become a spirit, according to a Seward Peninsula man, because the mask actually belonged to that spirit and was merely lent to the shaman by the spirit itself or through an intermediary such as the deity of the moon or of the air. The shaman was not at liberty to explain the meaning of the mask, which had to be made as perfectly as the carver's technique permitted. If not, that particular spirit might cease its cooperation with the shaman and oppose him (Ray field notes).

On the Kuskokwim, where masks occasionally had doors to cover the face, a helping spirit showed his liking for the shaman by letting the doors clap open, permitting him to show his face (Himmelheber 1953:58).

The wolverine mask made by a shaman at Point Hope was a protection against the machinations of evil medicine men. One of the shaman's spirits had taught him how to carve the mask and sing its song. This mask had a human head, a tail on top of the head, and four legs. A leg and an arm of an unfriendly shaman were in its mouth. While the shaman wore the mask outdoors, the people sang the song, which had been taught to them by the shaman (Rasmussen 1952:132).

In 1966 James A. Killigivuk carved a Point Hope wolverine mask similar to the one described by Rasmussen, but the story behind the mask is different from Rasmussen's.

When a wolverine killed two caribou, he asked, "How can I carry two caribou?" His dilemma was solved when he found a man ("the other man," or the spirit of the wolverine) to help him. Thus, the face of the mask represents the *inua,* or spirit of the wolverine, as a human being, and the wolverine itself by its tail and four legs. Mr. Killigivuk said that although he had never seen a mask embodying either of these stories, his mask would have represented his story according to Point Hope tradition.

At Point Hope also a shaman acquired the abilities of a wolf by wearing a wooden wolf mask. This power, however, came not directly from the wolf but from the mysterious spirit of the air. The wolf had a sea mammal in its mouth, symbolizing the shaman's wish that his people would catch game with the ease of the wolf. The mask could be used for all game animals, but only one kind at a time (*ibid.*:133).

Some of the most varied and imaginative masks were those commemorating shamans' journeys to the spirit world, ranging from trips to small local spirit centers to more prestigious landings on the moon. These masks, with many figurines and appurtenances attached, were generally larger than others, though occasionally they differed little from deity masks. They, too, had to be well carved, and the meaning kept secret. The shaman wore a mask like this for the first time during a public performance during which he recalled his experiences in a dance and a song. After that he wore it for such special purposes as changing

the weather or asking for seals. Rarely was it worn when doctoring. The mask could also be worn later by a dancer chosen to enact the song related to the mask (Pls. 1, 2, II).

The principal spirit represented in a mask depicting a shaman's journey was actually the fusion of two spirits—the shaman's own spirit and the spirit of one of the shaman's tutelaries. Both traveled with the shaman as one form, usually that of the tutelary, a walrus, for example. Thus, a human face on a walrus mask represented the spirits of both shaman and walrus. The mask, which was the property of the combined shaman and walrus spirits, not the physical beings represented, was kept hidden until time for a ceremony (Ray field notes).

Mythological beings were often fashioned into abstract forms, but interpreted by the shaman within an areal style. Mythological beings universally represented in masks were the half-man (Pl. 12) and the half-man half-animal (Pls. 30, 44), as well as local dwarfs, giants, and beings of mountains (Pl. VII), streams, or tundra—places that were noted either for some environmental or historical peculiarity, or because they were the residence for a flock of these beings.

Many were dangerous and were than called collectively *tungat* (singular, *tungak*). Their forms were never seen by anybody but a shaman. The half-man and the half-man half-animal were, however, friendly and lovable in the Bering Sea area, though evil and difficult for a shaman to obtain at Point Hope. Most of the surrealistic masks with discordant features were the shaman's interpretation of these beings. Occasionally a shaman's tutelary was obtained from this group of beings (Pls. 3, III). On Nunivak Island, dwarfs with pointed heads and round protruding mouths were often shaman's helpers (Lantis 1946:198). The uses of these evil creatures are not entirely clear, but apparently the shaman used them to combat evil shamans or to counteract a disaster that threatened the public welfare. Furthermore, many of these creatures became evil only when the shaman made them so.

Animals such as the eagle and the raven were also made into masks, not as generic spirit masks, but as individual animals to be

used in the Messenger Feast (Pl. 19; for an explanation of this ceremony see pp. 35–37). These birds were not represented in the festivities as a genus because of their mythological, and thus individual, character.

Deity masks were limited to beings of the moon and the sun, made principally by Yukon River people, although their distribution extended as far north as Point Barrow. These masks were often similar to those commemorating a shaman's journey; they, too, had background boards and sometimes concentric root circles, concerned as they were with other contemporary worlds. A St. Michael man told about seeing a great shaman "making medicine to the moon" about 1915 with a mask carved into a woman's likeness, as in Plate IV. The woman in the moon mask was made as beautiful as possible, with lovely features, and adorned with baubles in her ears, nose, and chin. After the shaman donned the mask and began to shake his intestine parka, everyone could hear him talking to her. The woman, according to an informant, represented the moon, a unique idea since the Alaskan moon deity usually was a man. Nevertheless, in 1881, E. W. Nelson recorded a St. Michael tale in which a woman turned into the moon when pursued by her brother, who became the sun (1899:481).

Uses of Masks by the Shaman

Masks were worn far more in festival dancing than in shamanistic activities, but the shaman's role in their conception and carving cannot be completely understood without a discussion of their use by him.

Some nineteenth-century observers said that the medicine man never used a mask while treating patients, but consulted the spirits, bare-faced, inside his gutskin parka. However, masks were widely used for curing in the North, though apparently reserved only for cases that had wider social implications than a simple illness. For example, if the illness had been caused by breaking a rule, the spirits concerned might bring further troubles to everyone. This also may be what Hans Himmelheber means when he says that masks were not worn by the Kus-

kokwim shaman for individual cases of help (1953:57). The Chugach medicine man wore a mask, but not a gutskin parka, while curing the sick (Birket-Smith 1953:126–27).

E. W. Hawkes, who taught school on Little Diomede Island from 1909 to 1911, said in his personal appraisal of the shamans that they ascribed

... certain disorders to certain evil spirits, and do not pride themselves so much on their ability to drive the devil out of their patient as on their success in deciding its name and family history. After it has been driven out it becomes subject to the witch-doctor, and increases his family of familiar spirits. The more devils he has the stronger he is. Some of them have a whole boxful, and a complete assortment of hideous masks to represent them [1913a:584].

Knud Rasmussen heard about a mask called "Tunraq kajueriaq (strong)" (probably "tunraq shangirun," strong spirit) worn in the *kazgi* by a Point Hope shaman for doctoring. This mask in the form of an ugly monster was also used by the shaman to ask for sea mammals, at which time he wore the mask indoors while the people sang its song outside (1952:135).

The shaman most commonly used masks to consult with spirits at a time of crisis, wearing a spirit mask to investigate the cause. Certain dances during ceremonies, particularly the Bladder Festival, actually were consultations in which the animals were flattered and implored to allay a continuing threat of famine. Occasionally, however, a sudden crisis materialized—a storm, severe ice conditions, a number of mysterious injuries, or an epidemic—and then the shaman went into action at any suitable time and place.

The shaman who used the moon mask mentioned above once disappeared through a hole in the ice to seek the cause of poor winter sealing and to provide better luck in spring hunting. He stuffed his mouth full of wood shavings and dressed himself in three intestine parkas, two sealskin pants, a pair of high waterproof skin boots, and a

small wooden mask. After he had remained under the ice for several hours he crawled out of the hole and told the waiting people that he had walked all over the bottom of the sea. Shells and seaweed tangled in his clothes proved that he had been there, but he was dry (Ray field notes).

At Point Hope, masks were conceived and worn by the shaman for numerous crises. A mask called "Juktorajulik (the spirit which goes after people)" was worn by the shaman to moderate the weather, for example. The face of the mask was a land animal, which flew, however, as an eagle to visit the ruler of the weather. "It is so far away that no man knows what it is that makes the weather bad. The shamans know, but they do not tell ordinary people much about it" (Rasmussen 1952:134. The name of this mask is not in the Point Hope dialect, and may possibly pertain to a Nunivak mask. Rasmussen in his *Alaskan Eskimos* describes, but does not illustrate, fifteen kinds of Point Hope masks. Some of his descriptions, however, might belong to Nunivak Island masks instead. Confusion may have arisen from Rasmussen's having a Nunivak man draw pictures of masks for him in Nome, as well as from the circumstance that the book was published posthumously for both Rasmussen and the translator.)

A white fox mask at Point Hope was worn by the shaman when caribou were needed. The fox had a salmon in its mouth and had carved wooden seals at its ears to "satisfy the vanity of the seal as game" (*ibid.*: 135).

The shaman sometimes used masks on his visits to the land of the dead. A famous shaman of the Teller area, about 1870, donned a mask before being burned alive (so as to be acceptable to the dead) in a pile of driftwood. His assistant set fire to it in front of a semicircle of people, who watched until the wood was ablaze. They were then sent home and warned not to poke around in the ashes (Ray field notes). Nelson said that being burned alive was common also between the Yukon River and Norton Sound. Near the Koyuk River he saw the grave of a shaman who had miscalculated and died. No one could revive him

after the fire, although he supposedly had suffered only one small burn (1899:433–34). Perhaps his injuries had been greater than reported, or he had died of a heart attack.

Masks were used in other ways by shamans. In 1936, Himmelheber recorded a Kuskokwim River shaman's trick with a large mask, a story that is still told with relish in St. Michael. A shaman, standing on a housetop, stuffed folded fur parkas into the back of a huge round mask, which he lay face down on the roof. He leaned over and pressed his face into the topmost parka. Without the use of his hands and without fastenings, the mask stuck to his face as he straightened up to his full height (1953:59). This supposedly demonstrated the shaman's power to unbelievers.

Large, lightweight masks were used similarly during dimly lighted dances and seances. When a shaman placed his face on the inside of a mask it appeared to stick to him by magic, but actually he gripped a mouthpiece with his teeth. The spectators did not know (or at least pretended not to know) how the mask remained on his face without support because they were not allowed to inspect a shaman's mask. The masks in Plates 1 and IV were used in this manner.

Masks of the Nunivak shaman in the recent past appear to have been restricted to a few shamanistic performances and certain ceremonies of the Messenger Feast. The shaman usually put on a spirit mask before beginning a performance and wore a huge mask to meet arriving Messenger Feast guests outside the ceremonial house. These large masks, after being worn by several shamans, were hung sideways in the center of the house (Lantis 1946:200, 201; 1960:11, 12). Visiting shamans wore masks of their bird or animal spirits. One of Margaret Lantis' informants recalled a performance of two shamans at a Messenger Feast at Cape Mendenhall, Nunivak Island: "One had a large carved wooden body (with arms and legs). The shaman used this to call his spirits or to show the power of his spirits." The other shaman, who carried a fish trap, walked around the house with the masked shaman (1960:71).

Nunivak shamans also wore tall, pointed masks called *a'nsun*

during the Messenger Feast, but Lantis was unable to obtain further information about the mask itself. One of her informants reported seeing a shaman wearing such a mask at a time other than a festival:

"One time I saw this happen, between two shamans. One came out from the village wearing an a'nsun in the way they used to do at the Messenger Feast. Another met him, with his arms through the sleeves of his parka but not wearing the parka—just had it spread in front of him. He spread his arms, the sleeves, out and brought them together in front of him [like the opening and closing of butterfly wings or flapping of bird wings]. The other shaman fell down, his spirit left him and traveled down under the earth. It came back and he got up. He started on, but the other shaman, still approaching him, again flapped the parka. The shaman fell down again, and his spirit traveled to the sky world. He said there were five worlds, one above another. They looked like this world, only far away. The second shaman didn't know that these things would happen to him" [ibid.:121–22].

This mask may be similar to that called "anisût (going-out mask)" by Rasmussen. The word is from the Point Hope dialect. Rasmussen does not describe the mask, but says that it was worn by a female shaman in male dress.

The shaman has been known to use a mask—or what might better be called a masklike image—for prognostication. Long ago in the Kauwerak area the shaman consulted a carved wooden face on a post in the caribou corral to foretell hunting success. An informant called this a mask, but actually it was a piece of sculpture never intended to be worn. The face had a wide open mouth with teeth of sharpened caribou leg bone, eyes with opaque red pupils, but no ears. Eyebrows and hair were made from long caribou neck fur glued on with salmon egg paste.

The shaman himself carved the image and placed it in the corral, which he visited every morning for signs of blood flowing from the mouth. When only a small amount trickled from the corners he told the hunters, "We won't kill many caribou today," but if a heavy stream ran down both sides he said, "We're going to get lots of caribou." My informant did not know where the blood came from, but surmised that

the shaman had mixed crushed ocher or alder bark with urine or water and had applied it surreptitiously during his visit (Ray field notes).

Images of protective spirits were used everywhere in Eskimo country, but these were not technically masks, either. These images were hung in a house or *kazgi,* or placed in an oomiak or kayak. They were fed fresh food and were fiercely protected. The loss of one was considered to be a tragedy. When A. E. Nordenskiöld in 1879 saw wooden images of birds with red outspread wings behind two tents on Port Clarence, he was unable to persuade their owners to part with them at any price (1882:579, 581).

Even after death the shaman was not separated from his mask. Residents of the Teller and Kauwerak area say that only shamans and "important people" had their personal guardian spirit masks hung over their graves on a stick or a tripod of wood. A shaman's mask was always ugly, "with a big tooth sticking out," and sometimes was splashed with alder bark paint to represent blood running from its mouth. Before placing the shaman's masks in the graveyard, the people wore their own masks for his funeral. They expressed their sorrow by dancing and singing his compositions to the accompaniment of another medicine man's drumming. Tensions built up by such occasions were relieved by accepted license to make remarks about masks being worn: "That's an ugly one," "Who made such a wretched mask?" and so forth (Ray field notes).

On the Yukon, Gordon said that a complete statue, rather than just a mask, was erected for an important personage (1917:136).

Genuine face masks were placed on graves all along the coast north of St. Michael, the Point Hope cemetery being a notable example. Nordenskiöld saw two wooden face masks smeared with blood near a corpse at the Sinramiut graveyard on the northern shore of Port Clarence. One was a human face with a whale's tail nose and a small spirit face in the middle of the forehead; the other, a wolf mask (1882:581).

Masks were not placed directly on a corpse's face among Eskimo

Plate III. *A mask with one eye and exaggerated mouth, a configuration common on the lower Yukon*

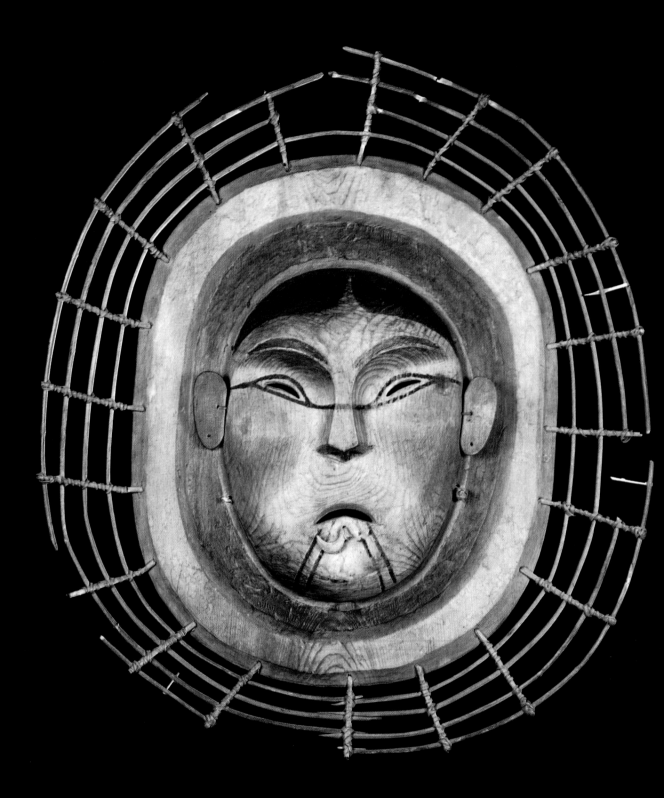

or Aleut peoples, as far as we know, although this was once thought to have been done because of repeated finds of masks in old graveyards. In the Yukon and Kuskokwim river areas, memorial face images (not masks made to be worn) were placed on a board near the grave. E. W. Nelson assumed that the custom of placing memorial images on boards or on top of a post was restricted to the Yukon and southward, but it occurred sporadically throughout the Unaluk-speaking area of Norton Sound and possibly farther north in the eighteenth and nineteenth centuries. As late as 1900, Eugene McElwaine, a gold seeker and writer, photographed a memorial post in a graveyard at Solomon, forty miles east of Nome (1901:123). The post and image are similar to those illustrated by Nelson from Cape Vancouver (1899: Fig. 104) and by Gordon from the Kuskokwim (1917:131). The Solomon figure held a gun in rudimentary hands and was surrounded by paddles and several other domestic and hunting objects.

The ivory segments found at Point Hope in an Ipiutak burial were probably used as memorial images. If so, they are the most elaborate ones of their kind found either archeologically or historically.

To those who remember the great feats of the shaman, the mask remains one of the mysteries that accompanied his activities. Nevertheless, it was also an object that became of importance to everyone because it was worn by lay dancers, as well as for its ceremonial and artistic values. Of even greater importance was the personification of the spirit world by the shaman in such a form that the visually minded Eskimo was able to see some of the results of shamanistic activity. In this way he validated the shaman's successful rapport with the spiritual world and reinforced his own relationship to it—in some cases, even after death.

The tremendous range in subject matter and style of masks in any one area, and the successful visual realization of imagined forms, can be explained in terms of cultural acceptance and encouragement of such activity. Few primitive cultures have been more concerned with

Plate IV. *Identified as the woman in the moon, this mask is a realistic portrait of an Unalit woman*

the conscious pursuit of art than the Eskimo. Thus, the creation of a specific esthetic form from an abstract image or dream was not only the privilege of the artist, but the expectation of others who were to see the finished product.

THREE

Masks in Dances and Festivals

MASKS WERE USED MORE OFTEN FOR DANCING than for any other activity. Dances were for the most part religious, an integrated part of the Eskimos' cosmological beliefs. However, they were performed also for the enjoyment of participants and observers, and today many older persons who gave up dancing to conform with their new religious mentors' wishes wistfully recall that dancing had been one of the best parts of an Eskimo's life.

Non-Eskimo eyewitnesses to the old dances rarely understood what was taking place, so it is now difficult to separate strictly religious ones from those that were both religious and secular, or only secular. Religious dances were usually festival dances, although not all festival dances were religious. Secular dances were usually spontaneous occasions staged without masks for the enjoyment of a household in the winter, or as a public outdoor get-together in the summer.

A dance portrayed many events of Eskimo life, but particularly those connected with survival—a man hunting walrus, villagers driving away strangers, a woman picking berries or gathering bird eggs. Nothing was too insignificant for the dancers, who could wring beauty from the simplest pantomime. As important as gestures in the dance was the movement of undulating feathers and appendages on masks and clothing, or in the hands. (Nelson gives a complete description of ceremonial objects worn on the body—armlets, feather headdresses, fillets, wands, rods, and belts—1899:415–21).

Every dance had its own story, song, and gestures, and though not every dance had a mask, every mask had its own story and dance.

Some of the old dances and songs could be performed and sung by anyone, but others belonged exclusively to the man who had inherited them. New songs and dances were composed for every festival, usually in commemoration of a worthy deed or unusual event. Religious dances had special meaning; only secular dances were invented as mere whim. A new dance was performed first either by its originator (usually a shaman) or by someone who had learned it from him. After that it became public property if the original owner consented. All songs and dances, whether new or old, were carefully rehearsed for weeks before a public appearance.

Dancing and all its accouterments—music, gestures, story, staging, stage properties, and personal ornamentation—were basically the same everywhere in Eskimo Alaska. In 1880, on Sledge Island, Nelson saw "an ordinary dance" that often opened an evening of dancing in villages all the way from Sledge Island to the Kuskokwim River (1899:355).

Many were one-part dances; others were two-part: a solo followed by a chorus of singers and possibly additional performers. A dancer sometimes used two different masks in the same dance, one during the solo and the other for the chorus, or he might wear a composite mask that could be altered between solo and chorus. The latter kind was used south of Norton Sound. I was told that in the St. Michael area a large mask like that in Plate 5 was used during a solo dance, followed by a small one like that in Plate 28 for a chorus dance. The solo part stopped abruptly when the director told the dancer, "Put on the other mask." The drumming and the singing then became livelier than before, and the dancer, wearing the small mask, jumped around energetically. A few masks south of the Yukon had doors that opened suddenly to reveal a face, a signal for the singing and dancing to change (Dall 1884:123).

Rhythmic accompaniment was provided by singing, tambourine drums, and various percussion devices such as rattles, clappers, and pieces of wood. From Cape Nome to Point Barrow, a large wooden box

drum was used for special dances of the Messenger Feast (see Pl. 55). This drum, 3 feet high, 2 feet deep, and 1 foot wide, was suspended from the ceiling. A deep booming sound was produced by striking an ivory baton on a heavy pad of folded foxskin fastened to one side of the drum. This sound could be heard for many miles under certain atmospheric conditions. A number of pitches were produced by striking the skin in various ways (D. Neuman 1914:7; Ray field notes). At Point Barrow the box drum was hit on the bottom (Spencer 1959:215).

Nelson said that the people from Bering Strait to the Arctic coast beat "resonant pieces of wood . . . [with an ivory baton] during dancing," but he did not specify whether or not this referred to a drum. The use of the ivory baton and "resonant" wood implies the box drum, and from available data it is apparent that this kind of drum had been in use long before Nelson's time. Nelson made only one summer trip to the Bering Strait and one short winter trip in March to Sledge Island, and he did not witness a Messenger Feast, which took place in December. The box drum was either burned or stored in a secret place after the ceremonies.

E. W. Hawkes mentions that the Malemiut of Unalakleet used ivory clappers in one of their dances during the St. Michael Messenger Feast in 1912:

. . . the Unalaklit presented a very ancient dance from their old home, Kotzebue sound. This dance, I was told, was two hundred years old, and the old-style dance of the Malemiut. Strangely enough, no drums were used, but the chorus consisted of a double row of men who used ivory clappers to mark the time. Instead of stamping, the dancers bounded up and down on the balls of their feet, holding the legs arched and rigid [1913:15].

Rattles of various kinds were used by all groups. Sauer reported that the Kodiak Islanders had rattles of thin hoops, "one in the other, covered with white feathers, and having the red bills of the sea-parrot suspended on very short threads" (Dall 1884:128). Two of these rattles with puffin beaks tied on singly or in pairs are in the Lowie Museum (Heizer 1952:19).

The Point Barrow Eskimos used tall dancing caps with over-

lapping mountain sheep teeth that clattered when they moved (Murdoch 1892:365), and, from Norton Sound to Kotzebue Sound, long gauntlet gloves with dozens of attached pieces of ivory, puffin bills, or ptarmigan breastbones were shaken in time to the music.

Enclosed hollow rattles were sometimes used. Dall reported finding in an Aleutian cave long wooden cylindrical rattles that once had contained stones (1878:30), and Langsdorff said that at Unalaska singing was accompanied by "a rattle made of the bladder of a sea-dog filled with pease or small pebbles" (1814, Part II:49).

From the Bering Sea area, J. A. Jacobsen collected several finger masks fitted out as rattles. One came from the Kuskokwim River and five from the coast between Cape Vancouver and the Nushagak River. One of the Nushagak rattles was a round case, one side an owl's face, the other a seal, enclosing snail shells (Disselhoff 1936:182, 184).

In the Bladder Festival (pp. 37–40) of Nunivak Island, "little drums that sounded like rattles" were used, but no real enclosed rattles (Lantis 1947:56, 184). A folktale collected by E. S. Curtis suggests that hollow rattles might have been used in the North at an early time, for he said that horn rattles were used in the Messenger Feast dances that supposedly originated at Kauwerak (1930:198).

In northern Alaska men used or wore the rattling paraphernalia, but Chugach women in the South had their own rattles (Birket-Smith 1953:109). Finger mask rattles were used by women of Bering Sea.

Besides masks, clothing, and other personal appurtenances, many kinds of stage properties were used: traps, water holes, hoops to represent the sky, wolf holes, "clay" banks—all made of wood or skins— and an assortment of mechanical dolls and animals.

All Eskimo groups except those of Nunivak Island and possibly Prince William Sound used cleverly built mechanical animal and human figurines in their ceremonies. Zagoskin was the first to report these mechanical marvels north of the Aleutians. On December 5, 1842, at the village of Kikigtaguk between St. Michael and Unalakleet, he witnessed

many wooden figurines performing around the room: owls with flapping wings, sea gulls pecking at a fish, and ptarmigans pecking at each other (1847:93).

In 1880 Petroff said that the Nushagak people on Bristol Bay had stuffed animals and carved wooden birds that flapped their wings and moved around through the manipulation of hidden cords. Many of their masks had movable eyes and jaws (1884:135).

At Cape Prince of Wales a schoolteacher witnessed a whaling festival in December, 1902:

Under the shadow of the central lamp on the floor were mechanical figures of diminutive men, sea parrots and a twelve-inch wooden whale. The whale was made to imitate spouting by five blades of dry grass being blown from the hole in its head. The wooden sea parrots marked time to the music by turning their heads from side to side, and the little men moved heads and arms in the same manner as the real ones [Bernardi 1912].

At Point Hope during a whaling festival, the wings of mechanical birds beat drums, a doll nodded and gestured, and a crew in a skin boat paddled energetically (Rasmussen 1927:332). At the beginning of the Kauwerak Messenger Feast, a little doll always bowed and beat a little drum whenever a woman entered the dance house.

Dancing was usually performed in the largest building in the village, the ceremonial house or *kazgi,* which varied in size from area to area. Zagoskin said that some of the Bering Sea buildings could hold 300 persons (1847:232), and in the 1890's a building only 20 feet square at Stebbins was packed with 250 persons (Ray 1967). Every *kazgi* had an upper entrance through the roof and a lower one through the floor, both of which were used as stage entrances for dancers or shamans when sudden or terrifying effects were desired.

Summer dancing, which took place out of doors, was usually non-religious. At the annual trade markets on Kotzebue Sound and Norton Sound, several walrus hides were stretched edge to edge on the beach for impromptu dancing.

Dancing was staged for spectators, although everybody knew how to dance. Everyone danced at one time or another, but a few persons were famous far and wide for their ability. Men danced sometimes alone, but more often as partner with another man or with two or more women. They sometimes performed feats requiring great muscular strength and endurance. The women, on the other hand, always danced with more restraint, often standing and swaying in one spot, their upper bodies and hands weaving an accompaniment to the story enacted by a man dancer. Frequently six or eight women danced a story in unison without men. In northern Alaska they sometimes sat on a bench to "dance," moving their hands, head, and torso while their legs and feet remained still.

During the latter part of the nineteenth century, men danced stripped to the waist, wearing Siberian reindeer skin pants, ornamented fur boots, and either soft, tightly fitting fawnskin gloves or long cumbersome gauntlets, but, according to Zagoskin, during early historic times they danced in the nude so that fast movements would not be hampered by clothes (1847:228). Men always danced wearing gloves, although the reason for doing so had been forgotten before Dall, in 1868, searched the Yukon in vain for an explanation. One of my informants, however, attempted to explain why they continue today to cover their hands with skin or mail-order gloves: "It's for comfort." Another man has said that in dancing "for being good manners they cover their hand with glove when they get in front of lot people" (Green 1959:55). The most probable explanation for the use of gloves is either to serve as protection from evil spirits or, possibly, to protect the spirits from human contamination. H. M. W. Edmonds said that during the Bladder Festival at St. Michael a glove was hung up along with the bladders while intervillage competitive sport matches were under way. It was taken down and cared for by one person between contests (Ray 1967). That the covering of hands during dancing was an old, widespread trait is seen from a description of the Copper Eskimos of Canada: "fashion ordains the wearing of gloves while dancing" (Jenness 1922:224).

In early times women danced fully clothed, stripped to the waist, or naked, covered only by a translucent intestine parka. In the North they often held long wands of tufted eagle feathers upright in their hands; in the South they waved carved geometric pieces of wood or miniature masks decorated with feathers or caribou fur. These objects, traditionally called finger masks, were used to extend or emphasize the flowing movements of shoulders and arms, as well as to incorporate symbolism into the dance.

W. H. Dall witnessed a woman's dance about thirty-five years after traders had come to the St. Michael area, but before appreciable changes in Eskimo habits had taken place. In December, 1867, at Unalakleet, a chorus opened the Messenger Feast ceremonies. Each woman wore a new intestine parka over tightly fitting embroidered white Siberian reindeer breeches, a short decorated parka, and gloves made of white caribou fawnskin trimmed with wolf. Dall explains:

In each hand they held long eagle feathers, to the edges of which tufts of swan's down were attached. The opening chant was slow and measured. The motions of the dancers were modest and pleasing; the extreme gracefulness of the women, especially, would have excited admiration anywhere. They kept the most perfect time with the chorus and drum taps. Between the syllables of the former, words of welcome to the strangers were interpolated in such a way as not to interfere with the rhythm. The slowly waving feathers and delicate undulations of the dancers rendered the scene extremely attractive.

As the performance went on, the spectators joined in the chorus, which became more animated. Other villagers entered into the dance, and all joined in dumb show to imitate the operations of daily life. New songs, invented for the occasion, descriptive of hunting the deer [caribou], bear, and fox, of pursuing the seal in kyaks [sic], of travelling in the oomiaks, of fishing and other pursuits, were introduced in the chorus. . . . The next evening a similar exhibition took place, which was repeated every night for a week [1870:152–53].

In March, 1880, on Sledge Island, E. W. Nelson saw what, to him, was an unusual dance. Nine women, stripped to the waist, were seated on a bench.

Drummers and singers struck up a medley different from anything I had ever heard, and the women on the bench responded by executing a long and complicated series of swaying motions with the head, arms, and body, in perfect unison. From where I sat the dancers were in profile, and their light-colored bodies showed in strong contrast against the sooty wall. Their slow, regular motions, with bodies swaying alternately from one side to the other, now inclining forward and then swaying back, the arms constantly waving in a series of graceful movements, presented a remarkably pleasing sight.

The headman, ascertaining Nelson's pleasure with the dance, rewarded him by having the women "dance" more than twenty sets of motions, each with different words and music (1899:355).

In certain dances of the Seward Peninsula Eagle-Wolf Messenger Feast, where no masks were worn during the twentieth century, the effect, nevertheless, was brilliant and exciting according to D. S. Neuman who, along with his daughter Elizabeth, attended the last Messenger Feast on Seward Peninsula at Mary's Igloo in 1914. The ceremonies took place in a building, 30 feet square and about 14 feet high, which had been especially built for the event. Though Western civilization was by that time firmly entrenched, the dancing is described as being no less beautiful than that witnessed by Dall in 1867 and Nelson in 1880.

At the start of the Mary's Igloo festival, the box drummer took a long time to tune his drum by adjusting the foxskin on the side:

He seems satisfied, arranges his stool, seats himself, and holding the drum tightly between his knees, gives a firm strike. The chiefs [four who were hosts to the Messenger Feast] leap from the platform, and quickly don their head-dresses of eagle feathers and mittens, which entirely cover their arms. To each of these mittens one hundred and fifty-two breast bones of ptarmigan (dyed red) are attached, which produce a clattering sound, when the wearer moves.

The entire suit is of snowy white and the parka is adorned with countless ermine skins. Their costumes arranged, they stand in a row motionless, their eyes on the drummer.

The title of the first dance is "The coming of the birds in spring." The drummer sounds one, in a very low pitch, two higher, three, still higher. The fifth stroke sounds like thunder, then he stops.

A death like silence reigns. Then his head bends to the left, the drum-stick barely touches the drum, producing a sound which resembles the blowing of the wind through the willows; again and again, in rapid succession he strikes the drum, louder and louder grows the sound, his head is bent forward in signal to the dancers to begin, with his left hand he motions to the singers. There is a clattering sound of the dried bones on the dancers' mittens, their arms are outspread like bird wings, and moved rapidly and gracefully, to imitate the flight of the birds.

Louder and faster sounds the drum, and more and more quickly move the arms of the dancers.

After a while their bodies begin to quiver, their heads move from left to right, the birds are growing tired and hungry, and look for a place to settle, the drummer gives a signal, the motions grow slower and slower while the bodies are bent almost to the floor, with the arms pointing downward and quivering slightly, they pause for a second. Then the arms are spread again, and flight begins, they have found a resting place but no food. The flight continues for some time; once more there is a momentary pause, from which they suddenly rise with tremendous noise and clatter. The hunter has frightened them. Immediately the flight is resumed, growing faster and faster, while the tired and hungry birds, more often seek rest and food.

The dance took more than two hours to perform (D. Neuman 1914:9–11).

Sometimes a dance struck the observer as being one with a primary emphasis on tragedy. Zagoskin, in the early 1840's, saw such a dance. Three men jumped out onto the stage: one in a dog's mask pulling an imaginary sled; another with a human mask pushing the sled; and a third with an ugly mask combining frog and human features, decorated with feathers and representing a spirit. Zagoskin's explanation of the story was that a man and his dog were going from their summer home to their winter home. The dog, however, became so frightened after they had traveled a short way that he stopped and refused to move. After a long investigation, the man finally discovered that the trouble was caused by a spirit who was trying to warn him of danger at his winter village, where there was an epidemic of illness. The man refused to heed him, however, because he said that if he was to die he wanted to be at home with his family (1847:230).

Many dances were mentally as well as physically demanding to perform. As one of Himmelheber's Kuskokwim informants said, "one who wants fishes must think and think about fishes during the dance and also must declare he is thinking about them" (1953:51).

Religious Masks in Festivals

We have seen that masks were used for all occasions except outdoor dancing in the summer and memorial feasts to the dead. The most frequent use was in the Messenger Feast, which has mistakenly been referred to as a potlatch and, within this erroneous connotation, was supposed to have been borrowed from the Northwest Coast Indians. Long ago a common group of elements possibly gave rise to the many separate Alaskan festivals, but the Messenger Feast as found among the Eskimos of the nineteenth century had no functional or structural relationship with the traditional Northwest Coast Indian potlatch.

All evidence points to the Messenger Feast as a local Alaskan Eskimo development, and, indeed, contemporary native interpretations and folktales collected about its origin point to its beginnings in the Bering Strait area. In mythological times, Giant Eagle, mankind's benefactor who was commemorated in the Messenger Feast, lived in the Sawtooth or Kigluaik ("notch") Mountains of Seward Peninsula (Kakaruk and Oquilluk 1964; Rasmussen 1932; Ray field notes), and a Noatak River folktale says that the Messenger Feast originated in the village of "Kaiyoruk" i.e., Kauwerak (Curtis 1930:197–98), whose southern horizon was the Kigluaik Range. The booming beat of the drum represented the pounding of Giant Eagle's mother's heart after her son was killed, and the black triangular pieces of wood on the top perimeter of the drum were the mountain peaks. (Pl. 55. According to legend, the first drum had a foxskin head and a painted border of black peaks.)

The drum was borrowed by the people of King Island, Shishmaref, Wales, Noatak, and Point Barrow, and, although the festival in its historical form might have been an elaboration of an ancient theme, and the origin tales evidence only of ethnocentrism, it is significant that the

stories designated Kauwerak as its original home, and that the drum with its sawtooth theme had spread so far.

From the Kuskokwim to Point Barrow, the Messenger Feast integrated homage to game animals, entertainment, feasting, trade, and romance. On Nunivak Island elaborate wooden masks were worn during the Messenger Feast, but only simple wooden forehead or skin masks during the Bladder Festival. Masks representing well-known supernatural beings seen by shamans were used throughout the Messenger Feast on Nunivak Island by both host and visiting shamans. Point Hope shamans wore masks when greeting visitors at the Messenger Feast. Guest shamans also wore masks (Rasmussen 1952:135).

The activities of the shaman in Nunivak Messenger festivities have already been discussed (pp. 20–21), but ordinary people also wore masks while dancing. On the third day of the festivities, the hosts danced with small nonshamanistic masks but "according to the way the shaman had told them." Then the visitors borrowed their hosts' masks to dance in family groups. On the fourth day, both sides again danced with masks for entertainment after distributing presents. Masks were not worn while gifts were being distributed. As a finale on the last day of the Messenger Feast the hosts, wearing different kinds of elaborate wooden masks, danced the same dance and sang the same song, which belonged to a shaman (Lantis 1946:192; 1960:11, 12, 23).

Many large wooden animal, bird, and fish masks with hoops and appendages were worn on the head, held on with bands, instead of on the face in the Nunivak festivities. These should properly be called head images, not masks. Curtis describes three of them in detail: a predatory bird holding a fish in its mouth, a seal, and a caricature of a beaver (1930:39). Northern Eskimos wore the heads of real animals or birds, such as the ermine or the loon, in a similar manner on the head.

On Seward Peninsula, Messenger Feast ceremonies were complicated and elaborate though no carved wooden masks had been used within memory. When Wales and Kauwerak, the two richest Seward Peninsula villages, celebrated together, they participated in sumptuous

banquets, lavish gift-giving, and marathons of singing and dancing. At that time, the hosts for the feast (the headmen of one of the villages) wore elaborate eagle feather headdresses, garments of the best Siberian reindeer skins decorated with hundreds of white ermine skins, and boots with intricate fur mosaic designs sewed on the tops and sides. Stuffed heads of wolves, walruses, foxes, and ravens were worn on the dancers' heads instead of wooden masks (at least in the early twentieth century), and a large stuffed eagle was a prominent fixture during the entire festival.

One of my informants said that his Kauwerak grandfather had told him that shamans and other people wore wooden masks in the dances at one time, "but it must have been *long* ago, because I haven't seen any masks even in sites." We know, of course, that wooden masks were made by groups adjacent to the Kauwerak people with whom they had constant communication—Little Diomede and King islands, Cape Prince of Wales, and Sinramiut (near Teller). I was told that the people of Sinramiut always accompanied Kauwerak people to the Cape Prince of Wales Messenger Feast. Sometimes Sinramiut, which was located near the first reindeer station in Alaska, was host to its own Messenger Feast. From the report of a festival at this village in 1892 we know that masks were then in use:

This amusement [dancing] often assumes the proportion of a festival lasting several days, and whole villages often go long distances to visit those of another. On such occasions the men bedeck themselves in all sorts of grotesque costumes, wearing upon their heads feathers of birds, their faces concealed behind hideous-looking wooden masks, and their bodies bare to the waist [Bruce 1894:14].

At St. Michael, masks were worn during both the Messenger Feast and the Bladder Festival. H. M. W. Edmonds, while in the service of the United States Coast and Geodetic Survey, collected several of the masks illustrated in this volume and recorded his observations of the St. Michael Eskimos during his stay in 1890, 1891, and 1898 (Ray 1967).

Although he did not obtain significant meanings of the dances and individual masks, he nevertheless wrote a description of festivals in general. In one of the dances from what was probably the Messenger Feast given at Stebbins (Atowak) for St. Michael people, Edmonds said that one of the drummers crawled out from under a bench with a human mask on, kneeling at one side of the room before he jumped up to dance. When he did so, two women placed themselves behind him and imitated his movements with their hand-held feather ornaments. In the next dance, the drummer wore the same mask, but another man joined him wearing a half-mask on the top of his face. They danced exactly the same movements (ibid.).

The Bladder Festival in its classic form was celebrated from Norton Sound southward, although certain whaling and caribou-hunting ceremonies of the North incorporated the bladder theme. The traditional Bladder Festival reported in the nineteenth and twentieth centuries coincided with the distribution of the Unaluk language and related dialects. The Unalit once lived along the entire rim of Norton Sound as far west as the old village of Ignituk between Nome and Golovin. As late as 1882, Johan Adrian Jacobsen observed a traditional Bladder Festival in the village of Atnuk, only eighty miles east of Nome (1884:289–91).

The Bladder Festival, which was celebrated to insure success in hunting, was actually a memorial service for all food animals that had been killed the preceding year. As Himmelheber observed in 1936, the principal aim of the masked dancers was to influence the innermost soul of the animal or bird so that it would be flattered and would reciprocate with a plentifully supplied larder (1953:50). Among Unaluk speakers the seal was the principal animal so honored although caribou, sea lions, and beluga (white whale) were also included. The Eskimos believed that an animal's soul resided in its bladder; therefore, seal, walrus, and caribou bladders, for instance, were saved during the year to be inflated, painted with various designs, and hung in the kazgi during the long days' festivities. On the last day of the festival the seal bladders were ceremonially put back into the sea through the ice where they were reborn to tell the

other seals how well they had been treated. E. W. Nelson said in 1879 that a Kashunuk shaman, bound hand and foot, was put down into the winter entrance of the *kazgi* to make a trip beneath the sea in order to ascertain the Eskimos' degree of success after the bladders had been sunk. He followed

. . . the shades of the seal bladders. He said that he had talked with all but two of the shades and had seen some shades of the bladders he owned playing together in the water; that some of the shades told him they were very much pleased with the men who had taken them and given them such a fine festival; others complained that the hunters had treated them badly and had not offered them sufficient food. He added that the shades of the bladders swam faster this year than the year before, making it more difficult to overtake them [1899:390–91].

Participants in the Nunivak Island Bladder Festival used few wooden masks but had small, simple wooden mask-images and real animal heads to wear on the forehead:

One inogo [amulet of an inherited protector] of a certain man was Crane. He owned a frayed specimen of a crane head which he wore in a certain part of the Bladder Feast. Also, at various points during the Feast, he imitated his inogo; as he burst the seal bladders and put them down under the ice, he cried like a crane. At the end of the ceremonial, this little forehead image was carefully put away, not to be used until the next Bladder Feast [Lantis 1946:239–40].

In the St. Michael area the Bladder Festival was also an occasion for a display of masks for the pleasure of their game animals. The masks displayed not only the spirit of a bird or animal represented in a dance, but also the likeness of a dancer's guardian spirit. The latter masks, which were sometimes patrilineally inherited, were worn in one of the chorus dances.

E. W. Nelson's detailed, composite description of the Bladder Festival as he saw it at St. Michael, Kashunuk, and a village in the vicinity of old Andreafsky trading post (St. Mary's) does not mention the use of masks. Edmonds gives no name to a ceremony he witnessed at

Plate V. *Mask thought to be the spirit of a murre*

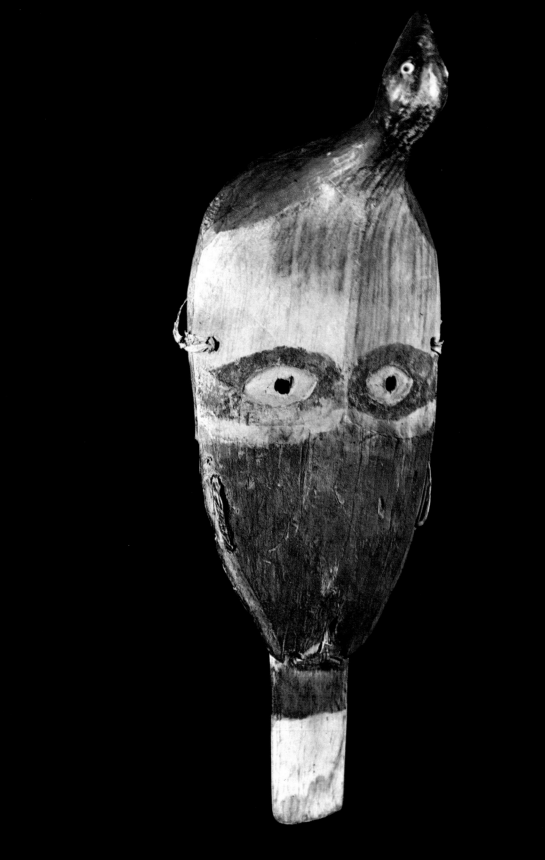

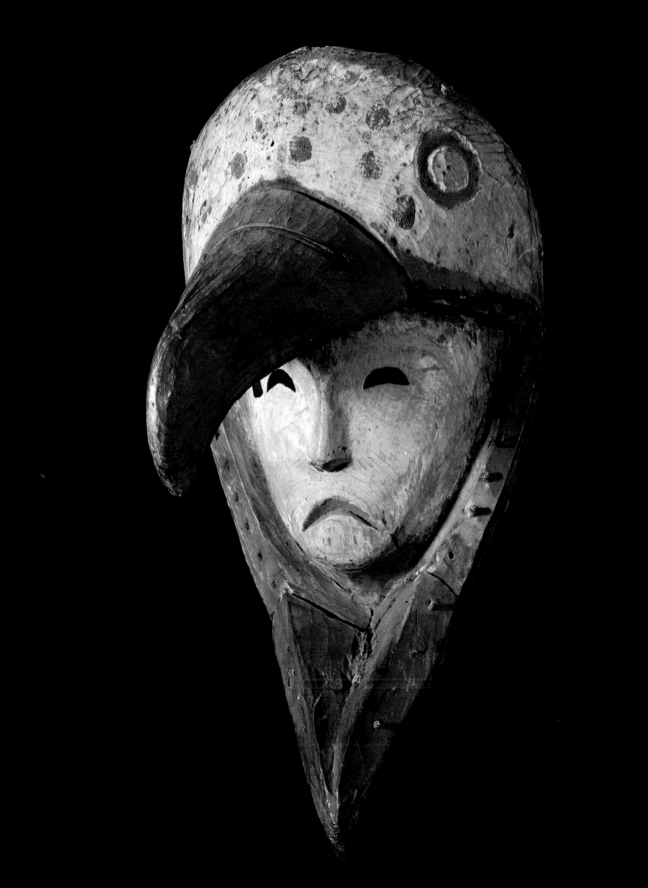

St. Michael, but his description of certain elements, particularly the throwing of bladders into the water at the end of the festivities, leaves no doubt that it was a Bladder Festival, and not a Messenger Feast.

Edmonds wrote:

All the amusements are subsidiary to the great game dance, which is usually planned and rehearsed by the actors under the direction of a Shaman. . . . The news was given out of a great mask dance, but one going over to the casine [*kazgi* or *kashim* as it was called south of St. Michael] would not suspect anything unusual for the Eskimos are lying around telling stories that seem endless.

Finally the natives range themselves along the sides of the room and a few dances of the ordinary kind take place. Then comes the great dance. The participants all gather down beneath the floor, while the drumheads are beating. The Shaman takes position near the middle of the floor, when suddenly from all sides are heard, the calls of birds and the cries of animals being imitated. A dummy hawk is suspended near the roof in such a way that it can be made to swoop down upon its prey or be drawn up again in the air. The prey below is a dummy ermine fixed by its wired legs to the floor, and by the proper mechanism made to come down at every swoop of the hawk or to rise erect when the hawk descends.

While this is going on, the Eskimos jump up through the floor, all having masks on, representing hawks, foxes, wolverines, etc. etc. They all proceed with their backs to the center of the room and so remain till at a given signal they turn around and advance toward the center: at the same time the hawk swoops down upon the ermine. Up through the hole in the floor jumps an Eskimo flopping about and growling like a bear while another Eskimo appears at the hole as a fish. From behind the lamps Eskimos come out rigged up in devil masks and look on at the proceedings to see what mischief they may make. Then all at another signal from the Shaman, go to their places and repeat the preceding *ad infinitum* until, at another signal, they raise their arms aloft to the four cardinal points, and with the hissing noise, make declaration that the ceremony is over.

Edmonds said that the festivities continued for four more days, but without masks, after which the masks and other appliances were destroyed, and the bladders and guts thrown into the water (Ray 1967).

Plate VI. *Unique mask with immovable beaks*

Edmonds mentions that the shaman directed activities, but sometimes it was a layman who knew all of the songs and dances. In the North, the director was usually the player of the box drum or one of the tambourine drums; in the South, the director was the principal tambourine drummer, as well as the shaman. In any event, the director was considered to be a very important person.

E. W. Hawkes observed the so-called Inviting-In Feast, a form of Messenger Feast, at St. Michael in 1912, but presented only in summary his observations of what apparently was a long and complicated celebration (1913b). Comic dances occupied the first day of the festival, "group dances" the second day, and "totem dances" the third. With the exception of several comic dances and a few of the "totem dances" (spirit dances) Hawkes describes none in detail. (The comic dances are discussed in the following section.)

On the third day of the festivities, one of the dances was performed by a man from Unalakleet who

... wore a very life-like walrus mask, and enacted the features of the walrus hunt, modifying the usual gestures. In pantomime he showed the clumsy movements of the great animal moving over the ice, the hunter approaching, and his hasty plunge into the water, then the hunter paddling furiously after him, the harpoon thrust, and the struggles of the dying walrus.

Next two young Unalit gave the Red Fox dance. They wore the usual fur trimmings and masks, and the leader flourished a fox foot with which he kept time to the music. This dance depicted the cunning habits of the little beast, and his finish in the trap of the hunter. The Unalaklit responded with the White Fox dance, which was quite similar, showing a fox stalking a ptarmigan. The stealthy movements and spring of the fox were cleverly given.

The Unalit, on whom the dance had made a great impression, put forward their best dancer in the celebrated Crow Dance.

The dancer entered from behind the press of the crowd, stooping low and imitating the cawing of the raven. The cries appeared to come from above, below, in fact, everywhere in the room. Then he appeared in all his glory. He wore a raven mask with an immense beak, and bordered with fur and feathers. Labrets and fillets of wood adorned the sides, and a spotted black and white design covered the forehead. He bore a staff in his hand decorated with a

single feather. After pirouetting around the room in a ridiculous fashion, he disappeared in the crowd and appeared dragging a bashful woman, who was similarly attired. They danced for a short time together, the raven continuing his amatory capers. Then, evidently tiring of her charms, he disappeared into the crowd on the opposite side of the *kázgi* and reappeared bearing in tow another bride, evidently younger. After squawking and pirouetting around her for a while, the three danced, the two women supporting him, making a pleasing background of waving arms and feathers. At the conclusion of the dance, he seeks again his first love, and is angrily repulsed while seeking to embrace her. This greatly amuses the audience. Then the three leave the scene, quarelling and pushing one another. This concluded the dances proper [Hawkes 1913b:16–17. Compare the crow dance with Zagoskin's description on the Yukon, and of a twentieth-century King Island dance (pp. 4–6 and 194)].

After the crow dance, a shaman wearing a human mask went under the floor to commune with the spirits who had attended the dances.

Masks were used in the North more often and in greater variety than has usually been reported. Froelich Rainey was fortunate in 1941 to witness portions of an old whaling ceremony called "the sitting," which was performed as new ice began to form on the sea. Although the entire performance had not been given since 1910, Rainey was able to obtain a substantial outline of the four-day festival (1947:247–52). Masks were used in a number of ways: as representations of heroes, in dances, and in pseudo dances. The following account is a summary of the role of masks in these festivities.

In both of the men's houses at Point Hope, the first day was devoted to hanging up the *qologogoloqs* ("a group of sacred objects, masks, small boat models and figures of animals or men kept permanently in the qalegi probably for generations"). These sacred objects represented a famous ancestor or a well-known incident or circumstance of the past. Each had a special tale.

The chief sacred object in one of the houses was a wooden mask known as *tatqevluq*. It had ivory eyes, labrets, and ear pendants, and was suspended over the lamp during the sitting.

It was placed face down on a board with a large hole cut in the center so that the face of the mask was exposed to the light of the lamp. The board was known as "the ruff," i.e. the fur ruff of the hooded parka worn by all northern Eskimos. This mask remained above the lamp for four or five days after the other qologogoloqs had been removed following the fall ceremonies; during this period all the [boat owners in this kazgi] were privileged to steal it if they could manage to do so unobserved. If successful, the [boat-owner] secreted it in his meat cache (to bring him luck in the spring whale hunt) until the following fall when he returned it to the qalegi with a large piece of whaleskin which was to be eaten when the mask was again placed above the lamp.

The tale of the mask, tatqevluq, follows: in Tigara, one summer after the ice had gone, a man named Tatqevluq went out to sea, southeast of the village, to hunt with his brother-in-law in two kayaks. They saw two big whales and a small one. Tatqevluq speared the small one with a small seal harpoon; when the whale sounded, he sang his . . . song to hold a harpoon fast in a whale. The whale rose, dead. Its jawbones were erected at the place where the whaling boats were kept where they can still be seen. An exceptionally good carver made a mask to represent Tatqevluq, who, before he died, asked that it be kept in a warm place. For some time after Tatqevluq's death the mask was stored near the ceiling of a meat cache. When it fell to the floor occasionally, the ice under the nostrils melted "as though a real person breathed there." Of course Tatqevluq's remarkable feat was to kill a whale from a kayak with a seal harpoon rather than from an umiak with a large whale harpoon, assisted by his own crew and other boat crews.

At Point Hope, according to J. A. Killigivuk, another masklike image in the form of a woman's face was made by his grandfather and father for prewhaling ceremonies, which he himself has witnessed in the kazgi. (One of these masks, collected in the latter nineteenth century, is in the Washington State Museum, number H-K 100/12.) Called Uwilopaluq, it was placed on the floor in front of a small drum hanging on the wall. A pot containing fresh water obtained from ice in Ipiutak pond was placed on top of the mask. Before his father went out whaling in the morning, he took the little drum and began drumming while his mother took the pot and poured water into the mouth of the image. Then they marked with a hawk feather attached to a stick an imaginary half-

moon on the gutskin pane that covered the upper entrance. Next they removed their pants and parkas and sang a hunting song. After singing they put on their clothes and poured more water into the face's mouth. The remainder of the water was poured into the tunnel just outside the inner door. The image was removed from the ceremonial house after the whaling season to be stored in the entrance tunnel.

During the sitting, a group of performances called *suglut* took place (Knud Rasmussen called them "Suvdlut"—1952:60). The name was taken from the word for half-masks made from tanned white caribou skin. Any man was permitted to make one, but boat owners painted hunting scenes on theirs—a boat crew attacking a whale, men spearing seals or killing caribou. Men also painted black designs on their faces, the boat owners putting a heavy black line across their eyes. The two *kazgis* raced to see who could complete their *suglut* masks first. The winning group sent a boy to the other with an invitation to a special group song enacted by masked dancers that indicated the relationship between the land and the sea; this song became the accompaniment for solo dances that followed. After that, the visitors remained to see a puppet whaleboat crew perform.

The following day dancers put on feather headdresses and painted their faces. When guests arrived from the second *kazgi*, each seated himself and imitated the sound of his protective animal spirit. Thus ensued a confusion of animal and bird cries as in the festival reported by Edmonds at St. Michael (see p. 39). The medley of sounds ended when all faced the audience simultaneously, all calling loudly.

During the festival, a stuffed marmot was manipulated in such a way that it dragged off a suspended whale bladder. Knud Rasmussen, in reporting the same performance at Point Hope, said that all at once

. . . the little ermine sticks out its head from its hole in the wall, pops back again, and then looks out, and finally runs across to the other side to vanish into another hole, snapping up a rattle with a bladder attached as it goes. All hold their breath, for should the creature fail to enter the hole with rattle and bladder behind it, one of those present must die within the year (1927:332).

This is another parallel with the St. Michael festival where an ermine dragged off a hawk. The "Ermine Dance" concluded the Eagle-Wolf ceremonies of the Messenger Feast at Mary's Igloo on the Seward Peninsula (E. Neuman 1914:19).

Secular Masks in Festivals

A significant use of secular masks was to set at ease guests invited to certain festivities. A favorite device was to wear comic masks that ridiculed a physical peculiarity of a person or group of persons. The Eskimo's love of joking and his mastery of the sly dig has rarely been surpassed by any culture. Though humor was usually reserved for story-telling or spontaneous interpersonal situations, festivals had their share of it. The period before the first evening's dancing of a long intervillage or intertribal festival, for example, was often one of great fun, sometimes biting sarcasm, and occasionally lewd behavior. Ridicule and buffoonery by clowns, which were a part of almost every session, spared neither dancers nor the audience. Sometimes the lessening of restraint or the setting of the stage occurred without dances or masks as in the Yukon village ceremonies observed by Zagoskin when old men came out to tease the audience (p. 5). Zagoskin also observed that clowns capered, sometimes indecently, with the dancers and spectators between acts (1847:228–30).

Similar behavior took place in the 1914 Messenger Feast at Mary's Igloo, as described by D. S. Neuman:

Before the dance, the assembled people laugh, talk, smoke and have a general good time. The chiefs meantime sit on the platform motionless, as Chinese idols, their eyes closed and every muscle relaxed, in preparation for the ordeal to come, which requires not only skill, but the greatest bodily endurance.

The drummer takes a long time to tune his instrument, this process is accomplished by much wetting of the folded fox skin on the middle of the drum [i.e., the wooden box drum]. The two head singers chant their monotonous songs. The audience become impatient and caustic remarks are passed on the drummer who delays the dance [1914:8–9].

Sometimes the prelude to a performance was sly humor, indeed. At the Mary's Igloo Messenger Feast of 1914, each guest was greeted by a thunderous boom of the box drum, and, in addition, every woman was noticed by a wooden mechanical doll that turned its head when she entered the room, beat a little drum, and threw her a sigh (Rasmussen 1952:108; D. Neuman 1914).

In 1902 at Cape Prince of Wales, James Wickersham attended a "You-wy-tsuk" dance (of the Messenger Feast) in which the dancers wore their finest spotted deerskin clothes. Visitors entering the *kazgi* were greeted by dancing members: "The action of the drummer, or singer, or relative, in dancing with the visitors, was to do them special public honor," and, as a special number,

... up through the floor popped three boys, dressed in the worst old clothes they could find, and masked, one as a white man, one as a negro, and the other as an eskimo. Their antics and grotesque dress; their bad singing, and worse dancing, greatly amused the audience and the visitors. After their two songs, they quickly disappeared before their identity was known [1902:222].

E. W. Hawkes briefly described several humorous dances of the St. Michael festival of 1912 and illustrated the masks worn. Hawkes said that if the hosts (Unalit from St. Michael) succeeded in making the visitors (Malemiut and some Unalit from Unalakleet) laugh, the hosts could ask for anything they desired. Therefore, the first day's activities were devoted to humor.

The first comic dance was danced by an Unalit man from St. Michael as soon as everyone was settled.

Strange noises were heard in the tunnel, gradually approaching the room. Then a horrible-looking wooden face was thrust up through the entrance hole worn by the chief comic dancer of the Unalit. The mask was made lop-sided, with one cheek higher than the other, and the mouth and eyebrows twisted to one side. One eyelet was round, the other being in the shape of a half moon. A stubby moustache and beard of mink fur, and labrets of green beads, completed the ludicrous effect. He gazed around the audience in silence for a full minute, throwing the children into fits of mingled terror and delight ... the

pantomime began. . . . But the Malemiut visitors, although their eyes twinkled, never cracked a smile.

Then he disappeared through the hole, coming up with a hideous green mask, with a long nose, and a big red streak for a mouth. Surrounding the mask was a bristling bush of reindeer hair. He sat down solemnly, and all his motions were slow and sad. . . . As a serio-comic, this was even more funny than the other, and the Unalit, who could safely do so, fairly roared. But the cautious visitors sat as solemn as owls.

Then the Unalit trotted out their champion, a lithe old fellow. . . . He wore a mask adorned with feathers and an enormous nose, which I was told was a caricature of the Yukon Indian. The Eskimo have lost none of their old hatred for their former foes, and still term them in derision ingkilik, "louse-eaters;" from the fact of their long hair being full of these pests. . . .

The old man took his place in the centre of the floor amid perfect silence. With head on his breast and hands at rest on his lap he seemed sunk in some deep reverie. Then he raised his hand to his head and cracked a louse audibly. This was too much for the Unalaklit, and they howled with laughter [1913b: 13–14].

The fragility of humor is indicated by the almost complete absence of comic masks being made for sale today. Long ago, each was an innovation for a unique purpose rather than a part of the ordinary, traditional songs and dances. They were not only in the minority, but were rarely copied. Also, humorous masks appeared to be more popular in some areas than others. A Shishmaref man, born about the turn of the century, told me that long ago his people did not make them, but that the King Islanders had always been famous for their "funny" masks.

Besides humorous masks, other kinds of secular masks were facsimiles of birds, animals, and human beings to be used in dances of common episodes. Several of my informants told me that masks like those in Plates IX, 13, 23, and possibly 14 were used in dances and songs designed purely for fun. However, these masks were said by Edmonds to be animal spirit masks worn in festivals. They may have had dual purposes during my informant's lifetime.

Spencer, in his *North Alaskan Eskimo*, surmises that the Point Barrow Eskimos used no, or few, masks in religious ceremonies be-

cause of their poorly developed "concept of supernatural impersona-tion" (1959:294). Though this may be true at Point Barrow, the majority of Eskimo masks throughout Alaska were based on spiritual interpreta-tions, and no other Alaskan Eskimo group made only secular or non-supernatural masks. This observation can even be extended beyond the boundaries of Alaska since long ago the Angmagssalik Eskimos of Greenland used masks to represent the shaman's spirit (Thalbitzer 1914: 636).

Furthermore, many mask elements found in religious masks to the south were also present in Point Barrow masks. These included background boards for masks, i.e., the so-called "dancing gorgets" (Pl. 39); paintings of important food animals or spirits of animals on the board; the half-man represented in masks; blood smeared around the mouth of masks; black lines painted across the eyes; grooves around masks for the insertion of halos of reindeer fur, feathers, and other ornamentation; painting that represented hair and tattoo markings; ani-mal masks (particularly the wolf, which was almost always made as the wolf spirit); and the insertion of dog's incisors as human teeth. The Point Barrow Eskimos also used the box drum and mechanical figurines in their ceremonials, particularly the Messenger Feast.

Dances were component parts of one of the most meaningful as-pects of western Eskimo culture—a religion and ceremonialism that bound the human world to the spiritual through a formal plan. The chief purposes of the dances were to honor, entertain, and flatter in a number of ways the spirits of game animals foremost in Eskimo economy, as well as to satisfy aspects of social cohesiveness through a reciprocity of pure entertainment. The greatest number of dances were designed to ensure the most important condition for the sustaining of life, a continu-ing supply of food. In a land where the diet was a variety of meat, pro-vided by the mysteries of the universe, certain controls had to be levied to make the supply regular, or at least dependable. The Eskimos' experi-ences told them that forces greater than they were at work manipulating

the basic needs of subsistence as well as the ends of life itself. The resultant body of beliefs was a religion that incorporated innumerable spirits and sometimes all-pervading omniscient deities such as Air, which were responsible for everything that happened. Nevertheless, the actions of the people who were the recipients or mirrors for these machinations could alter or temper the spirits' actions in various ways.

One was by negative action; that is, avoidance of performing any deed that might put an individual or a whole village into a vulnerable or dangerous position. The other was by positive action, the creation of beauty, song, and movement, and the making of lovely art objects to fill the spirits with good will toward those who depended upon them. The dance, and the entire festival with its songs and masks, was the one large concerted effort toward the maintenance of balance.

Masks were an important, though not an indispensable, part of the dances. Their use appears to have been an extra component, not a basic one, to weave additional meaning into the spell calculated to sway even the most recalcitrant spirit. Although a mask usually belonged to one spirit, song, and dance, upon occasion various kinds of masks, particularly guardian spirit masks, were used together for the same song and dance, uniting spirits and mankind in the face of vast, unsolvable problems of the universe.

Dances and festivals, however, had a secondary function, a social aspect that has already been hinted at. Because of the Eskimo love of comradeship, the festivals were of profound social significance. Although the shaman's role as interpreter and intermediary with the spiritual world was unquestioned, and his influence was felt at every turn of the festivities, ceremonial development would have shriveled without group interaction, particularly when different villages or even tribes were represented. The complicated staging and long practicing for dancing roles were perfected by performers for human as well as spiritual critics. The various long winter festivities, though aimed primarily at fusing the spiritual world with the earthly one, were in many cases, as with the Messenger Feast, occasions of great importance to the solidarity of in-

tertribal relations, and all entertainment was prepared with that in mind. Thus, the masked dances and festivals reinforced man's relation not only to the unknown, which was fraught with danger, but to other human beings, who also presented perils, or at least potential discord and disruption of the individual or the group.

FOUR

Carving a Mask

SHAMANS WERE RESPONSIBLE FOR ALMOST ALL THE concepts expressed in masks, but it is debatable to what extent the finished products were entirely their own because of the prevailing custom of appointing skillful carvers to interpret their visions. On the Kuskokwim, the shaman had neither the patience nor the ability to carve his own mask, according to Himmelheber (1953:76), but this was not true in the North where the shaman usually carved his own. If the northern or Bering Sea shaman did not make the entire mask, he often carved only the spirit face, leaving the rest to another man. The shaman's reluctance to carve at certain times or in certain areas was not because of any spiritual taboo or contamination inherent in interpreting the spirit world, but because of the desire to attain the highest esthetic resolution possible. If a shaman considered himself to be a good carver, then making his own mask would be the only way to perform this important act, which, theoretically, belonged only to the shaman.

According to twentieth-century informants the shamans of long ago, both north and south, were not the best hunters, the best fishermen, or the best carvers because their talents lay in other fields. This blanket statement refers to the ideal shaman—a hypothetical synthesis of all the shaman's qualities that were hated, feared, and loved by the people, as well as their rationalization of his superior gifts—but, in practice, a shaman usually was in the same economic and social slot as anyone else. It is true that occasionally a man's psychotic or neurotic tendencies kept him from being a good provider, and it was these same tendencies that decided his role as a shaman; but just the fact of being a shaman

did not mean that he was incapable of either subsistence or artistic pursuits. The many masks made by northern shamans attest to that.

The unique cooperation of the idea maker and the mask maker means either that the carver always worked within already established artistic styles and had only to choose from them, or that the finished mask was largely the result of the carver's own imagination. It is doubtful that even the most intimate rapport and understanding between shaman and carver could have created exactly what the shaman envisioned without a prior model. Only the shaman's own mind and hands could approximate the transformation of his original dream into the first mask of its kind. The model, however, could easily become the prototype for subsequent masks, and might establish not only a norm for a carver's subsequent execution of a shaman's directions, but the basis for cultural style. The rudimentary guidelines placed by the shaman on blocks of wood suggest that the carver, probably from experience, knew exactly what was expected of him. If not, he apparently was free to express whatever form he thought most nearly interpreted the shaman's vision.

Thus the mask was sometimes the product of one man's vision and another's carving, and sometimes of only one man's vision and carving. In either case, limits of cultural interpretations were broad. Rarely has the artist been allowed greater cultural freedom of expression. The result was a staggering number and variety of masks, and different kinds within one group or village, not duplicates, were the norm. Yet the individualism permitted the artist was the opposite of his expected behavior in religious and social conduct where his actions conformed to certain measures for the safety of all. Each individual was bound by a system of taboos, transgression of which might mean disaster to the community. Paradoxically, these highly individualistic masks were used in festivals in which the entire aim was the communal expression of one important aspect of life: survival. In at least one of the dances of the Bladder Festival, as well as in the Messenger Feast, many varieties of masks were worn at the same time and for the same purpose.

When festival time approached, the shamans decided what tradi-

tional or newly conceived masks were to be used and gave directions for carving them. On the Kuskokwim, the shaman went from carver to carver in the ceremonial house checking their progress (Himmelheber 1953:76).

Neither the shaman nor the mask maker necessarily wore the masks they created. Anyone designated by the shaman could do so. A mask was handled carefully both during carving and preceding its use in dances so as not to offend the spirit represented. When the mask was completed, it was concealed in a secret place, and it was carried from place to place under clothing, usually at night. Before the dance, the mask was put on in a dark corner where the audience could not see the transformation from dancer to spirit. This concern with its care may have been one of the reasons why the carver always attempted to finish a mask the same day he began it.

At the time of Himmelheber's visit (1936–37), a Kuskokwim village of a hundred or a hundred and fifty persons might have had ten carvers; nowadays, there are only one or two. Among the King Islanders today, only one man makes masks, which he sells whenever a buyer materializes.

Masks from one end of Alaska to the other shared a wide range of subject matter as well as a basic symbolism representing abundance of good fortune brought by spirits and interpreted by the shaman. Similarities of carving techniques, tool kits, materials, and paints also extended to all areas. With the simplest tools and the most ordinary materials, the mask maker created some of the most diverse styles ever found in one culture, yet all had the recognizable stamp of Eskimo manufacture.

All masks were made of spruce or cottonwood driftwood. Huge piles of driftwood had collected on many western Alaska beaches before whalers and gold hunters came during the latter part of the nineteenth century to deplete the built-up supply. Today masks, for the most part, are still made from spruce driftwood, particularly in the North where the preferred part of the tree is the stump.

Many of the old masks had a rougher finish than do modern ones, and in some cases the entire surface showed the texture of knife cuts. This was not a result of using stone tools, however, for the carvers had metal carving tools long before masks were collected in the latter 1800's. The smooth finish of masks made to be sold today has resulted from an esthetic outlook adopted from trade demands. The carvers are told by wholesale buyers that customers want a "finished" look, which they are able to achieve by the simple use of sandpaper. The placement of numerous jagged knife marks no doubt was a deliberate attempt by the old mask maker to create an esthetically desirable texture, but this has been abandoned by the contemporary carver. The weird dim lighting of the room caught the planes and angles of the rough texture to add another dimension to the action of the mask.

The tool kit of a mask maker during Zagoskin's time consisted of a small Aleut hatchet, a small crooked knife, and a drill made from a large nail (1847:218). At Nelson's time (between 1877 and 1881), the principal tool was the so-called crooked knife with a three-inch blade, which was used for "whittling, carving, and finishing all kinds of woodwork." A notched end of a caribou antler was used to smooth coarse edges, and a beaver tooth was used to hollow out boxes and masks. The back of the tooth was used for polishing. These small tools were used interchangeably, however, with a variety of steel and iron gouges that soon entirely supplanted them (Nelson 1899:85, 87, 89, 91). The tools used by a King Island mask maker in 1964 were a crosscut saw, an adz, chisels made from files, a jackknife, an old-fashioned bow drill for making holes, and sandpaper for smoothing.

During the carving, both southern and northern mask and ivory carvers unhesitatingly shaped a piece of wood or ivory with an adz to its first general features, than finished it with a knife. With complete self-assurance, they created whatever was planned without a trial carving, a model, or a sketch before them (Himmelheber 1953:76; Ray field notes).

In general, the form of masks was more complex south of Norton

Sound than north of it. The concepts from which they were derived, however, were equally complex. In the South, masks often had more appendages and greater distortion of human features, although these characteristics were not exclusive to that area. Two general styles were found south of Norton Sound, the simple one of the Pacific Eskimos and the complex one of the coastal area between Cape Romanzof (including Nunivak Island) and the southern end of the Kuskokwim River mouth including Goodnews Bay.

Complex, composite masks with either simple or distorted features were made, however, as far north as St. Michael and on the Yukon and Kuskokwim rivers as far upstream as Indian territory where, on the border, similar masks were made by Indians. The sizes of the masks of the Pacific Eskimos corresponded to those of northern Alaska. Their styles were also similar to those of northern masks in that they represented only a single human or animal face. In both areas composite masks with two faces or surrealistic characteristics were unusual, but not unknown. Pacific masks were highly stylized, but the position of the facial features corresponded to that of a normal face, and this was not always the case of various Bering Sea masks. Many of the Pacific masks had hoops and background boards like those of the Bering Sea.

North of Norton Sound, masks were less complicated stylistically than those of the Bering Sea, but were not the simple, human face used almost exclusively to illustrate the northern "type" of mask. On the contrary, many kinds—animal, human, and abstract—were made in every village, and, as in the Bering Sea area, the limit to designs was only the shaman's limit of visions. The use of masks at Point Hope and Little Diomede and King islands was equal to that of the Bering Sea Eskimos; the difference between them was only the degree of stylistic ornamentation.

Small and simple masks were made everywhere, even in the Bering Sea area which was famed for huge and complicated ones. The variation in mask size throughout Eskimo country was staggering, rang-

Plate VII. *Mask, probably from the lower Yukon, said to be the bad spirit of the mountain*

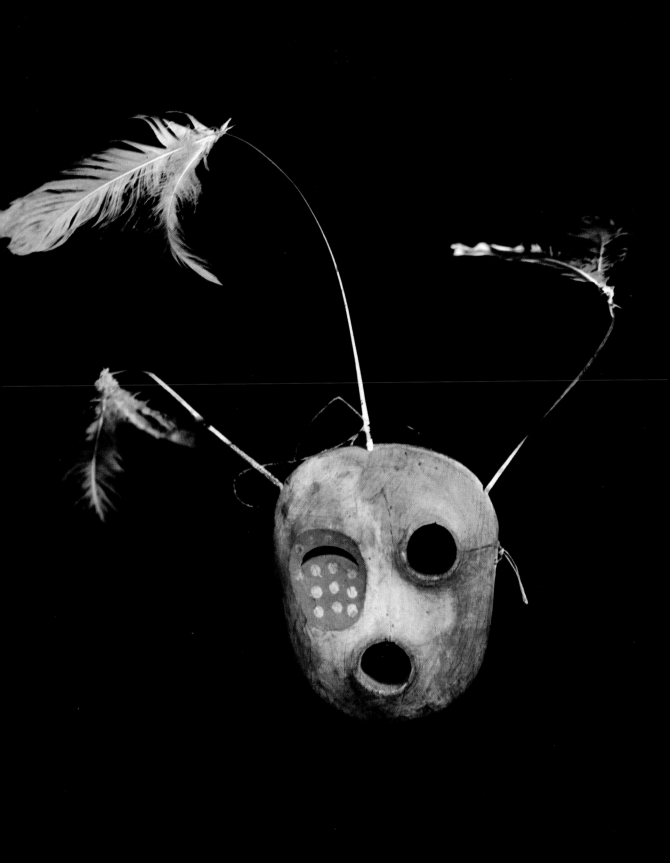

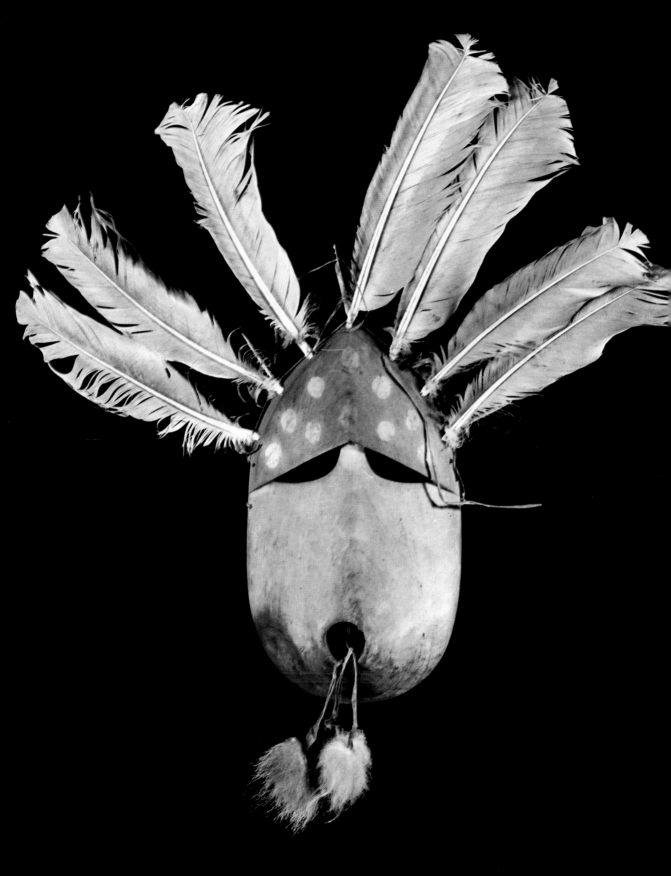

ing from the dainty one only 6 inches high illustrated in Plate 7 to one al-
most 4 feet high from Goodnews Bay in the Washington State Museum
(4258). The latter, which is a composite of several faces on the body of
a huge sea mammal, is equipped with a large handle on its reverse side
so that the performer could hold it in front of him. Nelson had heard
about similar masks, but did not collect any or see them in use. In re-
ferring to a mask 2 feet high and 13 inches wide he said:

Masks of this character are too heavy to be worn upon the face without addi-
tional support, so they are ordinarily suspended from the roof of the kashim
by strong cords. The wearer stands behind the mask bound about his head,
and wags it from side to side during the dance so as to produce the ordinary
motion. I was told that in all the great mask festivals several of these huge ob-
jects were usually thus suspended from the roof [1899:400].

While this may have been true, I have rarely seen a mask of any
size that did not have provision for a performer's free manipulation of it
either with mouth grips or with handles on the inside. One of the largest
masks in the Lowie Museum (19$\frac{1}{2}$ inches high) has no provision for
hanging, but instead was held to the face with a long mouth grip carved
in the reverse side of the mask (Pl. I. The hole at the top was for the in-
sertion of a bird's head). Many masks that looked huge and cumbersome
were actually easy to manage and to wear because they were made of
exceedingly lightweight driftwood. A mask was always scooped out on
the reverse side so that it would fit comfortably on the face. Many were
scooped out to follow facial features, with ample provision for the nose.
The carefully sculptured features were often rimmed with red paint
and looked like masks in reverse. Concave masks used as grave images
or protective house images probably were intended to be worn occasion-
ally by a human being.

Secular masks everywhere were usually plainer than religious
ones, although the line between the two is often difficult to draw. Masks
with exaggerated human features or ridiculously placed ornaments on a

Plate VIII. *A St. Michael mask representing the spirit of the driftwood*

human face were used in secular dancing of comic stories and action. Those with highly distorted features or of a completely abstract quality were usually of mythological beings.

Components of a Mask

Paint and ornamentation

South of Norton Sound almost every mask was painted, usually in several colors, but north of the sound some were left unpainted or were smeared with a graphite wash. Even then, red was usually applied to lips and nostrils. King Island masks during the nineteenth century were painted with multiple colors, dots, and geometric designs. Some very old Point Hope masks have red and black liberally applied to designs on the chin, cheeks, and around the eyes.

All colors were soft and subtle and did not detract from the shape of the mask. They were natural pigments taken from the environment and were easily applied to the light-colored driftwood, one reason why commercial paints did not become popular with the mask makers. Basic colors everywhere were red, blue-green, black, white, and natural. Aboriginally, red was obtained from hematite (ocher) and alder bark soaked in urine. Blue was obtained from copper oxides, black from ashes and graphite (later from gunpowder), and white from white clay. Hematite and graphite were easily obtained on Seward Peninsula and northward but, along with other minerals, were often items of trade elsewhere. For example, Nunivak Islanders obtained their iron oxide (hematite) for red paint and their cupric oxide for light blue paint from Nelson Island (Curtis 1930:59, 71).

Blue or green colors were rarely used north of St. Michael. John Murdoch, between September, 1881, and August, 1883, only once observed a color other than red or black at Point Barrow—it was a dingy green, which he assumed had been obtained from a fungus (1892:391).

In the Seward Peninsula area black was made by mixing graphite, crushed charcoal, or gunpowder with sour urine, blood, or water. Black

paint was also used everyhere for face and body painting in whaling ceremonials, feasts for the dead, and other festivities.

On Prince William Sound, red and black paint was found archeologically, but, according to one of de Laguna's informants, brown, yellow, blue, and gray colors had also been used. All were obtained from earth materials. Red and purple were also derived from swamp grass, a reddish-brown from boiled hemlock bark, and rose from blueberry juice. The colors were mixed with stale urine to make them permanent. Wooden bowls were painted with red paint mixed with nose blood (de Laguna 1956:251).

The painting of wooden objects was many centuries old in the North. Several wooden rods painted red with superimposed black designs, and belonging to the Old Bering Sea culture of St. Lawrence Island, have been found. Numerous wooden objects were painted red in the Punuk culture that followed (Collins 1937:174, 240). Red ocher was found in almost all of the early levels of the Nukleet culture of Norton Sound, and yellow ocher was found in the top five (out of fourteen) levels. A possible white paint was discovered in top levels three to five (Giddings 1964:72).

On Nunivak Island, ordinary people's masks were painted red, while shamans' masks, representing a spirit, were painted blue. Mustaches were painted on some to differentiate between those worn by men and by women (Curtis 1930:38).

Some of today's mask makers continue to use nature's paints, especially hematite and graphite. However, by 1895 W. J. Hoffman said that natural paints were giving way to commercial pigments (1897:782–83), although few masks collected before 1900 were painted with them.

The nineteenth-century carver kept his paints in small, well-made boxes that were often decorated with inlaid ivory or small animal carvings. He applied paint with a rag or his hand and made dots and other splotches of paint with a fingertip. According to Murdoch, the Point Barrow painter applied his paint by licking "the freshly scraped

wood with his tongue, so as to moisten it with saliva and then rubbed it with a lump of red ocher" (1892:391).

The mask makers utilized almost every material they could lay hands on for decorative purposes. The following inventory, obtained from an examination of about 250 masks, is but a sampling of the total array. Nevertheless, it will serve to show the lengths to which the carver exploited his environmental and trading resources: feathers (large ones from eagles, geese, ducks, gulls, swans, and horned owls; smaller ones from ptarmigan, terns, and the tail feathers of the old squaw duck), swan's-down, stripped feather quills, porcupine quills, hair (reindeer, caribou, wolf, dog, and human), seal pup fur, Alaska cotton, beach grass, willow bark, willow root, rawhide strips, bleached strips of intestines (natural color or dyed red or black), baleen pendants, beads, string, pieces of crockery, brass, copper, lead, iron, cartridge shells, ivory, pieces of wood in various shapes, and animal teeth (usually dog).

Walrus ivory was used only as a labret or as an inset eye of an attached figurine, rarely in the eye of the mask itself. Labrets, moreover, were usually fashioned from wood and painted to simulate ivory.

Feathers and reindeer hair framed almost every mask south of Norton Sound and a few north of it, but, because many were collected with these perishable pieces missing, it is difficult to decide when an ornamental device was used or what set patterns or combinations had existed. Although the various combinations of hair, feathers, and appendages were often used indiscriminately, a few generalizations can be made:

1. Caribou hair usually formed a halo round the entire mask or the head. Nelson said that it was attached to represent the ruff of a fur hood (1899:397), but it was also used on bird and animal masks. Caribou halos were attached into a groove made round the mask.

2. The most commonly used addition to the halo was a trio of trimmed quill feathers or tail feathers of the old squaw duck, often tipped with several downy feathers. The three-feather combination appears to have been a popular one. The feathers were always similarly

placed on all masks—one on the top of the head, and the others on either side of the forehead. Three feathers used in this way were often the sole decoration of a small mask.

3. Large quill feathers, inserted directly into the top part of the mask, were usually used without additional fur or feather decoration. Concentric rings, however, sometimes were used as support, and carved arms, legs, and wings occasionally were placed with the feathers. On Nunivak Island and the Kuskokwim River, the basal end of a trimmed quill feather or a bird's tail feather was stuck directly into the mask while the tip end held a small carved figure. The feathers with figurines often surrounded the entire mask (Pl. 44).

The number of plain large quill feathers apparently was an individual choice and did not correspond to any particular kind of mask. The usual number of feathers was from two to nine, although I have seen as many as twenty-six. They were usually spaced equidistant from each other, one feather balancing another on the opposite side. However, in the St. Michael and lower Yukon areas, where masks were carved from the same piece of wood as the background board, the feathers were sometimes thickly crowded on top of the board to create the impression of density, not space. From Port Clarence to Point Barrow eagle feathers were made into tall headdresses worn in the Messenger Feast in commemoration of the Great Eagle (pp. 35–36). Sometimes the headdresses were worn in conjunction with a real animal head or a wooden mask. Possibly the attaching of feathers to Bering Sea masks was an outgrowth of the original pairing of the two.

What meaning should be attached to the many ways of wearing feathers is not known. One of my informants, while discussing the tiny mask in Plate 7, said that the feathers crowded together on the top made the mask look as if it were flying, and Himmelheber said that certain feathers were supposed to represent a crown of foam (1953:59). On a finger mask representing a star, the feathers corresponded to its twinkling (Nelson 1899:413).

Stripped feather quills were often topped by tufts of feathers

that swayed during dancing. Both stripped quills and porcupine quills were used to represent seal whiskers.

Appendages were usually attached to the mask by rawhide strips, willow bark or root, and baleen. Baleen was used when an especially springy or quivery motion of the appendage was wanted. These materials were also used decoratively, either as dangling strips (sometimes with a small object or tuft of fur on the end) or as geometric designs.

Bleached intestine strips were used as free-flowing streamers, sometimes with chunks of fur or small beads attached to the ends. Large beads, shells, and pieces of metal or crockery were usually used to decorate the mask's face, i.e., as labrets or as nose and ear ornaments, although they were used occasionally in other ways.

Wood was cut into geometric shapes for two purposes: personal adornment of a human face (labrets, nose ornaments, and earrings), and decorative shapes attached to the mask. In some cases, the latter were intended to serve as rattles in the dance as well as to add visual appeal. In the Bering Sea area there were two predominant geometric designs, a thin lozenge and a cylinder, both made long or short. These were usually attached to long, delicate masks that represented mythical beings from St. Michael, the lower Yukon (especially around St. Mary's), the lower Kuskokwim, and Goodnews Bay.

The most common attachments on Kodiak, Chugach, and Aleut masks were geometric pieces of wood and feathers. Dall said that gaily painted flat wooden pendants were often attached to Aleut masks. He wrote:

Of these we obtained a great number and variety, and could not determine their purpose, as they were all detached, until after seeing a model of a mask made by an old man at Kadiak, and presented to the National Museum by Mr. Sheeran, (16268) to which similar pendants were attached in their proper places. They were of all shapes, crescents, disks, lozenges, leaf-shaped, and formed like lance and arrow points. They were painted with red, blue, green, black, and white native pigments, often nearly as bright as the day they were put on [1878:30].

Lipshits illustrates three Kodiak masks, one with long double-pointed pieces of wood alternating with large feathers, and another with square pieces of wood with feathers stuck into the end and a stripe painted across the middle. Each was attached by a long quill to a single crude hoop around the mask. A third mask alternated large feathers with round disks of wood, which were attached by a length of root or quill to a hoop (see Pl. 68).

Animal teeth were used in the mouths of human faces; rarely as decorative devices.

Facial features

The shapes and combinations of eyes, noses, and mouths of masks were almost endless. The carver was not bound by the feeling that he must use only one form, as appears to have been the case with the Northwest Coast Indian artist. Whereas almost all Northwest Coast masks were made with the same eye form, the celebrated "Northwest Coast eye," Eskimo masks utilized a large variety of shapes, many of which overlap eye forms used on similar objects of diverse cultures. The Eskimo eye, almost always cut through the mask, was made in the following shapes: round, crescent, oval, teardrop, half moon, almond, and slit. In the rare cases in which an eye was not cut through, the wearer looked through the nostrils or the mouth. Eyes were usually made without indication of pupils. However, sometimes the round eye was intended to be a pupil, and then the eye shape itself was indicated by a painted oval or crescent, or by a depressed double-pointed oval gouged out of the wood (Pls. 1 and IX, for example).

In rare cases, the pupil of some of the cutout shapes was represented by a round piece of wood or metal suspended by string or wire, or inserted into the eye by a peg. Occasionally the pupil was a part of the mask, and the rest of the eye cut out. Suspended eyeballs were popular on the lower Yukon, tear-shaped eyes in the Bering Sea area and as far north as Point Hope and Little Diomede Island, and the self-pupil on the Kuskokwim. Specific forms of eyes were not restricted to one kind of

mask or spiritual being represented, although human eyes were usually variations of a cutout oval.

The mask maker created an unusual variety of noses, but some spirits or mythological beings had none at all. The nose of a human mask or of a spirit in the form of a human face usually was slender and well shaped with small or slightly flaring alae. This nose was not the molded lifelike nose of the Northwest Coast, but was simplified into a suggestion of a nose. The nose of mythical beings and spirits included human-shaped noses, bulbous noses, and cutout noses of many shapes: commas, triangles, crescents, circles, or any likely geometric shape, singly or in pairs. Sometimes the nose was a long raised ridge down the middle of the face; at other times it was only a slight mound in the approximate place. A bird or an animal was made either with a long beak or muzzle or with the feathers, including the nose, flattened into a stylistic representation of the creature.

Masks only occasionally had ears, and lips were rarely carved in the actual form of human lips. Again, the mouth was only the suggestion of a mouth, and it was also made in numerous shapes—open or closed, downcurved or upcurved, slanting, skewed, round, or ovate. It was made with or without teeth. The teeth, if present, were of wood, bone, or ivory, either inserted as separate pieces or carved out of the mask itself. Sometimes they were painted on. A tongue was rarely carved, although certain masks and masklike images used in Point Hope whaling ceremonies had molded lifelike tongues (see p. 95). Sometimes animal masks had paddlelike pieces made to dangle or wiggle during a dance.

One of the commonly used shapes was a round mouth, found as far north as King Island and as far south as the Strait of Juan de Fuca in British Columbia. This mouth usually represented different kinds of mythological beings, depending on the locality. Among the St. Michael Eskimos, for example, a mask with a round mouth was called the spirit of the driftwood (Pl. VIII), and on the Yukon, another represented the bad spirit of a mountain (Pl. VII).

Carved figurines

Carved figurines attached to masks were of several kinds: (1) appendages to complete the body of an animal, human being, or spirit represented in the mask; (2) whole figurines of the shaman's tutelaries or of traveling and hunting devices such as kayaks or spears for use in trips to the spirit world; (3) objects representing food liked by the spirit of the mask; or (4) anything the shaman thought should be included in his interpretation.

The use of animal and human appendages and geometric pieces reached the greatest development and use on the Bering Sea coast—Nunivak Island, the lower Kuskokwim River, and the area south to Goodnews Bay and north to Hooper Bay. However, appendages on masks were also common in the St. Michael area and on the Yukon.

Animal or human appendages were more or less standardized, but not much conventionalized. The few conventional designs were a thumbless, four-fingered hand (often with a hole in the palm); a winglike appendage; a paddle-shaped piece; and a flipper-shaped hand. The hand usually represented a spirit's or shaman's hand; the winglike appendage, a wing; the paddlelike piece, the tail of a bird; and the flipper, a seal's flipper. Nelson said that south of the mouth of the Yukon all hands were thumbless (1899:401).

A variety of other unconventionalized designs—even hands, wings, and tails—were attached to masks. Some hands had three or five fingers, and wings, tails, legs, and arms were made in a number of arbitrary shapes. These appendages did not, by themselves, stand for a whole animal as was often the case in Northwest Coast Indian art; that is, the flipper of the seal did not represent the whole seal, but was used to complete the body of the spirit or the mythical being represented. (An exception to this may be the whale's tail of northern engraved ivory art. It has been suggested that the idea of engraving tails on ivory was borrowed from commercial whalers who sometimes entered in their records a whale's tail for each whale caught. Alaskan Eskimos, however, used the device long before the whalers sailed through Bering Strait in

1848. L. Choris, the artist who accompanied Kotzebue to the Arctic in 1816, sketched an Eskimo-made ivory handle engraved with a row of whales' tails [Choris 1822: Pl. IV].)

The use of whole carved animals, spirit helpers, and game animals on masks had a wider distribution than that of dismembered separate appendages. Masks from Port Clarence and Point Hope often had figurines of foxes, birds, and other animals attached. Tutelaries, spirits' and shamans' food, and other objects of the universe were usually represented as a whole realistic carving, or possibly a half animal or its head. These small objects usually were well made, with carefully carved facial and body features, and were sometimes very realistically fashioned. For instance, a small walrus figurine held in a large bird's beak was made with a cloth neck so that its head swung while its wearer was dancing (see Pl. 61, No. 4).

Painted figurines

The practice of painting figures on masks, appendages, or background boards was found from Point Barrow to the Gulf of Alaska. At Point Barrow, many figures of men and animals were painted in black and red on winglike so-called "dancing gorgets," which were worn on the chest and sometimes in conjunction with masks (Pl. 39). Spencer recorded

An older type of mask . . . the sakimmak. It was this one which had wings, an attached gorget, and to which various figures might be attached. Often the mask had boards protruding from it suggestive of the whale's flippers. On these were painted whales, walrus, and other sea mammals. Such seem to have been worn by the umlealiq [boat owner] in the procession of axraligiic [dancers for whaling feast] [1959:294].

During the whaling ceremonies at Point Hope, boat owners had the privilege of painting "a representation of a whale attacked by a boat crew on their masks [while the others] painted men spearing seals or shooting caribou with a bow and arrow" (Rainey 1947:247).

The Gulf of Alaska Eskimos drew animals on background boards

as well as on the masks themselves (Lot-Falck 1957: Pls. 7, 8; Birket-Smith 1953: Fig. 41). Many Kuskokwim-Yukon area masks had drawings on them. Nelson illustrated several: a realistic human face with a mythical animal painted round its edge (see Pl. 56, No. 3); a mask representing the controller of game, with two animals painted on a wooden board on the right side of its face (see Pl. 58); a small crude mask with drawings of mythical beings on one side of the face (see Pl. 64, No. 2); and one of a human body with a large face on the stomach. On either side of the face is a door; inside one are two whales, inside the other, two caribou (see Pl. 61, No. 1).

Symbolism

Although the individual parts of the mask were usually representational, they were often stylized, sometimes conventionalized, and occasionally symbolic. Though our total information about the meaning of northern masks is small, there is no doubt that their concepts were as complex as those of the outwardly more intricate ones of Bering Sea. Both areas utilized symbolic features, but those of the latter were more obtrusive and more easily observed. Because of this, more inquiries were made into their meaning during the height of mask making, and more is known about their symbolism. We can, therefore, discuss some of the most commonly used symbolic features of the Bering Sea masks: small faces on the surface, concentric hoops, background boards, hands with a hole in the palm, "spectacles" on the eyes, down-curved mouths, and a fish or an animal in the mouth.

The small human face, a spirit, was usually placed in the center of a mask but could be placed anywhere—on the forehead, as an eye, or as an appendage. This small spirit face was also used outside of the Bering Sea area, but greater use was made of it there. Its placement on masklike images is at least as old as the Ipiutak culture of the North at Point Hope where a small face was carved into a set of ivory pieces (Larsen and Rainey 1948: Pl. 55). I was told that the small face was also used long ago on Seward Peninsula masks, and in 1878 E. A. Norden-

skiöld at Port Clarence obtained a mask that had a small human face incised on the forehead (1882:581). Chugach and Aleut masks also had faces or geometric designs (usually circles) placed in the middle of the forehead (for examples see Pinart 1875: Pls. 2 and 3; Lot-Falck 1957: Pls. 4c and 5c).

Concentric hoops were used lavishly from Nunivak Island to St. Michael, including the lower Kuskokwim, the lower Yukon, and the border area between Eskimos and Indians. The use of only one hoop, often oval instead of round, was more widely distributed than that of multiple hoops. One or more oval-shaped hoops were used on Bering Sea, Kodiak Island, and Prince William Sound masks (see Pls. 68 and 69; Lot-Falck 1957: Pls. 4 and 7).

Himmelheber said that concentric rings on Kuskokwim masks represented the Eskimo universe, which contained five upper worlds and the earth, but he thought that the meaning had been added after the rings were well established as a part of the mask. As one of Himmelheber's informants said, perhaps the spirits also lived in the air (1953: 58). It seems reasonable to assume that the primary purpose of the rings was to attach appendages or to support feathers and halos, but no matter how or when the rings received a symbolic meaning, it is interesting that heaven and earth were brought into a mask where so many parts of the universe were already represented.

Large hoops that represented the heavens were placed at the top of a room in the Yukon River Doll Festival, which, according to legend, originated at Paimiut, at the upriver limit of Eskimo distribution. The festival subsequently spread up the river to the Indians, downriver to other Eskimo groups, and across the tundra to the Kuskokwim Eskimos (Nelson 1899:494).

During this festival two large hoops extended entirely round the *kazgi* interior about halfway between the roof and the floor. Suspended from the roof entrance hole were many rods, the lower ends of which were fastened to the upper hoop at equal intervals. Tufts of feathers and down were fastened to both the rods and the hoops.

These hoops and rods represented the heavens arching over the earth, and the tufts of feathers were the stars mingled with snowflakes. The cord suspending the rings passed through a loop fastened to the roof, and the end passed down and was held by a man sitting near the lamp. This man raised and lowered the rings slowly by drawing in and letting out the cord in time to the beating of a drum by another man sitting on the opposite side of the lamp. (This movement of the rings was symbolical of the apparent approach and retreat of the heavens according to the conditions of the atmosphere.) [*ibid.*: 496].

A drawing of a similar structure used by the Ingalik Indians in the Animals' Ceremony is illustrated by Osgood (1958:100). It is of interest that the Doll Festival, with its symbolic lowering and raising of the heavens, and the majority of masks with many concentric rings came from the same general area.

The background boards of the kind commonly used on masks between St. Michael and the Kuskokwim River were said by one of my St. Michael informants to represent variously the land, the air, or the water. For example, when the main portion of the mask represented a fish, it was the water; when the mask was the moon or the sun, it was the air—in other words, the boards, like the edge of one of the Point Hope masks, represented the universe. These masks were always the shaman's and were used both for seances and for festival dancing. Because of their normally large size, they were used for slow dances, which were usually followed by a chorus of faster music.

The hand with the cutout hole apparently represented a wish for continuing supplies of food animals. In 1880 Nelson in the Bering Sea area was told that the hole was placed in the palm so that the spirit of a bird would release the game, permitting the hunter to obtain it (1899: 395).

"Spectacles" drawn around the eyes have been said to represent a seal. Though this may be true for certain masks, there were other symbolic meanings. For example, the hosts for the Kauwerak Messenger Feast always painted lines around their eyes for good luck, and the boat owners of Cape Prince of Wales, Point Hope, and Point Barrow painted

stripes of black around their eyes during whaling ceremonies (Rasmussen 1932:51; Rainey 1947:250; Ray informant data). Black lines were not used around eyes that were of unequal shape or were placed lopsided on a face.

Markings of graphite were also important in Siberian Eskimo rites and ceremonies. During the first boat-launching rite at the beginning of hunting in May or June, the people used black lines on the face to represent special animals that would bring good fortune to a family (Hughes 1959:72).

[Graphite] "guards" a man from the evil spirits and from the sickness brought by them. The lines drawn on the face during the ceremony have two objectives: one is the depiction of the sea animals which the particular family worships, and the second is the protection of the man from the evil spirits [ibid.: 90].

It seems likely that black lines on masks were used for similar purposes.

The Anvik Indians, who borrowed a great deal of their ceremonialism from the Eskimos, put spectacles around the otter's eyes in imitation of the otter's natural markings (Chapman 1907:20). In 1881 Jacobsen identified an Eskimo animal mask with a human spectacled face from Cape Vancouver also as an otter (Disselhoff 1935: Fig. 14).

Paint splashes around the mouth, particularly on Yukon and Seward Peninsula masks, had meanings that are unknown. This is discussed more fully on pages 21 and 22. Mustaches were used on masks from Nunivak Island to differentiate the men's from the women's (Curtis 1930:38). The mustache was also popular on Hooper Bay masks.

The downturned mouth on a mask has generally been thought to represent a female, and an upturned mouth, a male. This may be true for specific Bering Sea masks, but I have not found it to be universal. In the first place, spirits were rarely female; in the second place, many masks from the North which definitely represent the male, and some of the "moon masks" (the man in the moon) from the lower Yukon area, also have downturned mouths.

The downturned mouth is in itself only occasionally symbolic. When it represented a seal it symbolized a bounty of food. One of the earliest known examples of this arbitrary facial feature is on Ipiutak carvings from Point Hope (Larsen and Rainey 1948: Pls. 25, No. 1, 54, and 55) and in Okvik (Rainey 1941: Fig. 29, No. 4).

The placing of a fish or animal in the mouth of a mask everywhere—north and south—represented the wish for abundant game or for good luck in hunting.

Because of our incomplete information about separate symbols occurring on northern masks, we cannot fit them into categories as in the South. Nevertheless, from Rasmussen's information, sketchy though it is, we can infer that dozens of separate symbolic meanings existed at one time. For example, horns on one specific mask indicated that the owner preferred to hunt caribou, and the ears on another—a salmon mask—represented the place where the spirit lived. Fox ears were symbolic of agility (1952:133, 135, 136).

Undoubtedly many other objects and characteristics in the South also had symbolic meanings unknown to us. For example, several masks from the St. Michael area have a slender piece of wood with wooden circles placed one above the other to represent bubbles. We can guess that this was related to the watching of bubbles in the water after completion of the Bladder Festival. In 1842 Zagoskin remarked that in three villages of the Unalakleet area, every bladder used during the festival was tied to a rock and sunk through the ice. The people foretold their success in hunting and fishing from the speed of descent and the character of the bubbles and rings on the surface (1847:106).

Red lines were sometimes drawn around eyes, nose, and mouth on the reverse side of a mask, but informants have been unable to explain their meaning. Ordinary persons were not permitted to see the back of a mask, not only because of these markings, which probably had some relationship to a spirit, but because of certain devices like mouth grips, which permitted a shaman to perform tricks (see p. 20).

Without the impetus of ceremonialism, wooden masks probably

would not have come into being among the Eskimos where the only material is driftwood. In many cultures, any kind of face covering would have been acceptable; even among early Eskimos, skins or animal heads apparently were the forerunners of wooden masks. (The caribou skin masks made for sale at Anaktuvuk Pass were a commercial innovation of the 1950's. See Atamian 1966.)

The aim of the shaman or mask maker was not to make a realistic copy, but to interpret an idea. This idea, which often originated in a vision, was sometimes mundane, but the shaman's or carver's interpretation cast it into a form that separates art from craft. Despite the large variety of spirits and mythological beings of the Eskimo cosmology, most of the masks looked like human beings or the animals they represented, but the ultimate creation was far from a copy of the type model. Great liberties of representation were taken in the making of a sculpin, for example (Pl. IX). Whereas a sculpin is flat from top to bottom, this anatomical feature was disregarded; instead, the face as seen from the front of the fish was elongated, widened, and foreshortened to make the mask an interpretive piece of art. Human faces were not in the least lifelike, though in contrast to masks of abstract design they appear to be.

Plastic surrealism reached one of its pinnacles in the history of art among the Eskimo. Mythological beings were interpreted not only in a nonrepresentational manner (Pls. VII and 10), but often completely in the abstract. Examples are masks from Point Hope (Pl. 50) and from the Bering Sea (Pls. 3 and III); a mask representing a bubble in the water and a finger mask representing a star (see Pls. 60, No. 2; 65, No. 1); and those of a crab and a jellyfish (Disselhoff 1935: Pl. 12), none of which could be identified from its appearance alone.

Although some of the masks appear to have been made in haste, and are crude, the conception in almost all cases emerges as one of exceptional creativity. The majority, however, have been carved with great skill and with as much attention to technical aspects as to the imagery that first prompted their manufacture. Besides the basic concept of the piece itself, the carver utilized several practices to attain

Plate IX. *A carefully made St. Michael mask representing a sculpin*

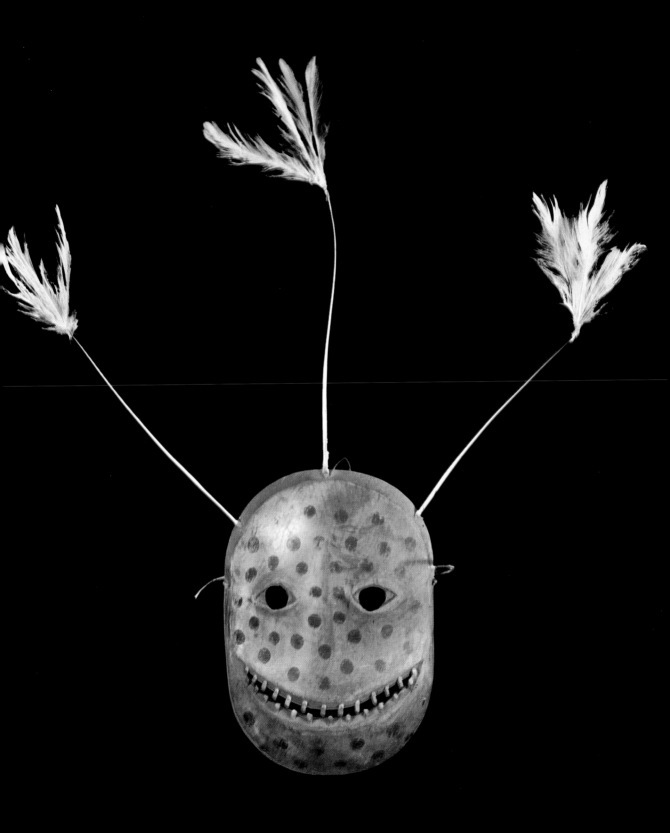

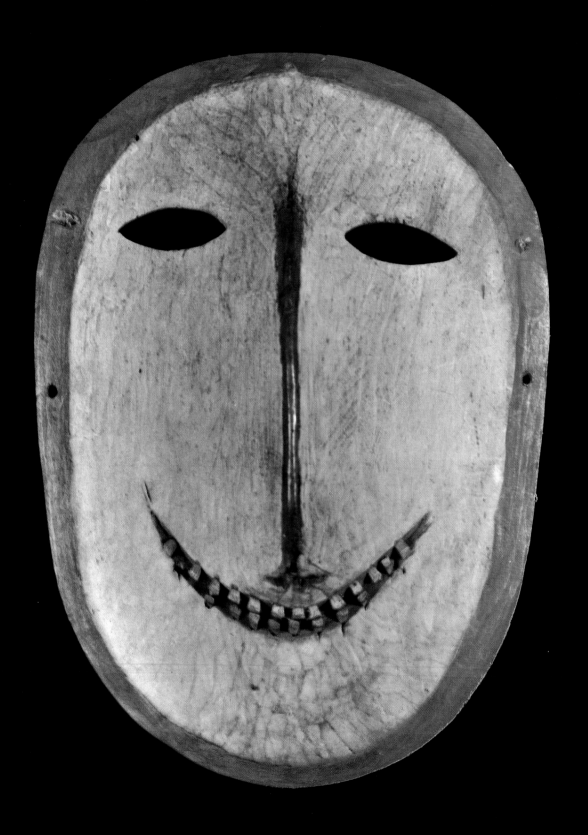

the esthetic ends desired. In the first place, he did not permit paints to distract from the form of the mask. Various planes of the face and features were, however, often clearly demarcated, and, though sometimes painted in atypical colors (such as blue for noses), did not detract from its unity. This feeling for unity is clearly revealed in carrying over such coloring to related features such as cheeks or forehead. Where unusual color areas were present (as in Pls. I and XI, for example), they were related to anatomical areas, possibly conveying an important meaning about the spirit or the being portrayed.

The carver was also very much aware of the play of movement added to masks by feathers, caribou hair, and wooden and baleen dangles. Feather tufts and dangles were often attached with segmented plastic materials such as baleen, split quills, or rawhide to give maximum action.

Unpainted masks, for the most part, were made so that the grain of the wood followed the contours of features to be emphasized (Pls. IV, 30, and 32, for example). Often the grain could be seen through a thin wash of paint. Knife marks were also used to emphasize the relationship of facial features.

The results of artistic endeavors cannot be put into handy categories for instant recognition since the finished objects were highly individualistic products. A catalogue or listing of various categories of masks is therefore possible only in the manner already presented in Chapter 2. Furthermore, the variations within the several categories— even of one geographical area—are so great that the definite placing of a mask without known provenience is sometimes impossible. Taking into account the many differences in component parts of the masks as discussed above, however, a reasonable guess can be made for any one mask within a generalized area.

Plate X. *A St. Michael mask with a long thin nose that protrudes an inch or more from its face*

FIVE

Archeological-Historical Relationships

ARECONSTRUCTION OF THE HISTORY OF MASK MAKING and associated ceremonies must of necessity proceed on the basis of meager archeological and ethnographic data. An outline of mask development is possible although numerous gaps are inevitable due to paucity of information—information that may never be recovered in the future.

What evidence we now have indicates that masks did not come into existence in ceremonially significant numbers until early historic times. Masks are almost completely absent in archeological sites, and wooden masks comparable to those made by the nineteenth-century Eskimo are found only in late sites. From one end of Alaska to the other, no face-size wooden masks have been found in sites that are definitely pre-nineteenth century. Negative evidence is weak evidence, but the tendency has been to interpret Eskimo archeological cultures in the light of a trait's absence as well as its presence. Therefore, the lack of masks in sites more than a thousand years old, including Old Bering Sea, Punuk, and Ipiutak, where many other wooden objects have been found, means that masks almost certainly did not then exist.[1]

The first known reference to Eskimo-Aleut masks was made in 1764–66 by Feodor Solovief, who said that the natives of Unalaska danced in the nude, wearing masks representing various sea animals (Coxe 1784:230). Afanassy Ocheredin and Ivan Popof also reported that dancers wore masks on the Fox Islands in the Aleutians. When they

finished dancing, they broke them or threw them into caves (*ibid.*:246). Gregor Shelikov, the founder of Three Saints Bay, Kodiak Island, mentioned in 1784 painted masks used by Kodiak Islanders (*ibid.*:298).

The first published drawings of masks were those collected at Unalaska in 1790 by Martin Sauer during Joseph Billings' expedition (see Pl. 67). These illustrations are of fairly realistic faces, entirely unlike the large-nosed, jut-jawed masks collected from Aleut caves by Dall and Pinart in the 1870's.[2]

It is unfortunate that early masks were not collected from the North, but European contact there was disjointed and casual, in contrast to southern Alaska and the Aleutians where trading posts were established in 1783 after forty years of raiding and trading contact. The early explorers to the North found the Bering Sea and the northern Eskimos wary and suspicious. Furthermore, those Eskimos lived in summer tents during the sailing season, away from their permanent homes where they had stored their winter ceremonial paraphernalia.

A number of tiny faces with masklike qualities have been found in excavations from Point Barrow in Alaska to the Strait of Juan de Fuca, British Columbia, as well as in northern Canada.[3] Although it is possible that some might be copies of large masks, no wooden face-sized masks were found in conjunction with them. Possibly these small sculptures never have represented masks, but were amulets, meant to be suspended or placed in a soft matrix like wood. They also might have been used on wands for ceremonial purposes, or only as dolls' faces.

There is no supporting evidence from data about nineteenth-century Alaskan mask making that such facelike images were actually miniature masks, that is, placed on faces of small human figurines. The so-called "finger masks," widely used south of Norton Sound, were somewhat comparable, but had none of the attributes of a real mask. A true mask always partially or wholly covered a face to transform a human being into a spirit, a thing, an animal, or another human being. The duplication of face masks in objects to be waved by dancing women was a duplication of design, not of function or of meaning. Women,

except in certain secular dances, did not wear masks, and under no circumstances could they represent a spirit or interpret a male shaman's dream in a mask. Even a female shaman's experiences were interpreted by a male carver. Some of the finger masks, furthermore, were duplicates only of mask appendages as seen in Plates III and 36, although a few finger masks were copies of large face masks.

As discussed earlier (pp. 21–23), a distinction should also be made between true masks made to be worn on the face and large masklike images used as grave markers or for prognostication or insurance of good hunting. The masklike objects from Ipiutak, Port Moller, and the Canadian Arctic may have been used for such purposes.[4]

The scarcity of masks in archeological sites can be argued to have resulted from a custom of burning masks and regalia after a ceremony. This custom, however, cannot account for the almost total absence of early archeological masks because the practice was far from universal and was more an ideal procedure than a practical one. Furthermore, the observations that they were destroyed were not consistent with the observers' success in collecting hundreds of them. A paradox of the Eskimo attitude toward masks was their care in hiding them until public ceremonial use, on the one hand, and their willingness to sell them, on the other. Nevertheless, this was entirely in keeping with the general pattern of Eskimo life, which was a series of pragmatic alternate choices in all parts of their culture in a harsh and quixotic environment. In this case, an alternative in the Bering Sea area was to burn or throw away an amount of wood equal to that of the mask (Nelson 1899:358), or on Seward Peninsula to burn effigies of the masks and other paraphernalia (Ray field notes).

In every area masks were kept from year to year. On Nunivak Island, both the small patrilineally inherited forehead images and the large shaman's greeting masks for the Messenger Feast were preserved (Lantis 1946:192). On Little Diomede Island, the shaman kept his collection of masks in a box (Hawkes 1913a:584), and the Point Hope people cached theirs beneath the *kazgi*.

Since only negative evidence for masks is apparent so far, we tentatively assume that ceremonial masks were a fairly recent innovation. The evidence relating to associated ceremonies is weaker than that for material accouterments, but points unequivocally to proliferation of masks as a consequence of an elaboration of ritual and development of ceremony. If masks are recent, what are the factors that contributed to their development?

The efflorescence of mask making (as opposed to masklike images) among Alaskan Eskimos may have been the result of two possibly unrelated circumstances: more efficient carving tools obtained through intensified European trade, and transportation developments that permitted greater interaction between distant groups.

Eskimos made many utilitarian and artistic objects before acquiring metal, but the introduction of knives without doubt enabled them to make all objects more easily and in greater quantity than with stone or bone tools. Although all the requirements for woodworking in minimum quantity were present at an early date, making large numbers of masks, which required a great deal of skill in tool manipulation, would have been a leisure-time activity outside the probabilities of earlier cultural pursuits. The prototypes were skin masks, easily fashioned with available skin-working tools.

Eskimos probably received their first metal tools from the Siberian Chukchi, who were the middlemen for a lively barter not only of aboriginal goods, but of postcontact European wares. It has long been supposed that small quantities of iron had come to the Bering Strait before A.D. 1000 (Collins 1937:304–5), and recent finds have pushed the date even further back, possibly to A.D. 500 (Chard 1960:57; Rainey 1959:6, 10). The small pieces available at that time were unquestionably used only to engrave small objects. Large, supple iron blades to be used in the well-known crooked knife were not available until metal was traded in large quantities.

The earliest date for historical trade iron in quantity was possibly mid-seventeenth century, but more likely mid-eighteenth century.

Iron was scarce when Captain James Cook explored the coast of Alaska in 1778. At Bristol Bay, thirty-seven years after the discovery of Alaska by Vitus Bering, the scarcity of iron tools was remarkable enough for Cook to mention, "nor was any foreign article seen in their possession, unless a knife may be looked upon as such. This, indeed, was only a piece of common iron fitted to a wooden handle. They, however, knew the value and use of this instrument so well, that it seemed to be the only article they wished for." At Cape Denbigh, farther north, he said that iron was "the beloved article" of trade, and he was able to obtain almost four hundred pounds of fish for four knives made out of an old iron hoop (1784, II:437, 480).

By 1816 when Kotzebue visited Kotzebue Sound, men possessed iron-tipped lances as well as long knives, which they wore thrust into a scabbard fastened to a belt. Kotzebue learned through sign language that they obtained the knives and the lances nearby from Siberian traders who carried on a mute trade (1821, I:211). Intercontinental trade had increased considerably after the establishment of a large Chukchi-Russian trading center especially for the Alaskan fur trade on the Anyui tributary of the Kolyma River in Siberia in 1789 (Ray 1964:86–87). By the turn of the eighteenth century, permanent Russian settlements in southern Alaska were also expanding. With this wealth of possibilities, no Eskimo trader would have failed to put a knife in every belt, since a network of trade routes and an overlapping chain of traders covered Eskimo territory with precision. Goods available to one group eventually became available to all.

Although the late appearance of the widespread complex of wooden mask making among the Eskimos probably resulted in part from improved tools, I suspect that it was more closely associated with intensified interaction between villages during the winter ceremonial season. It is significant that the Alaskan Messenger Feast, which involved traveling long distances in the winter, apparently developed after the introduction of dog traction, i.e., within the last three centuries. The Messenger Feast, on the basis of trait distribution, was the

youngest of all Alaskan Eskimo ceremonials. The Bladder Festivals and ceremonies commemorating the dead, which appear to be older, were widely distributed in Alaska with great variations from place to place. The Messenger Feast, on the other hand, had many identical traits spread over a large area. Wherever it was found, large quantities of preserved animal heads, wooden masks, and fancy regalia were used— more than in any other ceremony. Some of the Messenger Feast objects were borrowed without alteration, as the box drum, for example, was borrowed by Point Barrow Eskimos from Kauwerak people (see pp. 26–27). Terminology is similar for participants and events from Point Barrow to the Kuskokwim.

The Messenger Feast with its elaboration of trading and cere-monial competition must have developed within a dual village situa-tion where one village vied with another in all activities. The festival, usually celebrated in December, sometimes involved the transporting of two hundred or more persons and their possessions to a host village fifty to one hundred miles away. An annual or biennial trek of this magnitude would not reasonably have been undertaken merely for a holiday in the dead of winter had transportation consisted only of hand sleds. It seems therefore probable that an intervillage activity such as the Messenger Feast did not develop until the festival participants were able to carry all of their required ceremonial outfits and trading goods for a two or three weeks' stay on sleds pulled by dogs.

The new kind of transportation not only facilitated the getting of food to feed the many guests, but fostered a new kind of winter ceremony in the comparatively rich subsistence areas of the Bering Sea and the Bering Strait. The Messenger Feast undoubtedly developed its kit of ceremonial regalia and wooden masks for both the spirits and the people within its framework of intervillage competition and rivalry.

The historic relationships between the various styles of masks are almost as tenuous and difficult to determine as the beginnings of mask making. Nevertheless, from a few diagnostic characteristics of various masks we can see that styles were not confined to one village

only, but had traveled in some cases a long distance. Although nineteenth-century Alaskan Eskimos were more or less sedentary, representatives of every group, especially those of the North, were great seasonal travelers both by land and by sea, taking any profitable venture as an excuse to travel. Thus, when the Anyui-Kolyma fur market was in full swing, it effected far-reaching changes in Alaska, where a number of northern Eskimos became intra-Alaskan agents for the intercontinental fur trade (Ray 1964:86–87). Similarly, the Bering Sea Eskimos supplied furs to the south Alaskan chain of Russian trading posts, established at about the same time.

We know from eyewitness accounts that by the nineteenth century Eskimos were moving energetically from one part of Alaska to another. Before St. Michael was established in 1833, the King and Sledge islanders and Malemiut traveled regular barter routes to St. Michael (Tachek trade market) and to the upper Yukon. Zagoskin in 1842 said that the island people also went annually to the aboriginal trading center of "Pashtol" (Pastolik) as well as to the farthest south settlements on the Yukon (1847:76). After Zagoskin's visit, St. Michael became an active trading center, and both Eskimos and Indians came from afar to visit it. Thus, resemblances found in masks during the time of intensive collecting (1870–1900) could be partially explained by exchange of ideas brought about by expansion of trade. This would account for the many similarities in masks from Bristol Bay, the Kuskokwim and Yukon rivers, and St. Michael, and for the occurrence of many northern-style masks throughout the entire area.

The many varieties of masks collected from St. Michael do not constitute a "St. Michael style." It is also surprising to find so many of these masks in so many museums with counterparts ranging all the way from Point Barrow to the Nushagak River. Wholesale borrowing seems to be involved in many cases. For example, a simple face mask found on the Kuskokwim and Yukon rivers was collected in duplicate between the 1880's and 1900 (Pl. 45). This mask is almost indistinguishable from one of the simple styles made by the King Islanders (Pl. 47b).

Only the subtlest treatment in carving sets them apart. Where the mask was made originally is problematical, but most likely it came from King Island.

Only certain elements, on the other hand, were borrowed to be incorporated in a local style of mask. One of these was a large bulbous nose found on masks from Aleut caves and from the Bering Sea Eskimos (Nushagak, Kuskokwim, and St. Michael). Eskimo masks usually had small or no noses, yet a large nose was found on an Ipiutak masklike carving at Point Hope in northern Alaska (Larsen and Rainey 1948: Pl. 55). Some nineteenth-century Point Hope masks as well as those of Cape Prince of Wales and King Island had large noses (Pls. 48, 49, and 53).

No relationship appears to exist between the northern and southern large nose form: northern examples have a rectangular root with huge upturned nostrils, while the southern ones are large all over, the nostrils usually placed at the edge of the nose. A point to remember, however, is that faces with small, normal noses were also made in both areas. Masks with large noses often represented sea mammals south of Norton Sound.

Dall, in the 1870's, noticed a relationship between the Aleut nose and what he supposed to be a unique Nushagak nose, though the latter is flatter and less protruding. He said: "Such shaped noses [on Aleut masks] I have observed only once on masks not from Aleut caves. In that case the mask was one used in Shamanic ceremonial from the Nushagak River, Bristol Bay, collected by Mr. McKay" (1884:141).

The Nushagak type, in turn, is so much like many from the Kuskokwim and St. Michael as to be interchangeable. The direction of borrowing might have been north from the Aleutians and the Nushagak since travel between the Russian-American Company's Nushagak trading post of Fort Alexander, established in 1818, and the Kuskokwim River was quite common by the time Zagoskin had arrived in Alaska. He reported, furthermore, that about 1843 two families moved from Nushagak to the Kuskokwim (Fort Kolmakov, established only two

years before) because of dissatisfaction with the head trader (1847:210).

By 1866 large numbers of Kuskokwim River people were going to St. Michael. One of the young men of the Western Union Telegraph Expedition, Fred M. Smith, wrote in his diary for July 4 that two oomiaks full of people had arrived from Kolmakofsky Redoubt (Kolmakov) on that river (Smith diary).

However, since we have no basis for dating the masks with large noses—not even those from the Aleutian Islands—the direction of borrowing might very well have been the other way. Yukon and Norton Sound Eskimos were met on the Kuskokwim by Ensign Vassilieff during an exploring expedition in 1829. They told him about portages from the Kuskokwim to their territory (Bancroft 1886:547), and it was partly on their information that a trading post was built at St. Michael in 1833. Ivan Petroff said that by 1880 many families from the Kuskokwim and Yukon rivers and Norton Sound were living in the Nushagak area (1884:135).

Although Kuskokwim and St. Michael examples of the large nose shape in museums today far outnumber those from Nushagak, this may be of little importance in pinpointing an origin for this particular feature because of erratic collecting. We know only that it was made in almost duplicate form by mask makers from the Nushagak to St. Michael, 350 miles apart.

Another example of borrowing during the historic period illustrates the importance of one man's influence. A peripatetic shaman, Apaguk, formerly from Nelson Island, was well known on Nunivak Island (Lantis 1960:118) and on the opposite coast as far north as St. Michael. In 1964 one of my informants told me that in 1915 he had seen Apaguk at Stebbins (Atowak) where he wore masks like those in Plates III and 7 during his performances. All of these places were well within the area of travel during the early twentieth century, but earlier than that people from Nelson Island would not ordinarily have traveled to St. Michael, although it was not unlikely that they might have done so occasionally. In the old days a shaman might be called from afar to

dispense his services, but rarely from beyond the boundaries of his own dialect group.

Relationships between Eskimos and Contiguous Areas

One of the major misconceptions about Eskimo masks and ceremonialism has been the notion that much borrowing from the Northwest Coast had probably taken place. It is easy to see why this prevailed for those concerned with North American anthropology, since Franz Boas was largely responsible for the gratuitous and unsupported declaration that

. . . [it has been proved] conclusively that the culture of the Alaskan Eskimo is very greatly influenced by that of the Indians of the North Pacific coast and by the Athapascan tribes of the interior . . . [and] on the whole, I am confirmed in my previous opinion that the exuberance of form which is so characteristic of objects of Eskimo manufacture west of the Mackenzie River is due essentially to the stimulus received from foreign cultures, particularly from that of the Indians [1901:369–70; 1907:564].

These categorical statements were without evidence to support them, but Boas' prestige influenced many persons to follow in a similar vein. One of the most important aims of the present book is therefore to provide evidence for the independent origin of the Eskimo traits in the context of mask making.

Because of Boas' work with two strikingly different cultures, the Central Eskimo of Canada and the Kwakiutl of the North Pacific Coast, he assumed that all Eskimos except the Bering Sea mask makers were esthetically impoverished, and that all Indians were esthetically wealthy. However, subsequent archeological excavations have revealed that elaborate art existed north of Norton Sound shortly after the beginning of the Common Era.

William Thalbitzer's small dissenting voice in a relatively unknown publication a few years after Boas unfortunately failed to stem the effects of the latter's pronouncements. "Boas," he said, "refers to the Thlingit Indians, but there is hardly more reason to believe that the

Eskimos copied their art of masks for cultic purposes from these people rather than the reverse" (1912:640).

Recently, the majority of statements have tended to agree with Thalbitzer rather than with Boas. For example, Birket-Smith in his *Chugach Eskimos* said:

[I am] not so convinced as before that the impetus to the development of the grotesque type of [mask] actually came from the Northwest Coast, even though some influence from there may have drifted northwards to the Eskimo ... and I feel inclined to believe that [Margaret Lantis] is right in considering Eskimo and Northwest Coast masks as being parallel developments of some common ancient form [1953:205–6].

From archeological and historical evidence mask making is considered to be late also on the Northwest Coast. Preservation of wooden objects is not comparable, however, in the Arctic and the Northwest Coast because of the damper climate of the latter. Nevertheless, many objects of wood have been found in sites where masks have been absent.[5]

The apparently simultaneous development of the various mask-making complexes suggests that they were independently derived, particularly because the two areas of greatest complexity of masks, the Bering Sea and the Northwest Coast, are flanked by peoples who made comparatively simple masks or none at all. A third great center of mask making was Point Hope, far to the north, with King Island a fourth. None of these areas should be viewed in isolation, however, because nineteenth-century wooden mask making stretched in an almost unbroken line along the coast of Alaska and British Columbia from Point Barrow to the Strait of Juan de Fuca.

Although masks were collected in the Aleutian Islands earlier than in any other part of Eskimo country, the unfortunate lack of contemporary data for northern areas where tradition gives an equal age to masks leaves the question open as to simultaneity or original invention of masks among the various Eskimo groups.

Although Boas' implicit assumption was that the Chugach Es-

kimos nearest the Tlingit would have been the reasonable borrowers
of masks, he actually was referring to the Bering Sea Eskimos, who had
no direct contact with the Northwest Coast Indians. Before the Tlingit
moved north toward Yakutat Bay, the area had probably been occupied
by Eyak Indians (de Laguna *et al.* 1964:2, 207). Therefore the Tlingit, at
the supposed time of development of ceremonial masks, lived farther
south. Chugach masks, however, have no stylistic or conceptual rela-
tionship to those of the Tlingit. The difference between them is greater
than that between masks of Alaskan Eskimos living at the greatest dis-
tance from each other.

Boas' hypothetical relationship of Bering Sea masks with those
of the Northwest Coast cannot be explained on a basis of contiguity, or
even of borrowing Tlingit traits at second hand from the Chugach or the
interior Alaska Indians. The Yukon and Kuskokwim Eskimos, far down-
stream on the seacoast from the interior Athabascan Indians who shared
little with the Northwest Coast, could not be expected to have a direct
relationship with Northwest Coast art as Boas suggested. On the other
hand, the Eskimos of the Kuskokwim and the Yukon had little inter-
course with the Pacific Eskimos because of mountain barriers. Yet trade
routes had been established, and the greatest contact between the Pacific
Eskimos and Bering Sea Eskimos apparently was on the Alaska Penin-
sula in the Iliamna Lake district where mountains and portages were
less difficult.

Although some masks known definitely to be of Kodiak prove-
nience were similar to Chugach ones, many Kodiak elements—the man-
ner of painting whole figures on masks, the attachment of feathers and
geometric wooden pieces, and background boards—were related to
Bering Sea masks. The few existing Aleutian dancing masks, not found
in caves, are also similar to those of the Bering Sea (see Pl. 67).

The apparent lack of direct relationship in masks between the
Tlingit and their closest Eskimo neighbors, the Chugach, and the grad-
ually stronger relationship westward to the Aleutians and the Bering
Sea destroy the argument of S. V. Ivanov, who, in 1928, suggested that
the form and painting of Aleut hunting hats had been derived from

Tlingit animal masks. He argued that Northwest Coast Indian bird masks, particularly those of the Tlingit, were the prototypes of the Aleut birdlike helmets, proving, he said, "once more how at one time Indian culture influenced the Aleutian" (1930:490). His conclusions paralleled Boas' thesis that the Eskimos borrowed from the Indians, and his paper, which contains many interesting comparisons that could be used equally well with Bering Sea masks, was an attempt to corroborate it. In doing so, he disregarded the hundreds of nineteenth-century Bering Sea and northern Eskimo bird masks and carvings. Archeological excavations since 1926 have shown that bird motifs in Eskimo art are very old, and that the Aleuts need not have borrowed them from the Tlingit. Engraved bird head designs on Old Bering Sea ivory objects and ivory bird heads and beaks from Ipiutak were used for both ceremonial and utilitarian objects (Collins 1929; Larsen and Rainey 1948: Fig. 35, Pls. 51, 69, 70, 72, 74), and the Ipiutak bird beaks may have been used on hunting visors similar to those of the Aleut (Larsen and Rainey 1948:113).

The most apparent borrowing between cultures during the nineteenth century was on the Yukon and Kuskokwim rivers, where Eskimo and Indian territory adjoined. There, the Indians borrowed much of their art from the Eskimos.

De Laguna, in considering these relationships said:

[On the Yukon] we ought to include the whole complex centering around the kashim, since this was taken over by the lower Tena [Athabascans] almost in toto from the Eskimo. Only a few elements of the complex have reached the Koyukuk and middle Yukon. This complex includes the use of the kashim as men's club house, guest house for visitors, sweat bath house, and auditorium for masked dances. The masks and other paraphernalia for the dances, the occasions on which they are held (chiefly honoring the souls of dead persons or dead animals), and the type of dance performed are almost identical among the lower Tena and the Yukon-Kuskokwin Eskimo [1947:281].

This was not the first time that these specific relationships had been recognized. Early travelers to the Bering Sea area were unanimous

in their opinion that the Indians had been borrowers of Eskimo cultural elements, and not the reverse.

Zagoskin said that in 1843 the Indians of the upper Innoko and Yukon rivers did not use masks or have community houses, although the Eskimos on the lower Yukon were using wonderful masks and large community houses. The Indians living adjacent to the Eskimos, however, had both masks and community houses (1847:250).

Dall, in 1870, compared the Indians of the upper Yukon with the Eskimos of the lower part of the river:

A great difference is noticeable between the villages on the Upper and those on the Lower Yukon. Below, we find large, solid, permanent houses, gayly painted paddles, and great abundance of skin boats, the prows of which are frequently fashioned to resemble the head of some beast or bird; above, the dwellings are at best miserable huts, tents, or temporary shelters made of brush. Dirt, and a deficiency of the ornamental, mark the upper village, while the only boats are the frail and carelessly made birch canoes [1870:224].

Dall also said about the village of Anvik on the Yukon: "The natives are Ingaliks, but from constant intercourse and close proximity to the Innuit tribes of the coast, they have adopted many of the Innuit customs" (ibid.:217).

About ten years later, E. W. Nelson observed, "In ascending Yukon and Kuskokwim rivers, as the coast districts are left behind skill in carving becomes less and less marked among the Eskimos, until those living as neighbors to the Tinné appear to have but little ability in that art" (1899:197). He also mentions that the Eskimo ceremonial house had been adopted by the Indians nearest the Eskimos on both the Kuskokwim and the Yukon (ibid.:245).

John Chapman, who witnessed a festival of the Anvik Indians on the Yukon in 1905, also concluded that the Indians had borrowed their dances and festivities from the Eskimos since the upriver Indians did not have them (1907:16).

Because of the probable parallel development of Eskimo and Northwest Coast Indian masks from a common ancient source, it is

not surprising to find that many general elements contained in masks are shared by both, but specific elements to a lesser degree. Some of the general elements are distributed throughout North America as well. An isolated element determines neither provenience nor possible relationship of masks, and only when various elements are put together in a distinctive way does a mask emerge as wholly Northwest Coast, or Eskimo, or Iroquois. Even the combining of elements is not always enough to characterize a mask, and sometimes only the subtlest stylistic difference distinguishes one group's masks from others. It is as difficult to recognize the combination of elements that finally becomes a mask through description alone as it is to recognize a person's face from a word portrait. Therefore, a brief discussion of related, as well as unrelated, elements may help to clarify the discussion of general relationships above.

The following elements are common to both Northwest Coast Indian and Eskimo masks:

1. Masks made of wood. Spruce or cottonwood driftwood was used by the Aleut, Bering Sea, and northern people; cedar, by the Northwest Coast Indians.

2. Animal masks, particularly the wolf.

3. Human countenance masks. Both Northwest Coast Indians and Alaskan Eskimos made realistic, almost portraitlike faces. In Eskimo country, the majority came from the North, although they were common everywhere. Northwest Coast portrait masks were much more realistic than any Eskimo masks, but those of the Chugach, nearest the Indians, were the least realistic of any Eskimo or Indian group. Chugach masks, though made with simple and undistorted features, were stylized in such a way that they cannot be called portrait or even realistic. Countenance masks north of Norton Sound were nearest to Northwest Coast masks in realistic concept.

4. Painted masks. Painted masks were found everywhere in Eskimo territory. Some late masks were painted with brilliant commercial pigments by Northwest Coast Indians, but Eskimo masks were colored

Plate XI. *Mask probably from Pastolik. The white dots were applied by fingertip to the black background*

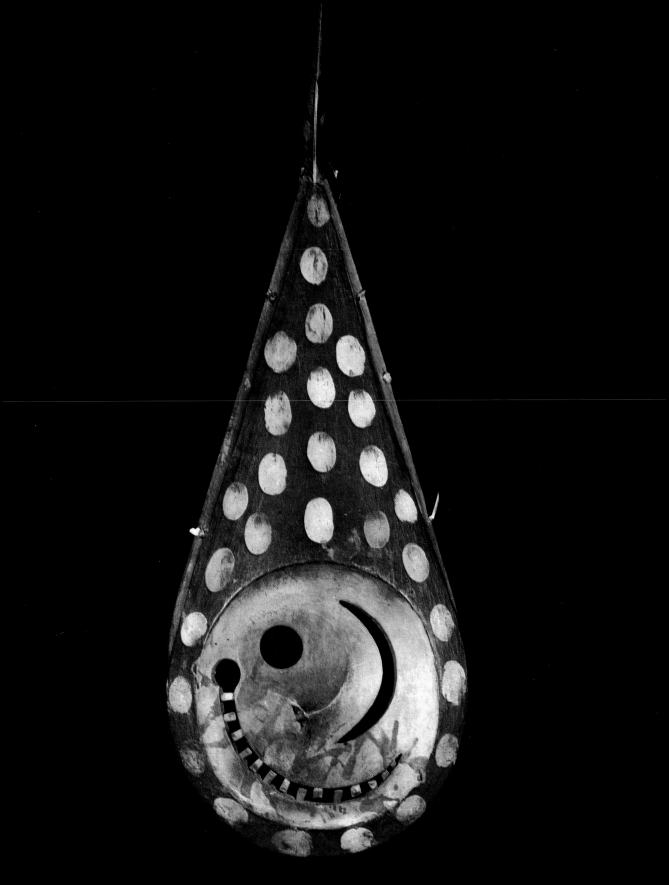

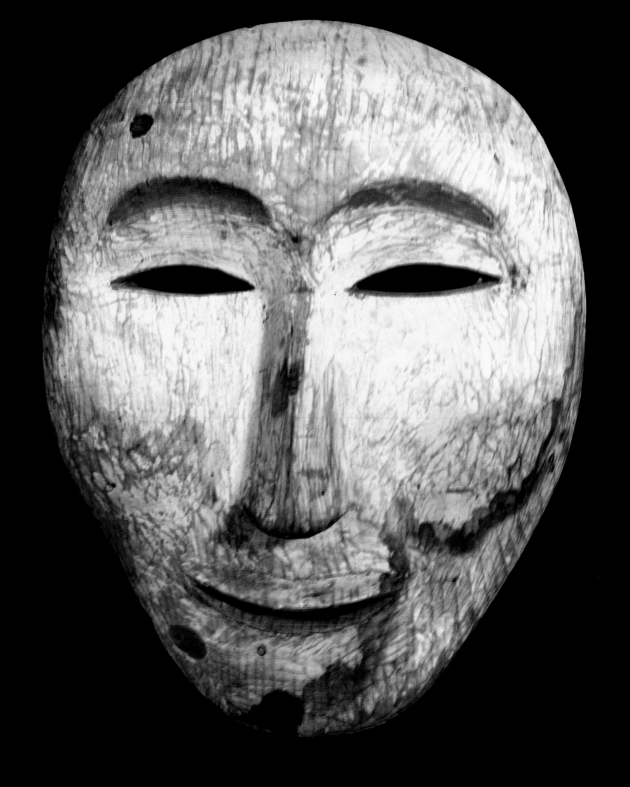

with aboriginal paints into the twentieth century and right up to the present. Commercial paints were used almost exclusively on Northwest Coast masks after the 1850's.

Planes of human or animal faces were emphasized by sculpture as well as by contrasting colors on masks from King Island to the Northwest Coast, including some of the Pacific Eskimo masks.

5. Attachment of small effigy figurines to masks. On Bristol Bay, the Kuskokwim and Yukon rivers, Nunivak Island, Norton Sound, Port Clarence, and at Point Hope, small effigy figurines of men, animals, and inanimate objects were attached to masks. The Tlingit used them sparingly, but the Pacific Eskimos who lived nearest them apparently did not use them at all. The Kwakiutl used them more than any other Northwest Coast group.

6. Ornamentation of masks with feathers, human or animal hair, and wooden geometric figures. Almost all Eskimo masks (including many from the North now denuded of their finery) had purely decorative ornamentation fashioned from materials at hand (see pp. 58–59). Feathers were used sparingly on Northwest Coast masks compared to Eskimo, probably because the airy plumes did not harmonize well with bold features and colors. Northwest Coast masks, however, often used large quantities of shredded cedar bark for dramatic effects unobtainable with feathers.

Decorative geometric, nonrepresentational pieces of wood were used mainly by Kodiak Island and Aleut people (that is, from what we know about the few existing masks), rarely by the Northwest Coast or other Eskimo groups except those from Bering Sea, who sometimes used tubes, cylinders, and squares, often for percussion effects in dancing.

7. Animal and human figures painted on masks.

8. Animal or human teeth in mouth.

9. Double-ended masks, i.e., two animals with heads or posteriors end to end. The double animal mask is small and unobtrusive in the North, but I have seen several from King Island and Point Hope. The greatest variety was made on the Bering Sea.

Plate XII. *A St. Michael mask with upper lip painted blue-black and lower lip red*

10. Small human faces on animal or bird masks. This element is found throughout Alaska and Northwest Coast and, like the wooden hunting visor, appears to have been an old element that went out of fashion in the North, but continued to be used and developed on the Bering Sea. This face was used on masks in Ipiutak and at Cape Prince of Wales (Larsen and Rainey 1948: Pl. 55; Nordenskiöld 1882:581).

11. Occasional use of nose rather than eyes for vision.

12. The use of masklike headdresses instead of masks. Ermine skins were used in dancing headdresses by Northwest Coast, Bering Sea, and northern Alaskan peoples. The last often wore them unassociated with masks. The northern headdress was sometimes a cured animal head that sat atop the performer's head. This was an old element of Nunivak Island, also.

13. The use of mechanical animals and other figurines in certain ceremonial dances. All groups, except possibly the Chugach and Nunivak people, used cleverly built puppets; sometimes stuffed animals were rigged up to move as if alive.

Similarities between Bering Sea and Northwest Coast masks, which appear not to be shared by either the northern or the Pacific Eskimos, are:

1. Masks with doors that open by the pulling of strings.

2. A human face inside a fixed beak or muzzle.

3. Attached parts of an animal or human body. This feature among Eskimo masks is almost exclusive to the Bering Sea, and is used in a manner unlike that of the Northwest Coast. The various parts of a body on Eskimo masks were used to complete, or make whole, the body of a spirit or being represented in the mask, but whenever a carved animal appendage was present on a Northwest Coast mask its intent was to represent the animal, not complete it. The various representational parts of Northwest Coast masks were often painted on the mask, not attached. This was not true of Eskimo masks.

The following elements of Bering Sea masks were not found on Northwest Coast masks:

1. Distortion of facial features; surrealistic treatment of a spirit.

No other peoples of the world used surrealism as effectively as the Eskimos. With few exceptions these masks did not extend into northern Eskimo country.

2. Concentric rings of root withes. These were used mainly on Yukon, Kuskokwim, Nunivak, and St. Michael masks, and never on northern masks. Sometimes they were made on Kodiak masks, but apparently not on Aleut or Chugach masks. The existing samples may be too few, however, to be considered conclusive evidence.

3. Eyes of unusual shapes, such as teardrop, lozenge, almond, and so forth. Northwest Coast masks usually used only two kinds, the typical Northwest Coast eye and a round shape.

4. Masks without noses and, except in rare instances, without ears.

A typical Kodiak, Bering Sea, and Norton Sound element, the background board, was used, to my knowledge, only on Northwest Coast masks representing the sun or the moon. Eskimo masks, however, used the background board for a variety of masks in addition to their own interpretation of the sun and the moon deities.

The following elements of design were not used on Eskimo masks and are an exclusive feature of Northwest Coast:

1. The double-pointed "Northwest Coast eye." This eye in its unique Indian form is not found on Eskimo masks, although an eye that is closely related in shape—a round cutout pupil with a double-pointed oval depressed into the wood surrounding it—was made on many old Point Hope, Kuskokwim, Yukon, Nunivak Island, Bristol Bay, and St. Michael masks (see Pl. IX, for example).

2. A heavy, divided eyebrow. On Northwest Coast masks, the well-defined eyebrow is always used in conjunction with the double-pointed eye; it is never used with the round eye that usually represented sea animals and fish. A similar eyebrow is found on Aleut cave masks with large noses, and a less pronounced, usually undivided eyebrow is seen on Pacific Eskimo masks collected by Pinart and illustrated by Lot-Falck (1957: Pls. 1–5, 8).

A prototype of the heavy Northwest Coast eyebrow is possibly

that of the early stone carvings of that area (Duff 1957). Eskimo masks often had indications of supraorbital ridges, but rarely carved eyebrows. Nevertheless, an unusual eyebrow is found on masks connected with old whaling ceremonies at Point Hope and Cape Prince of Wales, two of the largest northern Alaskan whaling centers. These masks had a nose carved in the shape of either an entire whale or a whale's tail. When the latter was used, two tails were placed end to end so that the bifurcation of one of the tails created the nostrils, and the more elongated bifurcation at the top formed pronounced, divided eyebrows. (An example of this, with a rather weakly defined tail as eyebrows, is illustrated in Plates 52 and 54.)

From the summary of related and unrelated component parts of masks it is obvious that an underlying ceremonial relationship existed throughout the entire northwestern North America, including northern Alaska, but that the styles of each area were distinct enough to have developed independently of another. Where definite similarities existed —alike enough to be an actual relationship—the data point to a late borrowing. The distribution of masks is almost entirely coastal (except for related Eskimo groups of the Kuskokwim and Yukon rivers). The interior Athabascan tribes of Alaska and Canada had no masks except where they were in prolonged and intimate contact with the Eskimos. This distribution is an additional indication that mask making developed late, when both summer and winter travel among the Eskimos had increased, and coinciding in time with a postulated late arrival of Indians to the Northwest Coast from an interior home.

Available evidence with adequate scientific certainty is sufficient to conclude that mask making was older in northern Alaska than on the Northwest Coast; that mask making appears to be as old in northern Alaska, particularly at Point Hope, as in the Aleutians where the first postcontact masks were collected; that the Eskimos and the Northwest Coast Indians developed their masks independently; and that some obvious intra-areal borrowing of specific traits took place in postcontact times, but that this did not wipe out the five very distinct styles of

Eskimo masks: northern Alaska, Bering Strait, Bering Sea, Aleutian, and Pacific.

Notes

1. In the following sites, small wooden objects, as well as large objects like house beams, were preserved.

St. Lawrence Island: Old Bering Sea and Punuk periods; many wooden objects, including snow goggles, were well preserved, but no masks (Collins 1937:230).

Kobuk River: A.D. 1250–1760. No masks (Giddings 1952:90–93).

Kotzebue Sound: fifteenth- and sixteenth-century sites. No masks (Van-Stone 1955:134).

Deering: Ipiutak *kazgi*. No masks (Larsen 1951).

Seward Peninsula: late prehistoric sites at Wales and Kauwerak. No masks (Jenness 1928; Collins 1937:238, 342, personal communication).

Cape Denbigh: J. L. Giddings, who excavated at Cape Denbigh on Norton Sound, found remarkable preservation of wood in permafrost in the culture that he called Nukleet. From every level of Nukleet (twelfth to eighteenth centuries A.D.) came wooden objects—dolls, handles, bows, snowshoes, harpoon dart shafts, and net gauges—but no masks (1946: Table 10).

Southwestern Alaska (Bering Sea area): Larsen's reconnaissance turned up no masks (1950).

Nunivak Island: recent prehistoric sites on the island are related to the adjacent mainland culture of the 1800's; no masks (VanStone 1957:112).

Kuskokwim River: at Crow Village site on the Kuskokwim River, Wendell Oswalt and James W. VanStone found three wooden masks that date from 1840 to 1910. They are indistinguishable from nineteenth-century Bering Sea masks in historical collections. One, a wolf, is similar to that in Plate 14, and the other two, with uneven facial features, apparently represented typical spiritual or mythical beings of the area (VanStone communication; Oswalt and VanStone n.d.).

Hooper Bay Village: Oswalt found two face masks and three finger masks made of spruce driftwood from the third and fourth levels, both dated after 1874, and several objects that might have been mask appendages from lower levels. His oldest date, obtained through tree-ring dating, was 1690 from the twelfth level. Other dates are 1836 from the sixth level, and 1874 from the fifth level (1952:73).

He states: "At Hooper Bay Village we know that the specialized mask forms are at least 300 years old" (ibid.:76), but from his chart of ceremonial objects it appears that all of the masks and finger masks, as well as eighteen out of the total of twenty-five ceremonial pieces, were from the top five levels, and only two from level 12 or below (ibid.:80). The six objects below level 5 are small wooden figurines, which could have been employed as toys or amulets as well as mask decorations.

The larger of the two face masks is of undetermined age and was purchased from a boy who said that he had found it near the test cuts. "On one side is a hole for a lashing thong, but unfortunately the face is too incomplete to show definite features. It appears likely that one side of the mouth turned up and the outer corner of one eye turned down in a curved line that intersects a round raised nose. The second mask is only 10.3 cm. across and appears to be too small for wearing. This mask does not have holes on the sides for a suspension cord. In the upturned mouth there are still traces of a little red paint and below each corner of the mouth as well as above each eye there are small holes which were probably for the insertion of feathers or other appendages." The masks and their appendages were similar to those of E. W. Nelson's time (1877–81), although three of the six found below level 5 were not illustrated by Nelson. All were crudely made (ibid.:71; Pls. 6 and 7).

Prince William Sound; Cook Inlet: Birket-Smith and de Laguna were told by Chugach informants that several masks had once been deposited in caves and were subsequently removed; otherwise, no masks were discovered (de Laguna 1956:96; 1934).

Over the years, masks excavated by Eskimos from supposedly "ancient houses" or "ancient ruins" have been purchased by collectors. One of the richest of such collections was obtained at Point Hope by Rainey and his colleagues in 1939 from an old woman who discovered them: "Old Nashugruk, an Eskimo woman of Point Hope, Alaska, was one of those ancient dames who spend the two summer months excavating ancient house ruins which adjoin her village. Some houses must have been built during the late Middle Ages, others as recently as the late century, but they are now abandoned to burrowing mice and the native collectors of antiquities. In the summer of 1939 she had dug deep into the rotting muck of the old town to the planked floor of a dance house and there she found a cache of some fifty wooden masks nicely preserved in frozen debris from the house roof. . . . Helge Larsen of the Danish National Museum and I bargained with Nashugruk for most of the summer and finally

succeeded in closing a trade for the masks with a pound of tobacco after supplies in the village had been exhausted" (Rainey 1959:11).

Sheldon Jackson collected an even greater number of masks from Point Hope in 1891; some came from ancient houses, but some from the cemetery behind the village. In 1924 Knud Rasmussen visited Point Hope and collected many artifacts, including masks. His collection, unfortunately, was a conglomerate lumping together of both recent and ancient objects of indeterminate age. Three masks in nineteenth-century style were said to have come from "old sites": a plain human mask that represented a spirit; a wolf "mask" with a long, protruding muzzle, which was usually worn on the head; and a fox mask (Mathiassen 1930:68). Two wooden dance masks from Point Barrow were half masks that fitted only over the top part of the face, leaving the mouth uncovered (*ibid.*:48). One had a large nose similar to some of the nineteenth-century Point Hope whaling masks.

Margaret Lantis illustrates a small plain countenance mask, probably worn on the forehead, which was excavated in Mekoryuk, Nunivak Island (1946:187).

2. Avdeev illustrates nine masks, supposedly printed in Sarychev's report of the same expedition, but the copy that I consulted had no illustrations.

3. Small face images found archeologically in Alaska are as follows (only those that are hollowed out and masklike are included here; whole heads that appear to be fragments of figurines have been omitted).

Nuwuk near Point Barrow: in the early 1950's a crew from the Peabody Museum of Harvard University uncovered a miniature masklike image of Birnirk age. This image, $2^3/_4$ inches high and patinated to a deep brown color, has a large mouth that is downturned on one side and upturned on the other like many nineteenth-century masks representing the half-man half-animal. The reverse side is scooped out (Ray museum notes 1954). This image could have been used as a protective object for house or oomiak, as a toy mask, or as a forehead decoration, but it was too small to be worn over the face.

A large wooden countenance mask of typical nineteenth-century Point Barrow style was found in a much later site.

Point Hope: a small face from the Ipiutak culture (Larsen and Rainey 1948: Pl. 52, No. 2).

Hooper Bay: a small ivory face used as an earring from the late nineteenth century. Other faces of wood were used as mask appendages or finger masks (Oswalt 1952: Pls. 6, No. 6; 7, Nos. 5 and 7).

Kodiak Island: See note 4.

Cook Inlet: a tiny face in Yukon Island II stratum (de Laguna 1934: Pl. 52, No. 2).

From the Fraser Delta, British Columbia, considerably south of Alaska, similar objects have been found: a pendant with a flat back in the form of a human head from the Marpole Phase (carbon-14 dates range from 943 B.C. to A.D. 179); and a small masklike effigy of a human skull from the Locarno Beach Phase (about 500 B.C.) (Borden 1962:12 and Pl. 5a and e).

Two other larger stone carvings, a human face and a bear, from the Baldwin Phase in the Fraser Canyon, reveal relationships to features of certain historic Northwest Coast masks (Borden personal communication).

In northern Canada, small images in the Dorset culture (700 B.C.—A.D. 1300) have been found in various places: two from middle to late Dorset are from the Alarnerk settlement at Igloolik, excavated by Jørgen Meldgaard (1960: 24, 41, and Fig. 5), and from Abverdjar, excavated by Graham Rowley (W. E. Taylor, Jr., personal communication). Two others, considered to be early, are from the Tyara site, excavated by W. E. Taylor, Jr., and from Pelly Bay (Taylor personal communication; Rousselière 1962:176 and Pl. I:15). The latter had "a suspension hole near its upper edge" (ibid.).

4. Archeological masklike images that have been found in sites prior to the historical era are as follows.

Point Hope: Larsen and Rainey found several pieces of ivory that fit into two masklike compositions (1948: Pls. 54 and 55). The pieces may have been placed on a wooden background for grave or memorial displays similar to those in nineteenth-century Kuskokwim and Yukon cemeteries.

Port Moller, Alaska Peninsula: E. W. Weyer, Jr., uncovered two bone masks, each about 6¹/₂ inches high, from a depth of 5 feet. The total assemblage of artifacts, according to Frederica de Laguna, is similar to Kachemak Bay III of the Yukon Island site (1934:218). A recent carbon-14 date places that period at an early limit of A.D. 600 (Rainey and Ralph 1959:368). The Port Moller masks, however, were probably later than the initial date of Kachemak Bay III, although any date would be conjectural. The earliest occupation of the Yukon Island site was between 748 and 1000 B.C. with few cultural differences stratigraphically (ibid.:371; Chard personal communication).

One of the Port Moller masks has a round face with lip, nose, and eye forms similar to nineteenth-century masks from Point Hope, Cape Prince of Wales, and King Island. The over-all impression is reminiscent of the tiny Ipiutak and Cook Inlet faces mentioned in Note 3, above. The second mask is

oval with a pointed head, large eyes with rims in high relief, and an open mouth, carved tongue, slack lower jaw, and real teeth (McCracken 1930:147–48; Weyer 1930:260). The form of carved tongue and hanging jaw is duplicated in several old Point Hope masks of wood now in the Washington State Museum. J. A. Killigivuk, of Point Hope, who examined these museum specimens, was unable to identify them. It is doubtful whether bone masks were worn by persons engaged in dancing because of their weight. One of the Port Moller masks had several holes drilled around the edges, suggesting its use as a grave image. The whalebone mask now considered to be a typical Point Hope product was made for the first time in the 1930's by Frank Ahvisenak according to J. A. Killigivuk. Before that, all masks were carved of wood.

Hrdlička's excavation of the Uyak site on Kodiak Island failed to uncover wooden masks, although a small ivory masklike image, 3 inches high, was found in the lower levels (Heizer 1956:80, 114, and Pl. 84e) The shape of the mouth is similar to that of the large whalebone mask with a rounded head found by Weyer at Port Moller.

Recently two fragments of worked wood were unearthed by Father Guy Mary Rousselière at Button Point, Bylot Island, Baffin Bay (Campbell 1963:579; W. E. Taylor, Jr., personal communication). One piece, 9 inches long, apparently about one-half of a rectangular board split longitudinally (with the grain), is thought to be a mask. The piece has a small gouged hole near the top of the split edge and a large angular notch below which could be interpreted as a mouth. The specimen is longitudinally concavo-convex with the concave side smoother. It is uncertain which side is meant to be the front, particularly since neither side is scooped out to fit the face. Such a mask would be difficult to wear without a provision of this kind.

The second piece is a narrow fragment (1¹/₂ by 6 inches), painted red and similarly split along the grain, but appearing to be well shaped and finished along its forward edge. I have not had the opportunity of seeing these pieces, but W. E. Taylor, Jr., kindly provided excellent photographs. At the National Museum of Canada the second piece has been fitted with a plaster cast representing the remainder of a human face. The wood of both pieces appears to be well preserved, but despite such preservation no full masks were found, nor were any pieces large enough to be identified without question—one of the cruel tricks of archeology, perhaps.

The contours of the smaller piece can be interpreted as those of cheek and forehead, and in what could have been the eye position (if this piece of only 6 inches length was, indeed, a part of a mask) there is a tiny angular

notch, but an eye would rarely have been placed so far to the side. A hole is gouged in the lower bulge, but this is not the usual position for a strap fastening in a mask of this height. This fragment is not typical of Eskimo masks, and if made to be worn full-face it would conform more closely to an actual head measurement of half again as much. Numerous nineteenth-century Alaskan masks were only 5 to 7 inches high, but they covered either the mid-face from bottom forehead to mouth, or only the upper half (cf. Pl. 7). Even the most realistic human portrayals would not have conformed to the reconstruction of the Button Point find.

Campbell thinks that it is definitely a Dorset piece, though the scarcity of "some important Dorset implement types . . . prevents a precise reckoning of the position of the Button Point site in the Dorset continuum" (1963:579). The latest possible Dorset date would be about A.D. 1300, which greatly antedates any unequivocally identified wooden Eskimo mask in Alaska, the area that produced innumerable masks in the nineteenth century, while other areas, including Baffin Bay, had few or no examples. Tempting as it is to push back the threshold of Eskimo wooden mask making to the early date represented by Button Point (possibly middle Dorset), scientific caution urges consideration of an alternative interpretation that these fragments were parts of some other kinds of artifact.

5. No wooden masks have been mentioned to date in archeological literature of the northern Northwest Coast, although other wooden objects have been found. Two fragments of a wooden masklike image were found at the Chase burial site, 37 miles east of Kamloops, British Columbia (probable dates between A.D. 1400 and 1750). Unfortunately, the mask was cut in two by a pothunter's shovel before archeologists arrived on the scene. The mask's protruding eyes are solid; the nose area, which could have been used for vision instead of eyes, is missing; and twined matting near the mask-image bore an eye imprint (Sanger personal communication; 1966: Fig. 10).

PART II

Plates

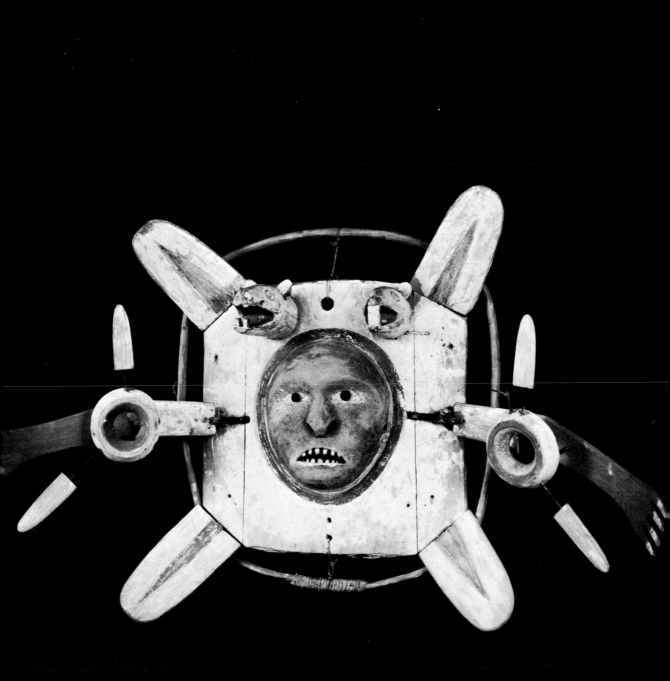

Plate 1. A mask for shamanistic performances, representing the sun, the moon, and the shaman's helping dog spirits

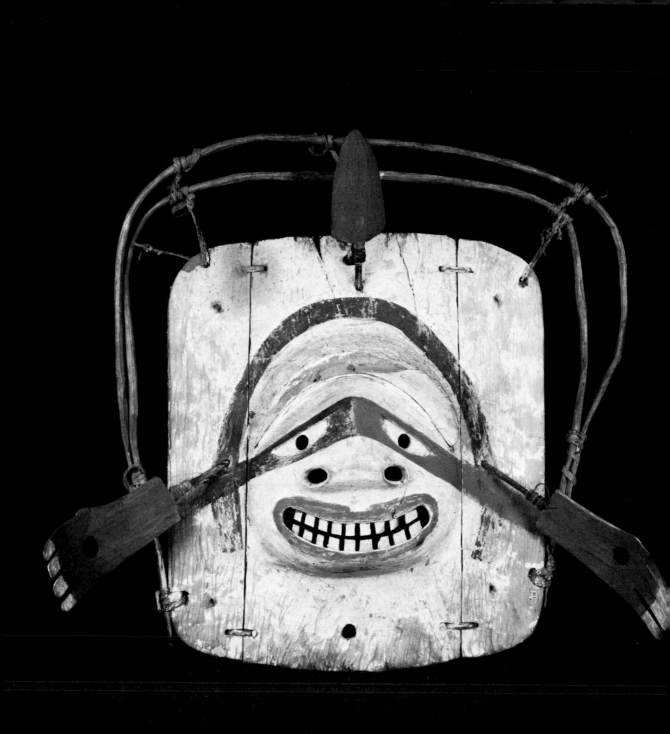

Plate 2. A massive mask worn directly on the face without provision for hanging from above

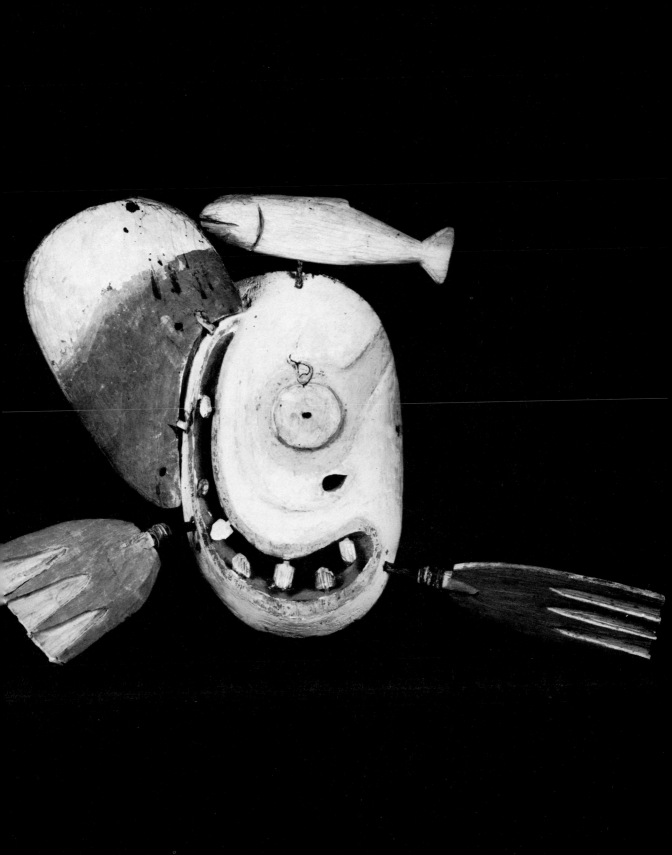

Plate 3. *A mask, probably from the lower Yukon, painted with the same paint as the mask in Plate III*

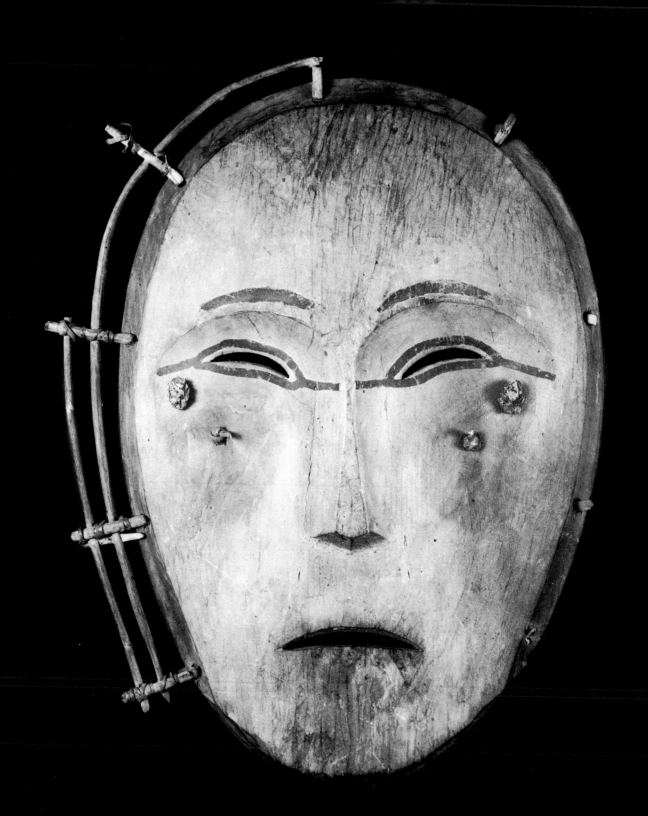

Plate 4. This style of northwest Bering Sea mask was also characteristic of Anvik Indian masks

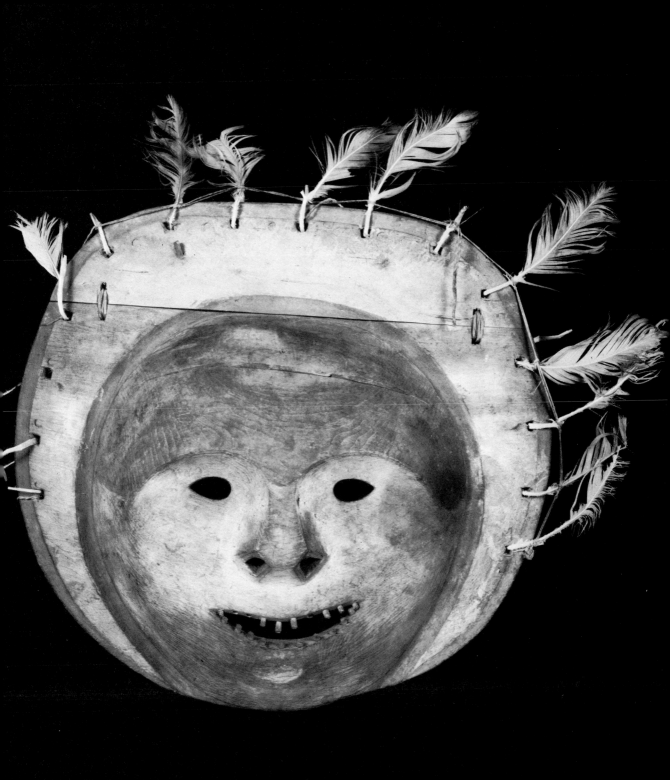

Plate 5. *The two-part construction of this may have had a symbolic meaning*

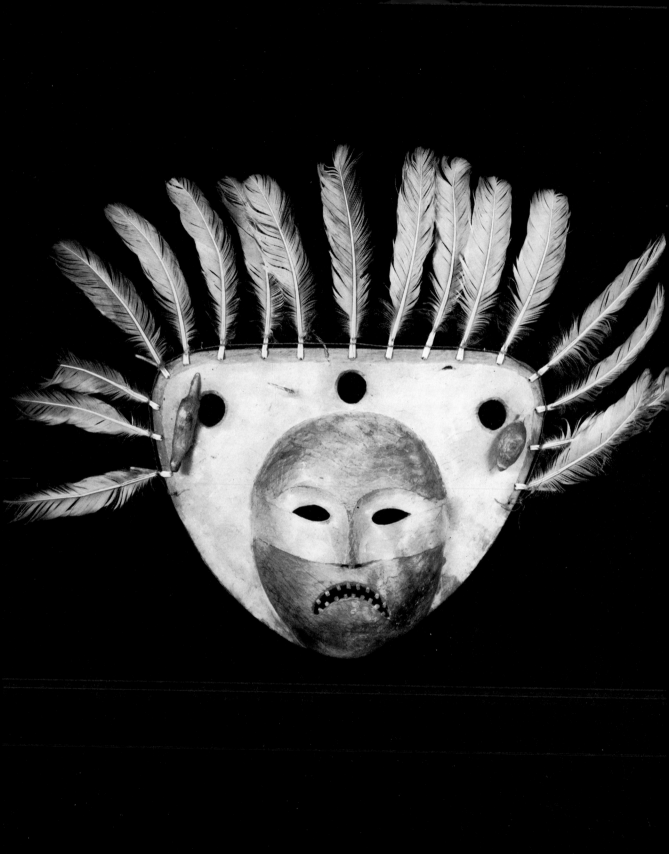

Plate 6. A St. Michael mask worn while a song was sung without motions

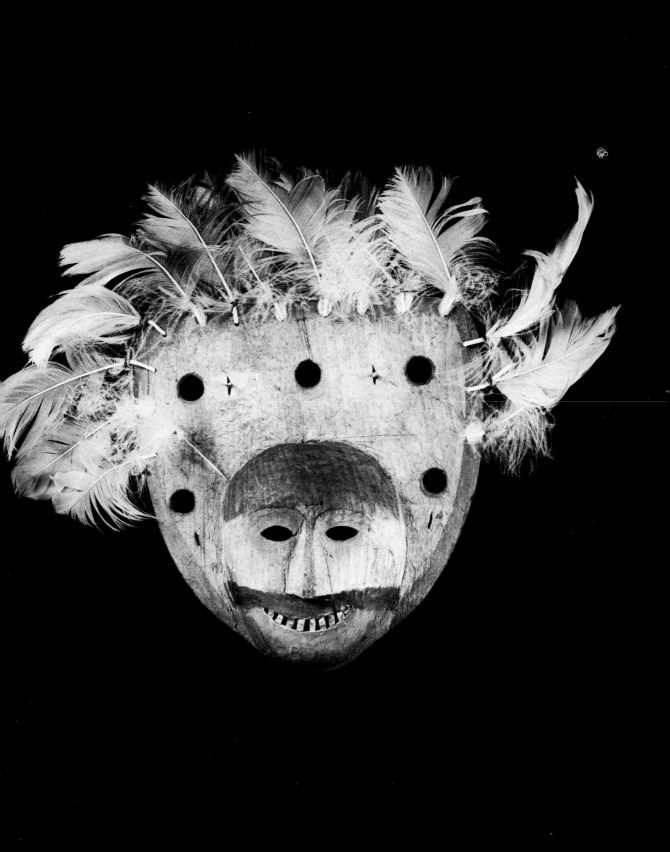

Plate 7. A small, delicate mask with a song, "You're going to fly"

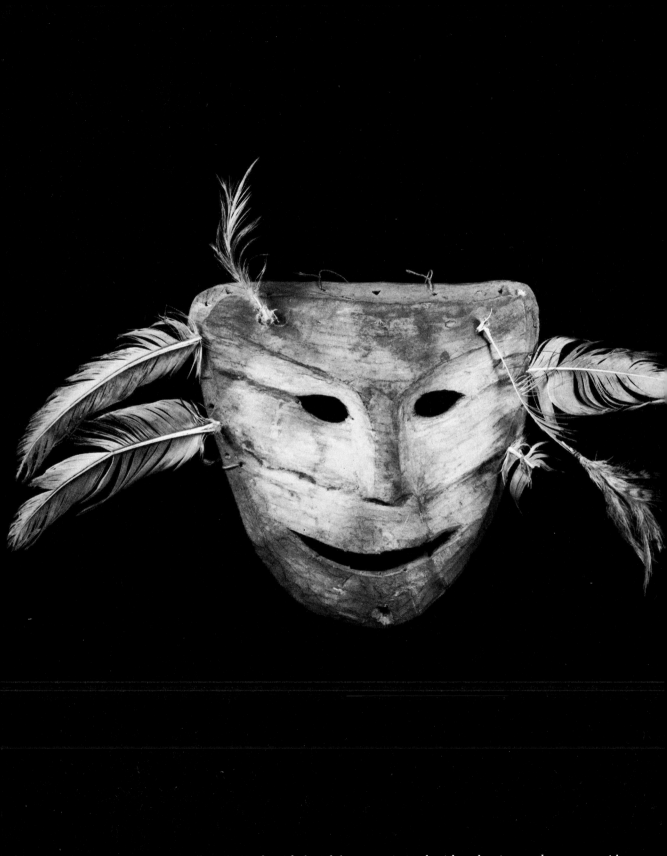

Plate 8. *Mask with facial features rimmed with red paint on the reverse side*

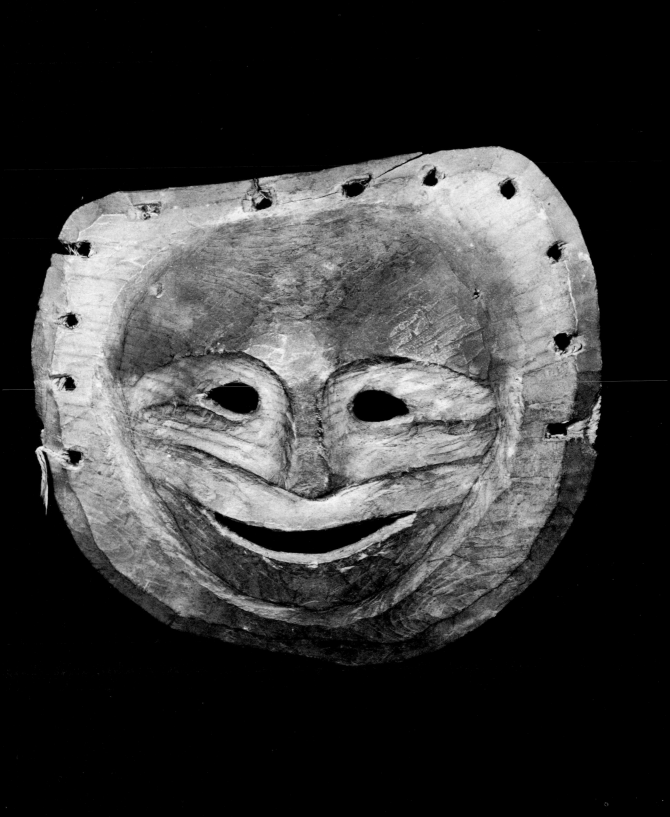

Plate 9. Mask, only 7¹/₄ inches wide, probably from the vicinity of St. Michael

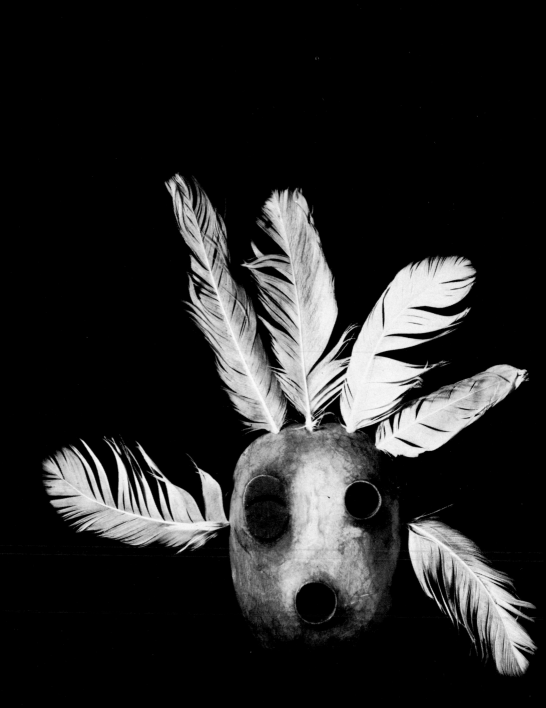

Plate 10. Numerous examples of this kind of St. Michael mask were collected
in the 1880's and 1890's

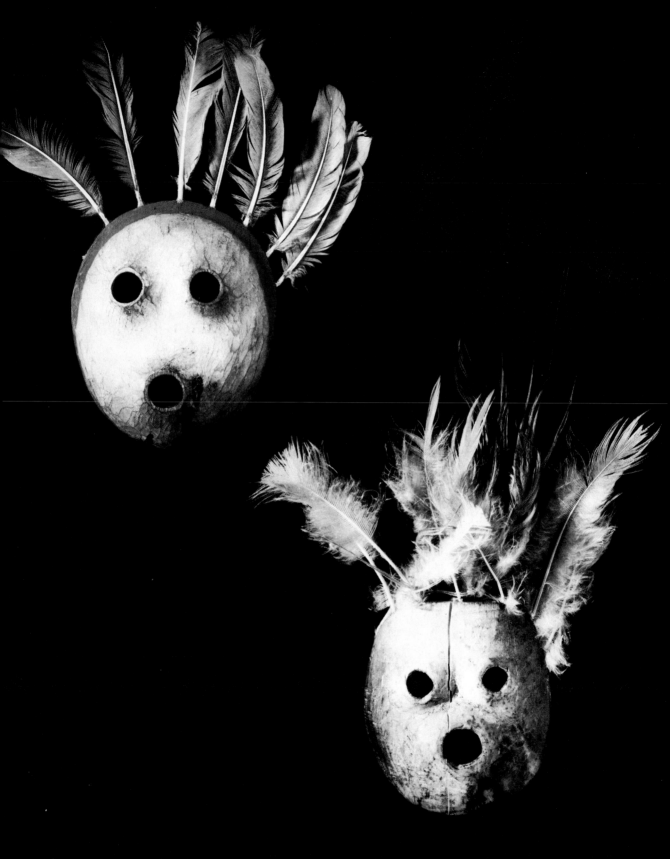

Plate 11. (Top) *Mask with four brown dots painted on the reverse of each feather.* (Bottom) *Ivory finger mask from Pastolik,* $1^7/_8$ *inches high*

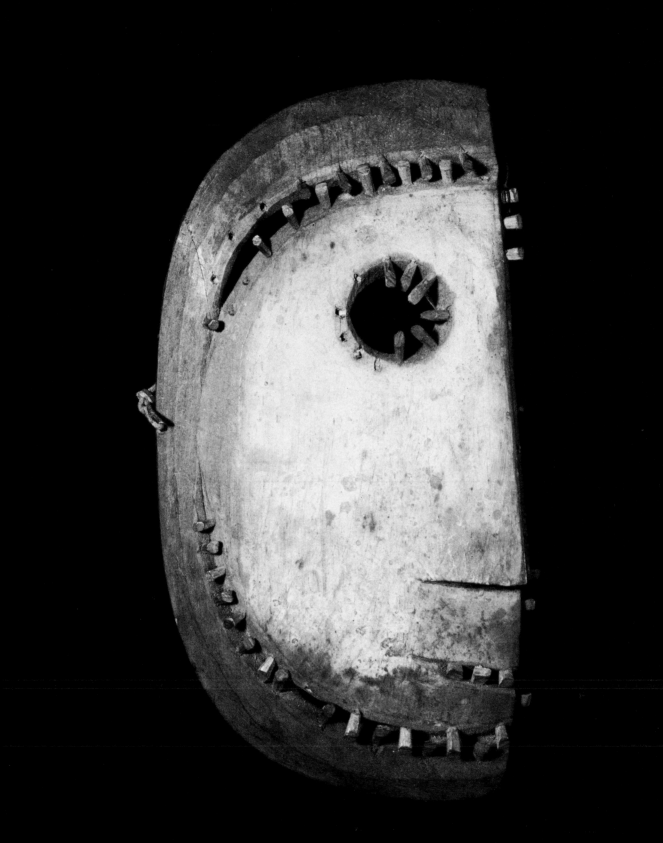

Plate 12. *A St. Michael version of the half-man*

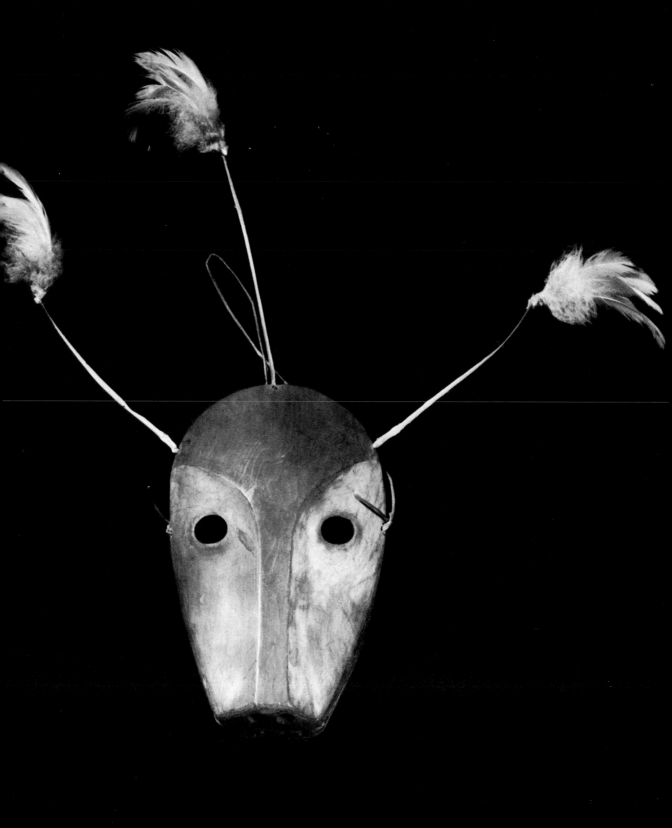

Plate 13. *A wolverine mask, painted blue-black and white, from St. Michael*

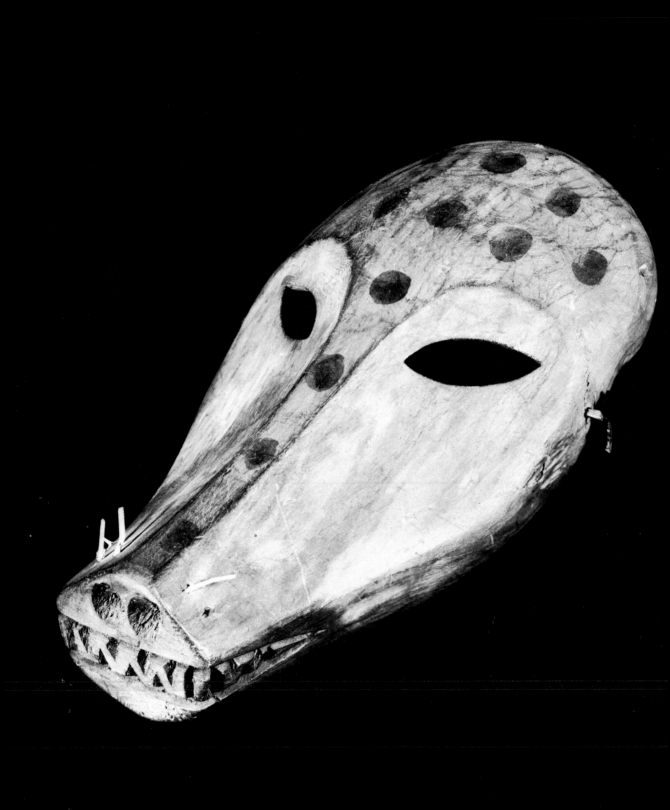

Plate 14. *Wolf mask from St. Michael*

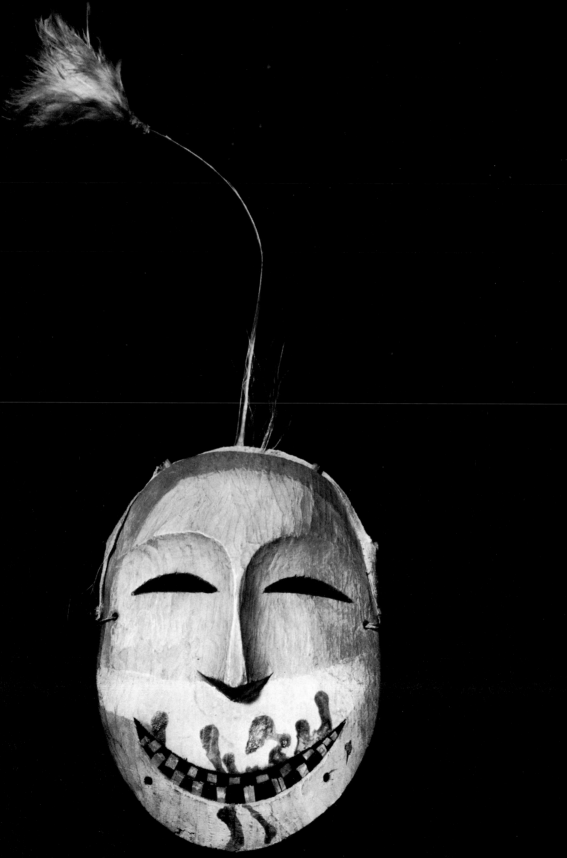

Plate 15. *Splashes of red-brown paint around the mouth were placed on masks from the lower Yukon-St. Michael area*

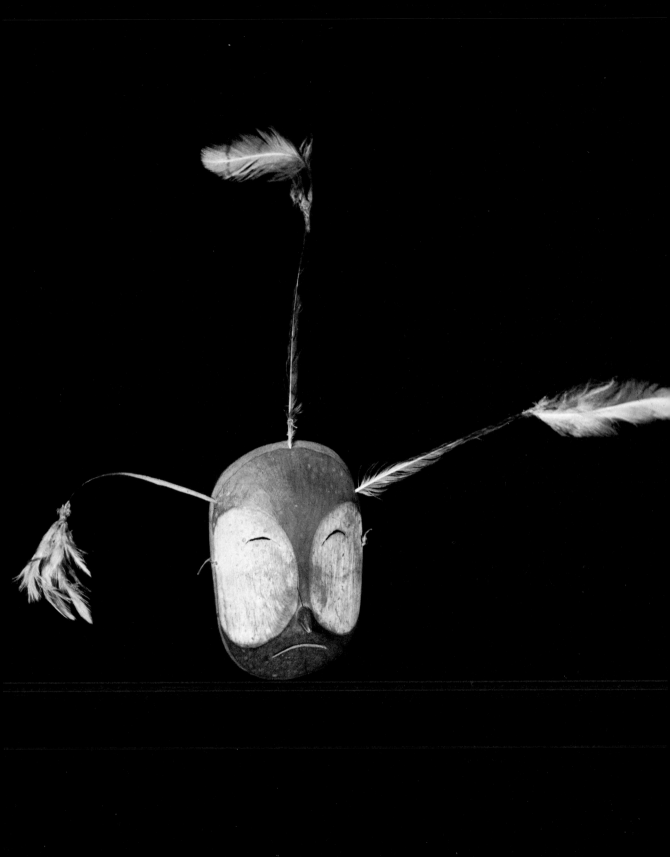

Plate 16. *Owl mask from St. Michael*

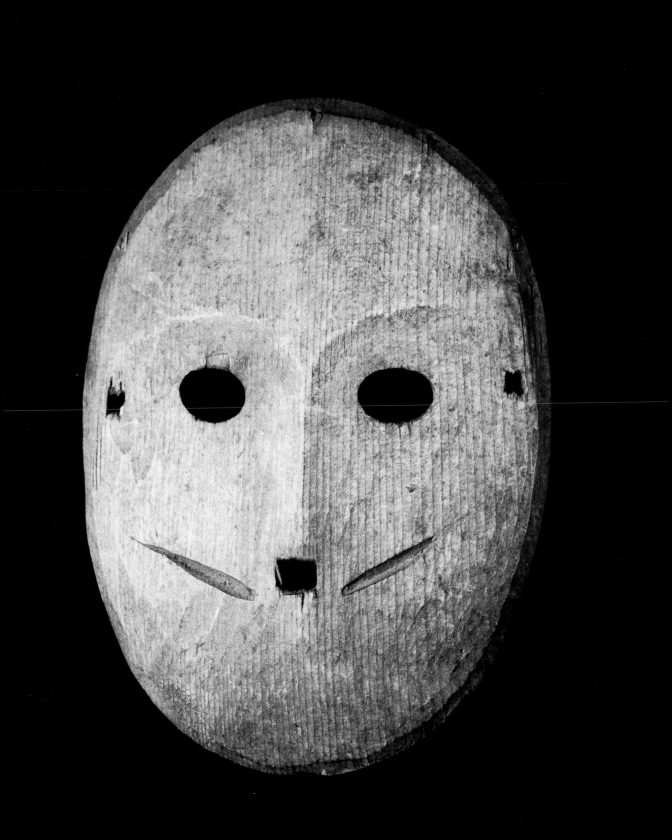

Plate 17. An incomplete mask of a bird, whose beak originally fitted into the square hole

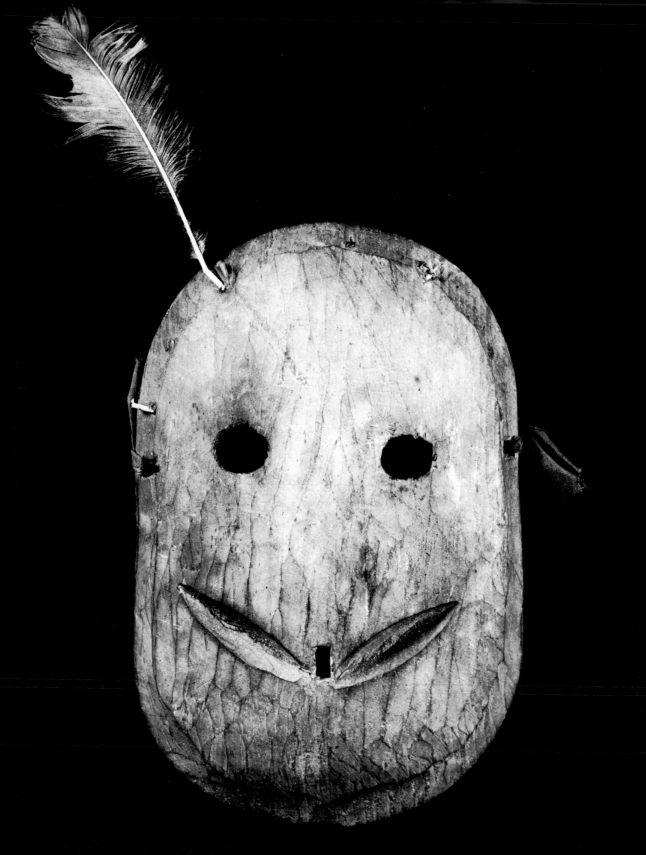

Plate 18. *Broken bird mask, with beak missing*

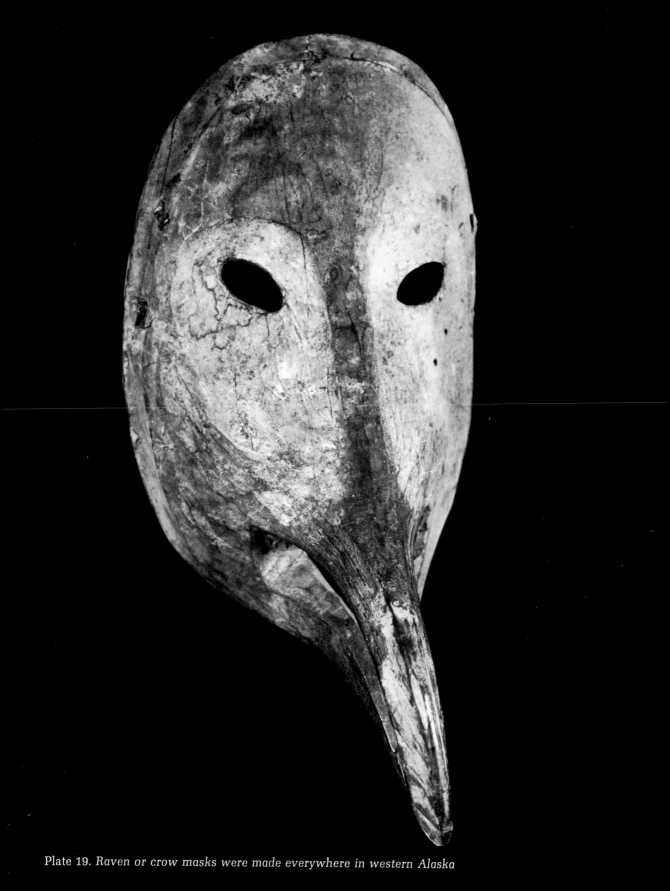

Plate 19. *Raven or crow masks were made everywhere in western Alaska*

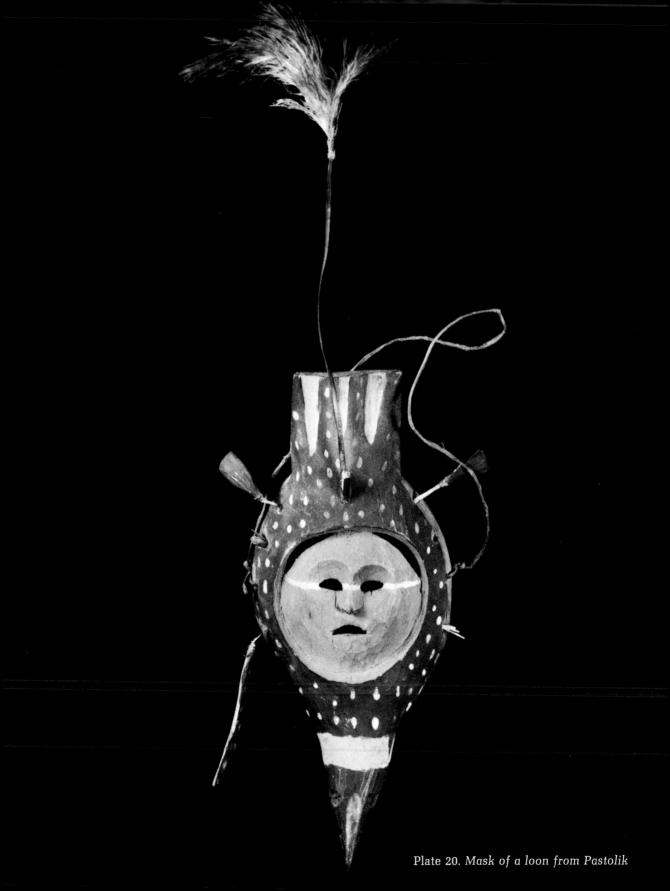

Plate 20. *Mask of a loon from Pastolik*

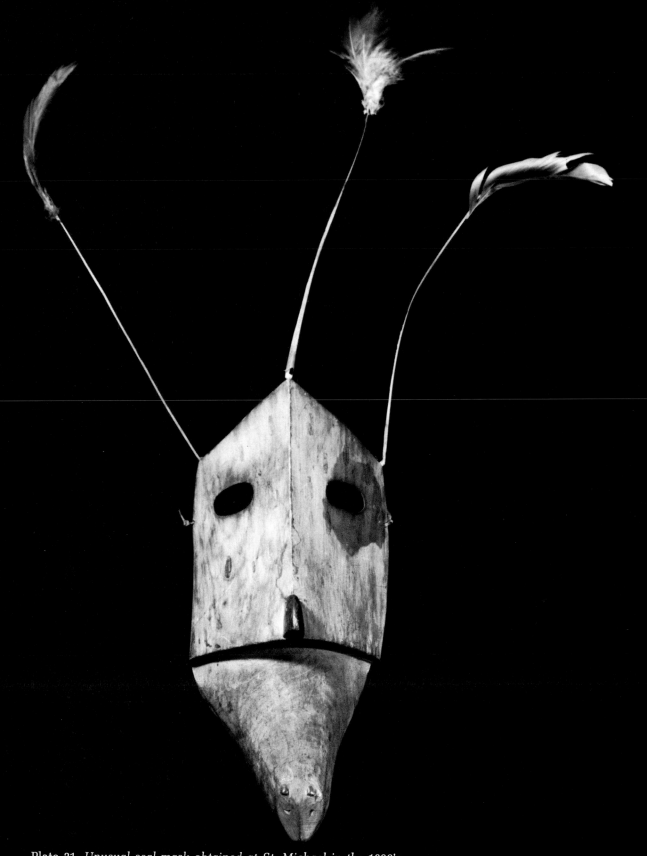

Plate 21. *Unusual seal mask obtained at St. Michael in the 1890's*

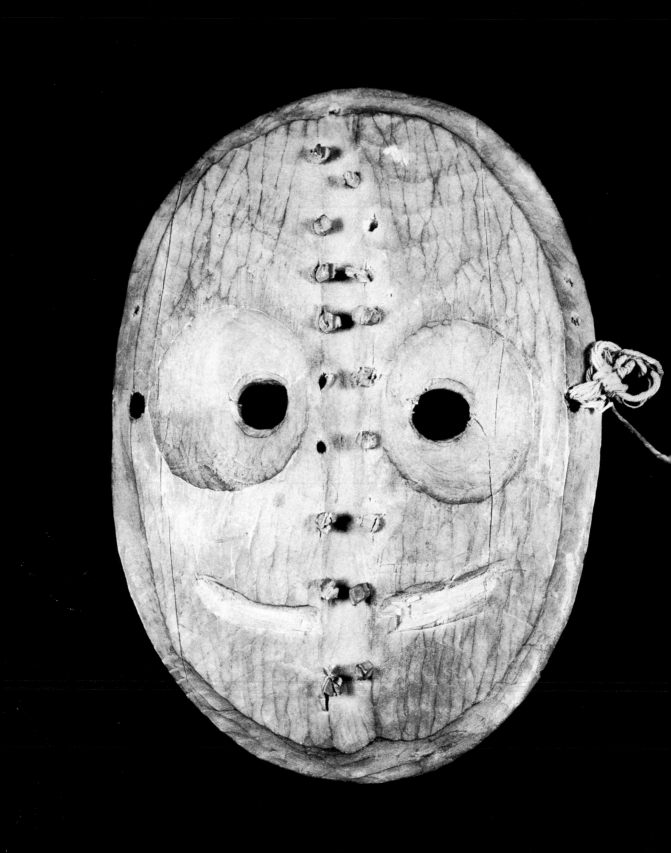

Plate 22. Mask possibly of an owl

Plate 23. *An unusually small and lightweight hooped mask*

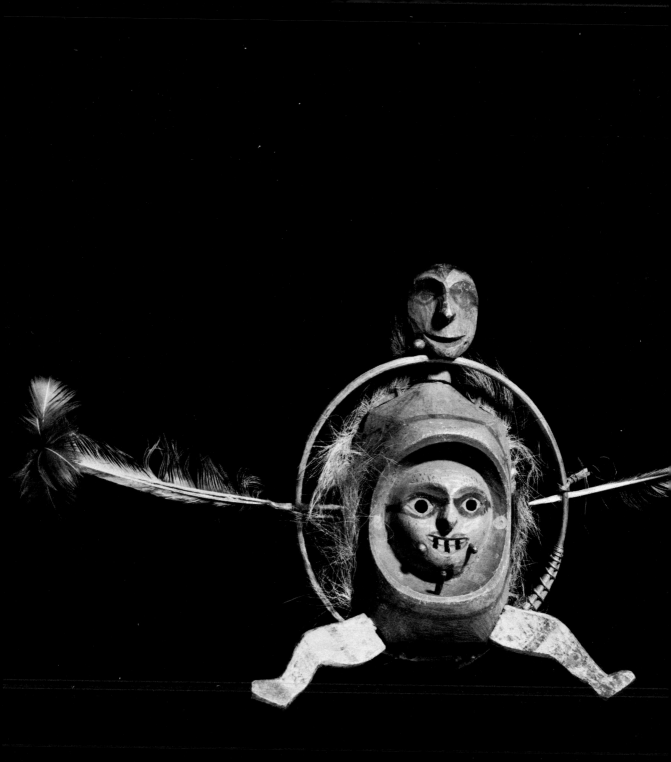

Plate 24. Masks similar to this St. Michael mask were also made south of the Yukon River

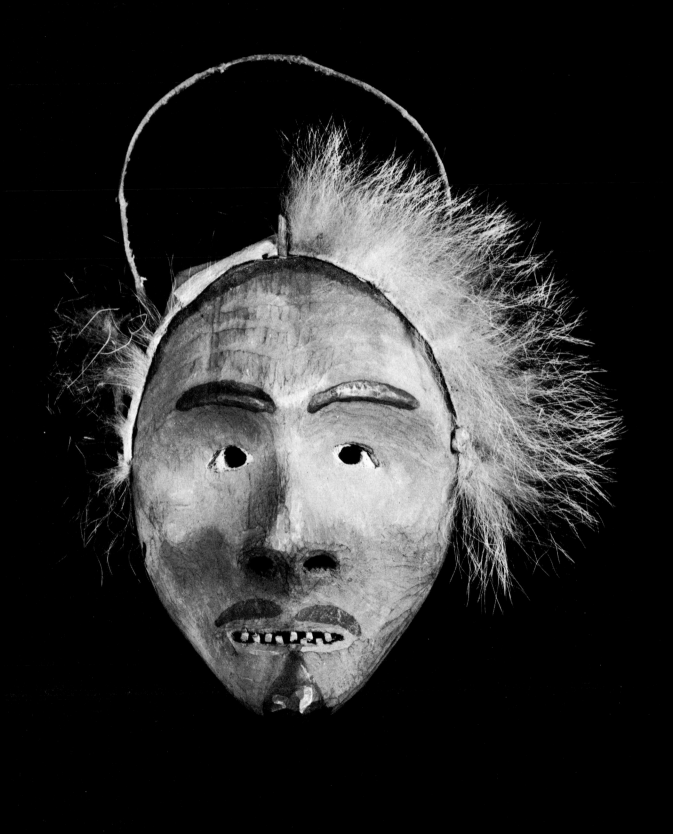

Plate 25. This mask, and those in Plates 26 and 27, are painted light brick red

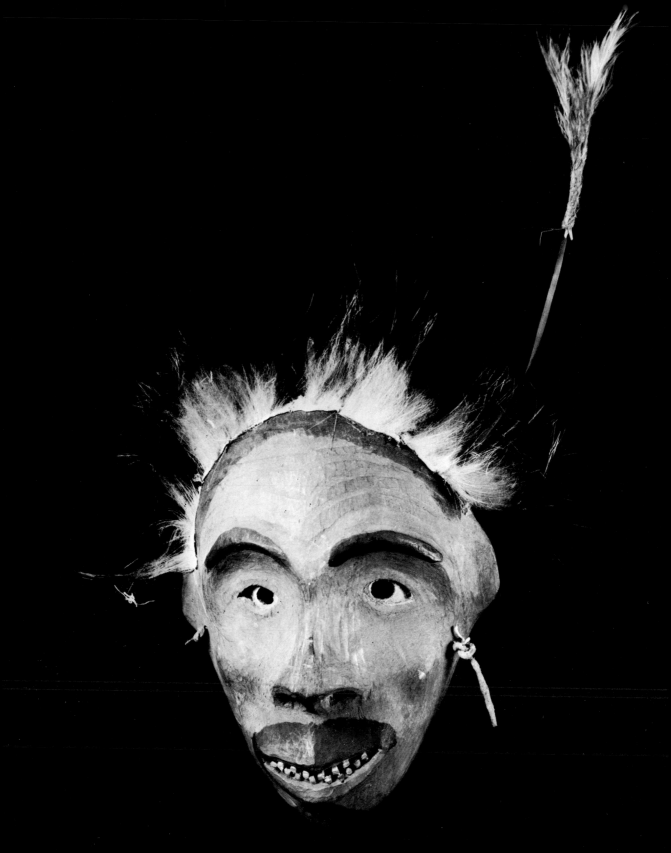

Plate 26. *Mask with forehead wrinkles, unusual in Eskimo sculpture*

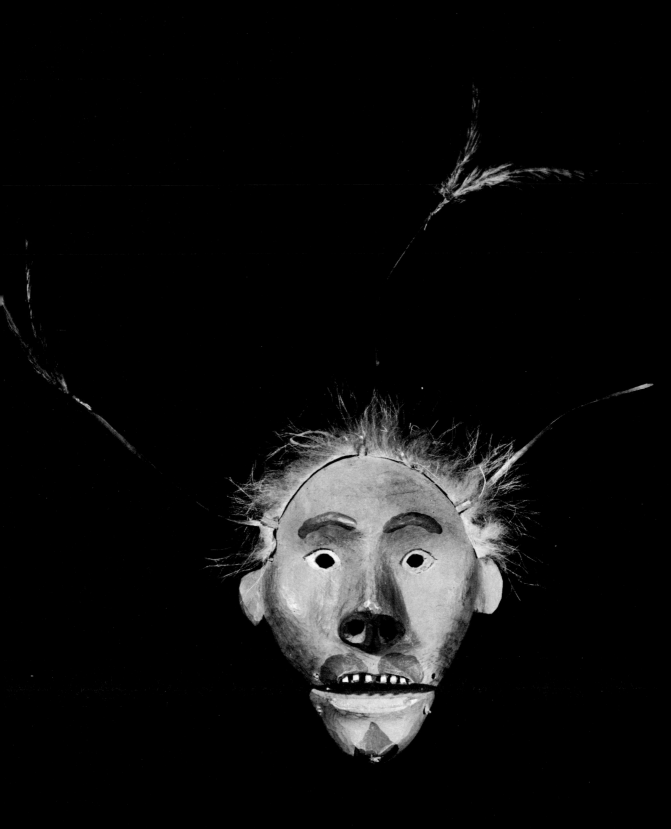

Plate 27. *Mask with hinged and movable jaw*

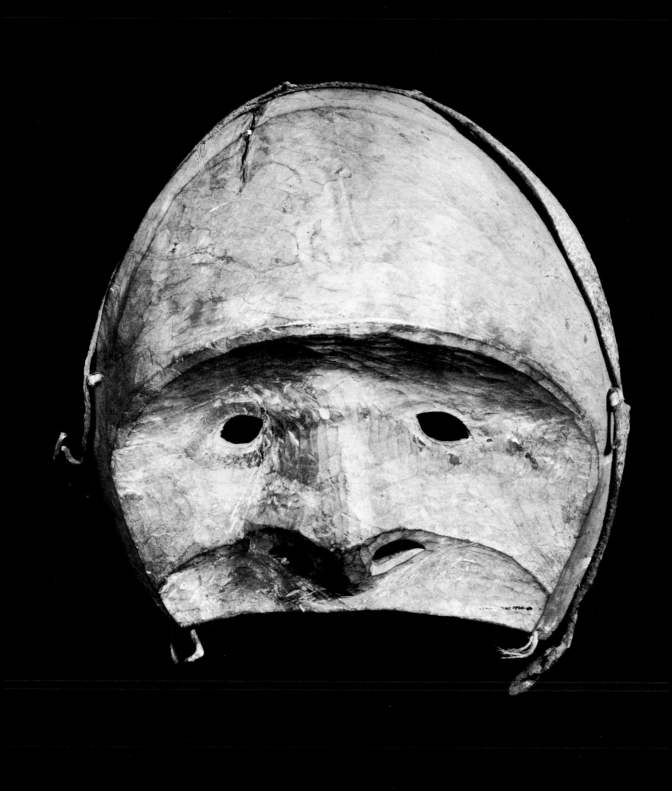

Plate 28. *Mask that once had an attached jaw*

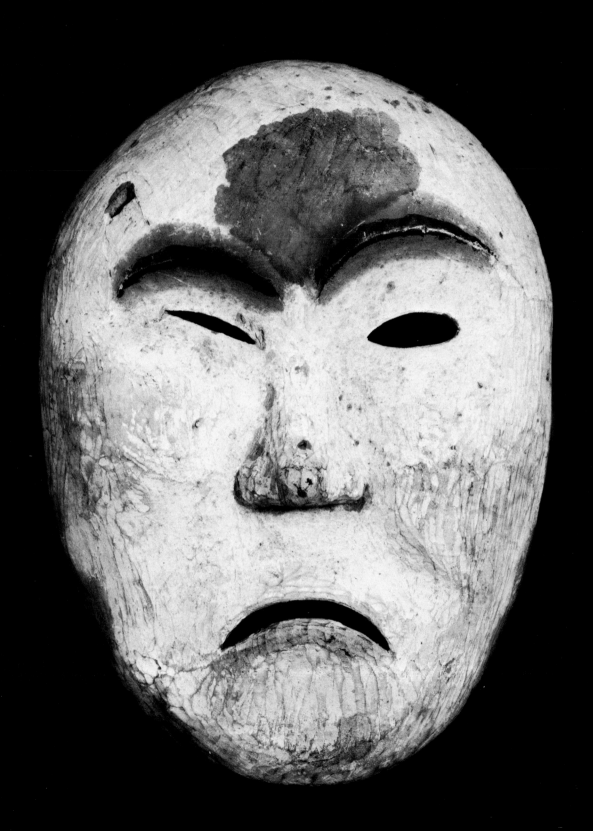

Plate 29. *A St. Michael mask reminiscent of plain masks from the North*

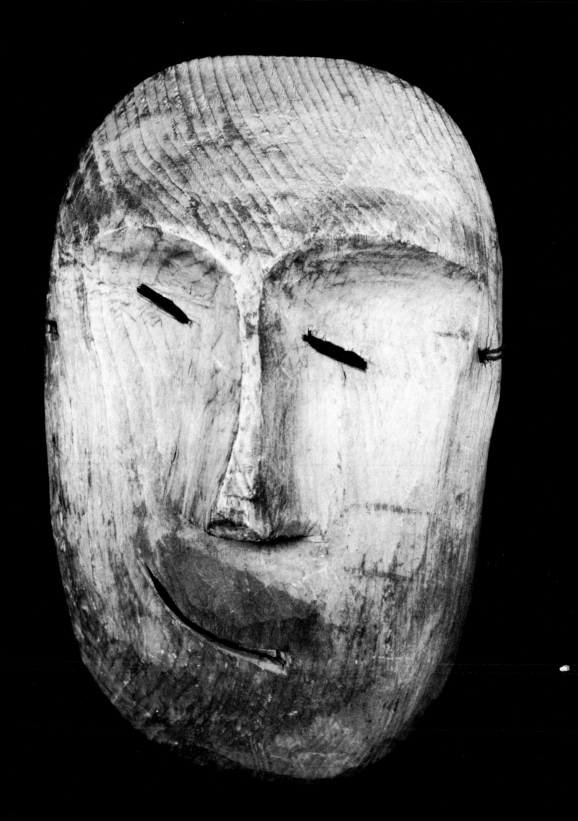

Plate 30. *Mask identified as the King Island version of the half-man half-animal mask*

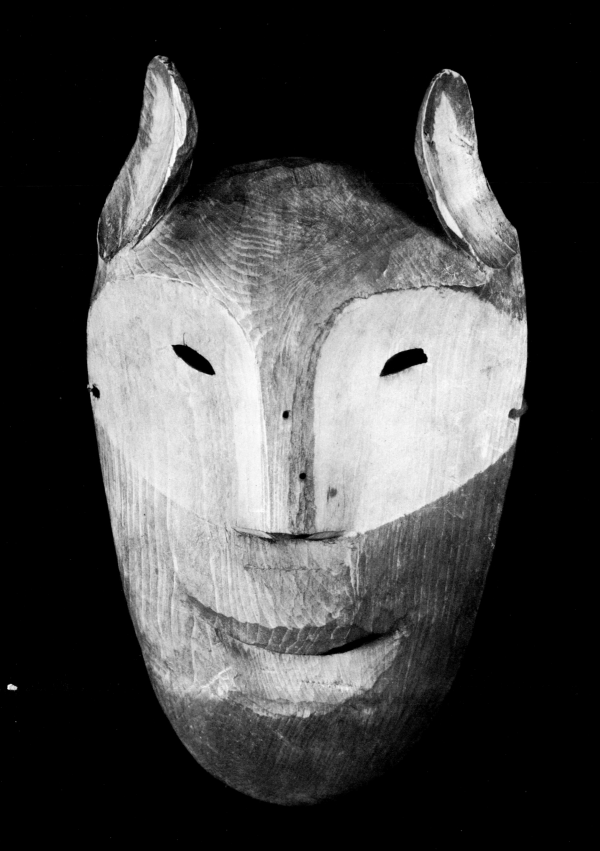

Plate 31. *Mask similar to old Cape Prince of Wales masks*

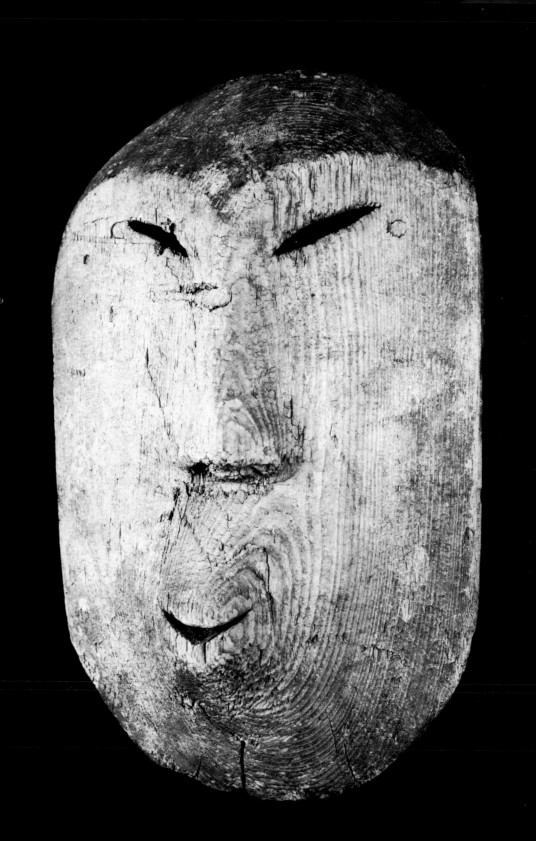

Plate 32. Point Hope mask collected during the early part of the twentieth century

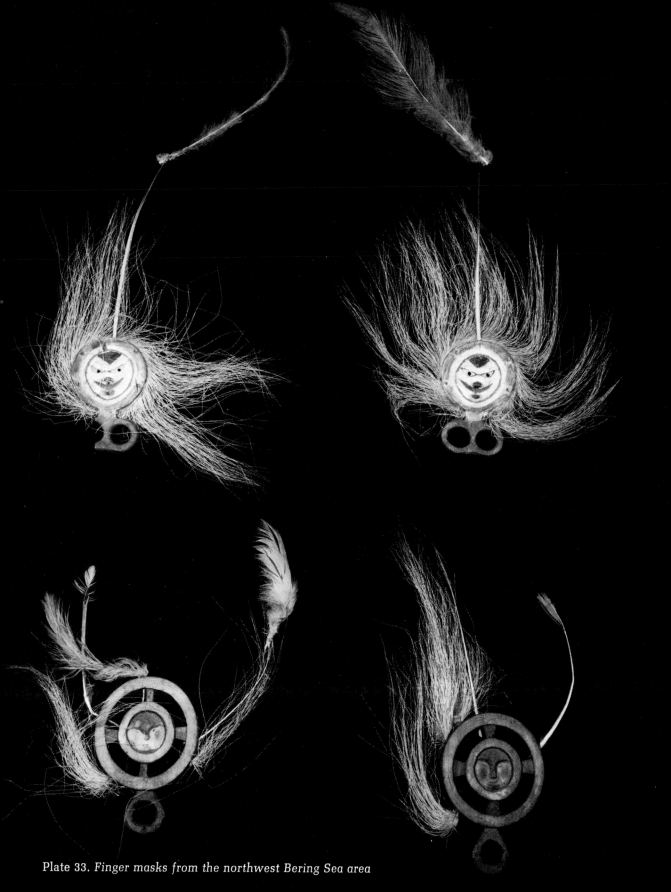

Plate 33. Finger masks from the northwest Bering Sea area

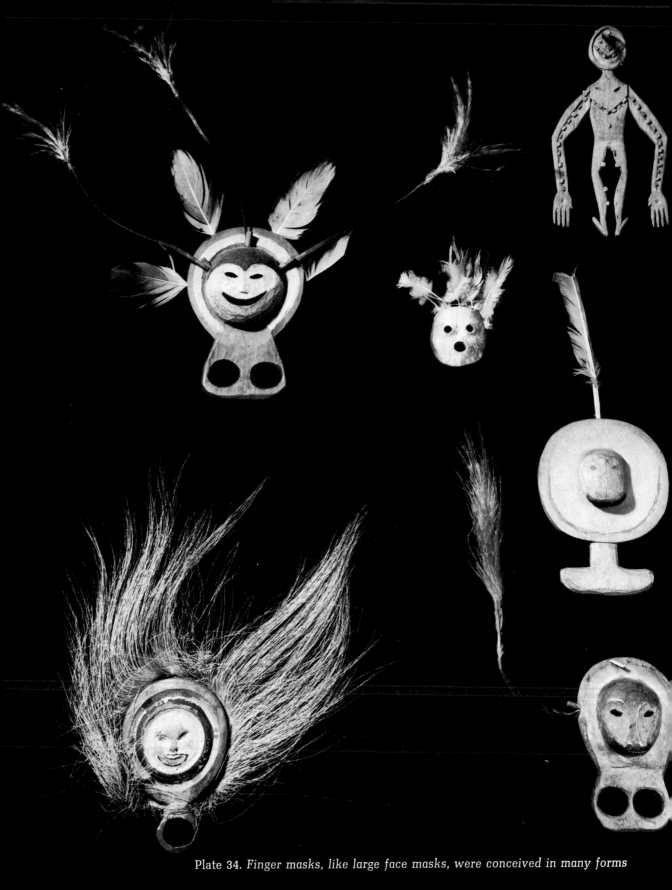

Plate 34. *Finger masks, like large face masks, were conceived in many forms*

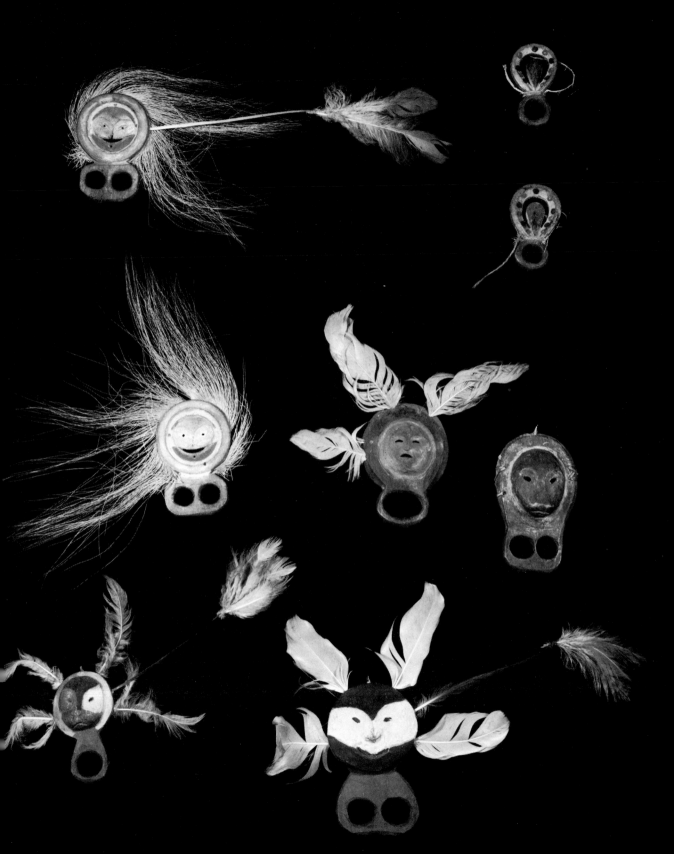

Plate 35. *These finger masks, like those in the other plates, were obtained before the twentieth century*

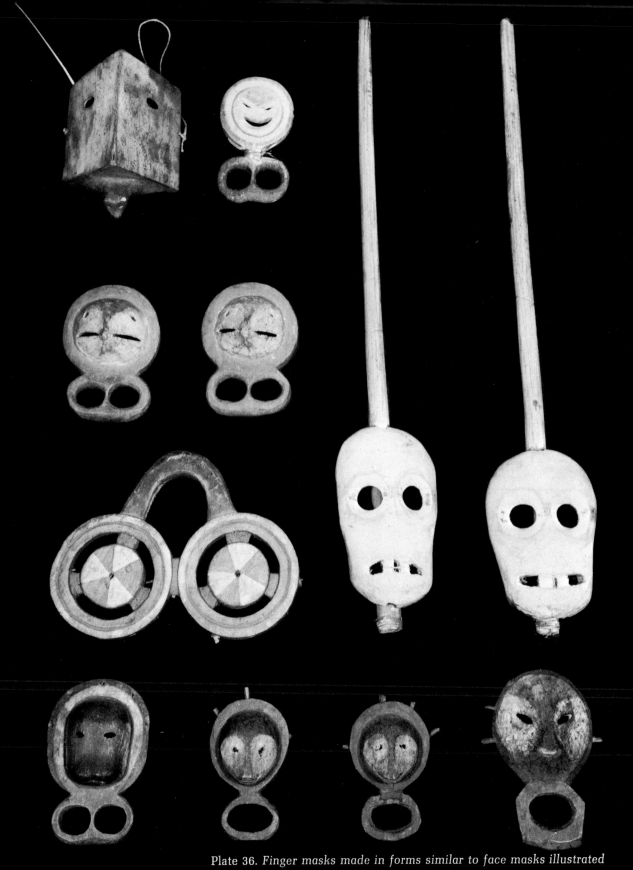

Plate 36. Finger masks made in forms similar to face masks illustrated

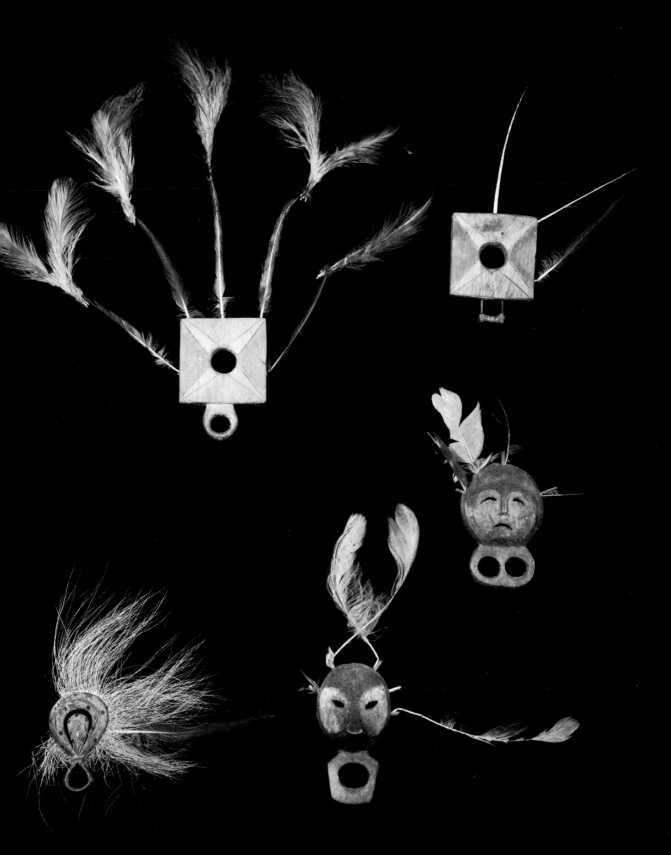

Plate 37. *Finger masks used mainly in the area between St. Michael and the Alaska Peninsula*

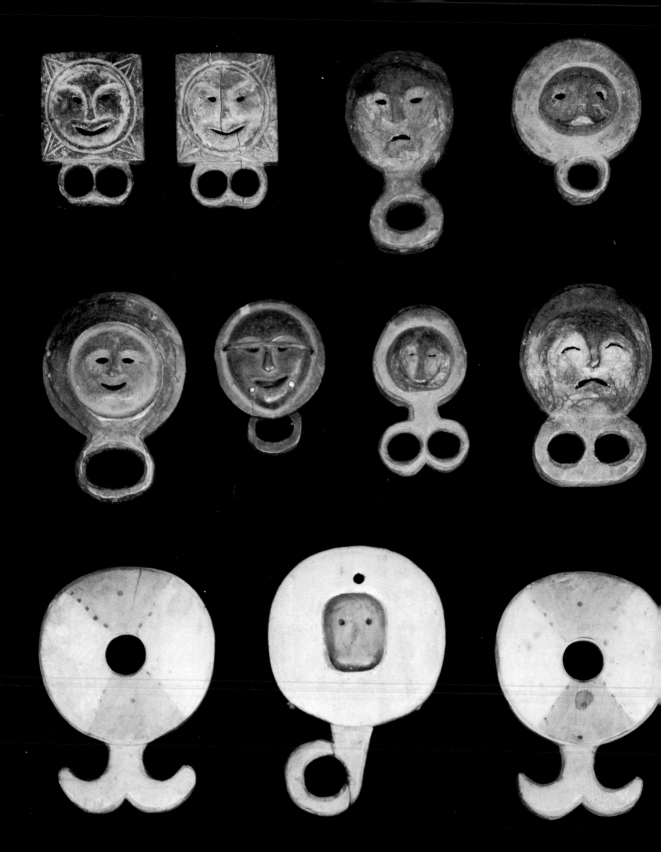

Plate 38. *The finger mask second from the left in the middle row has labrets*

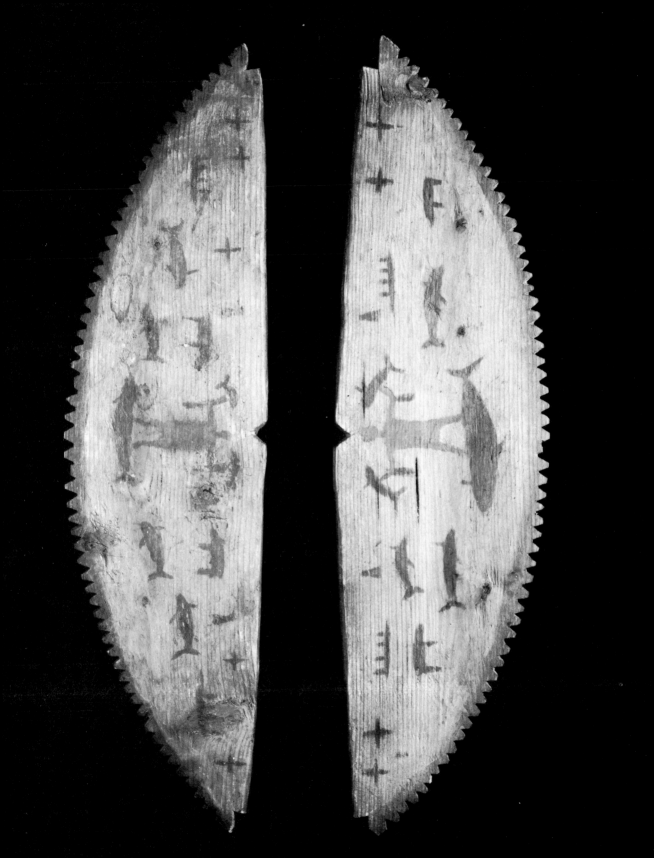

Plate 39. *Dancing gorgets used by Point Barrow Eskimos in their whaling dances*

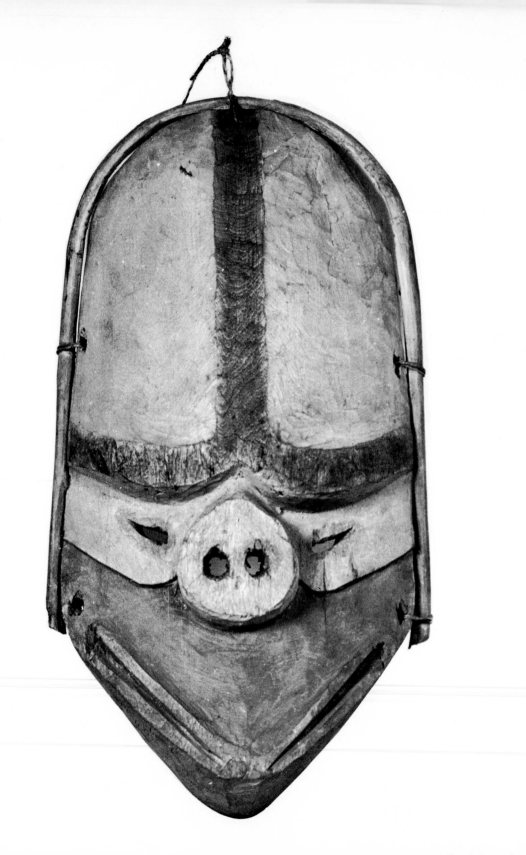

Plate 40. *Mask from Prince William Sound*

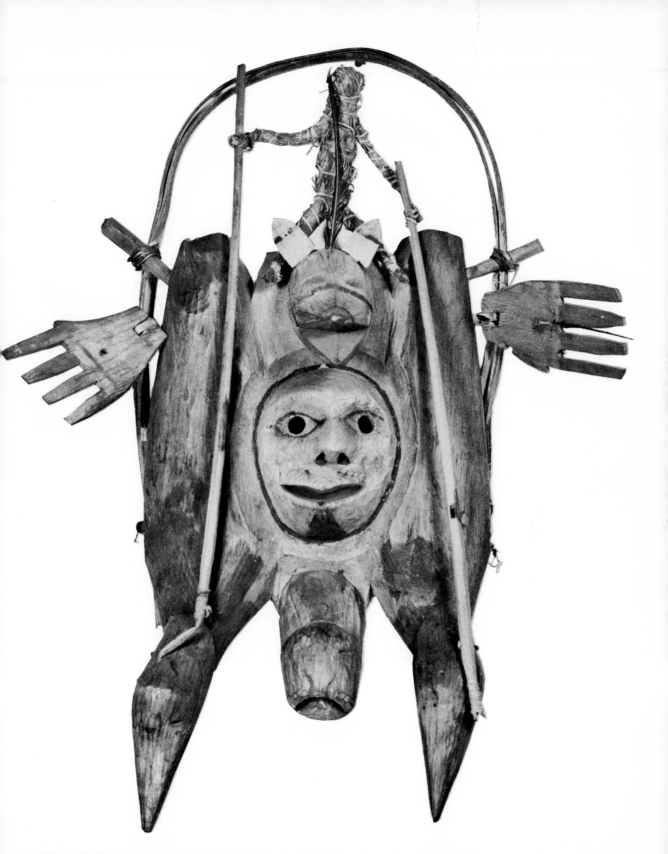

Plate 41. Large mask from Goodnews Bay, obtained in the early twentieth century

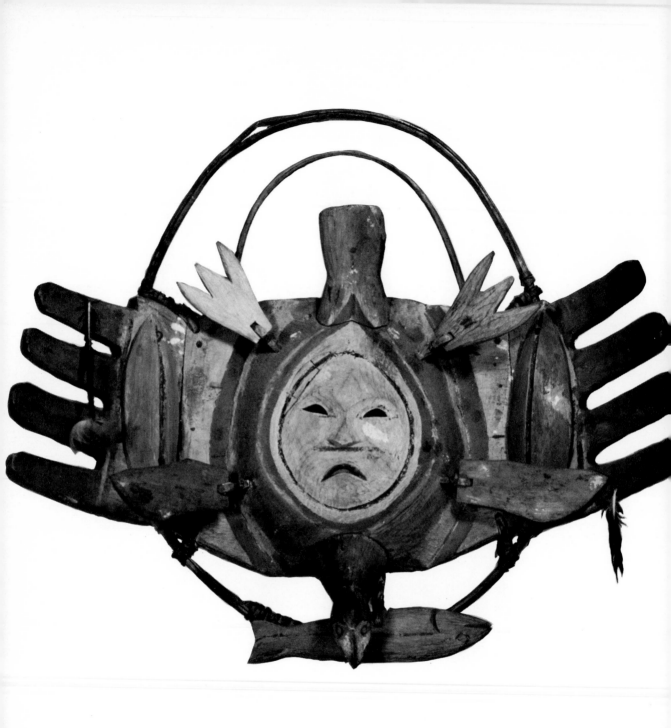

Plate 42. This style of mask from Goodnews Bay was also made at Hooper Bay

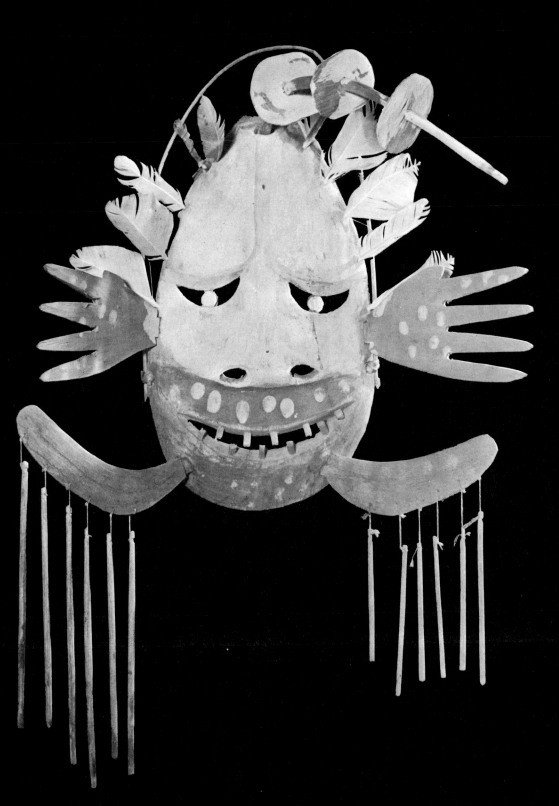

Plate 43. *Mask from the Kuskokwim River representing bubbles rising through the water*

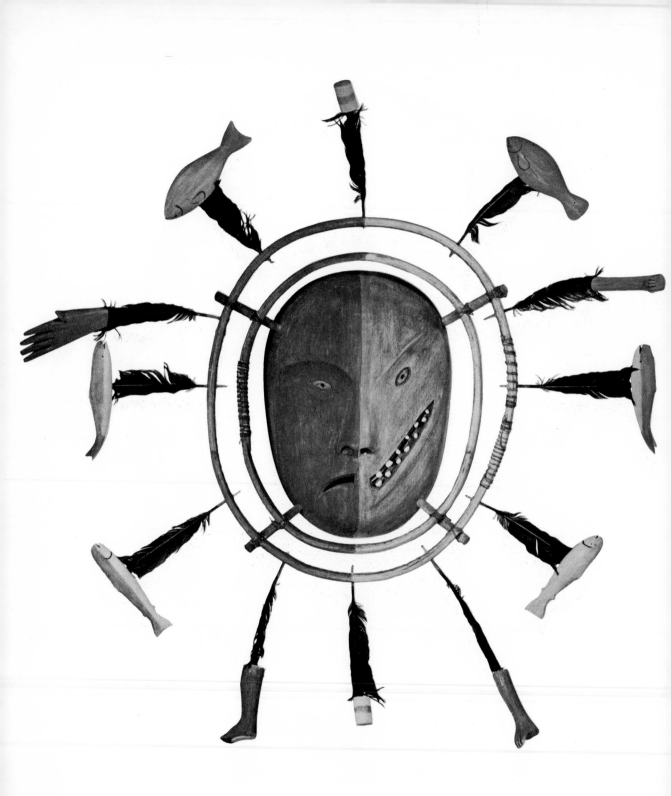

Plate 44. *The half-man half-animal (red fox) as interpreted on Nunivak Island*

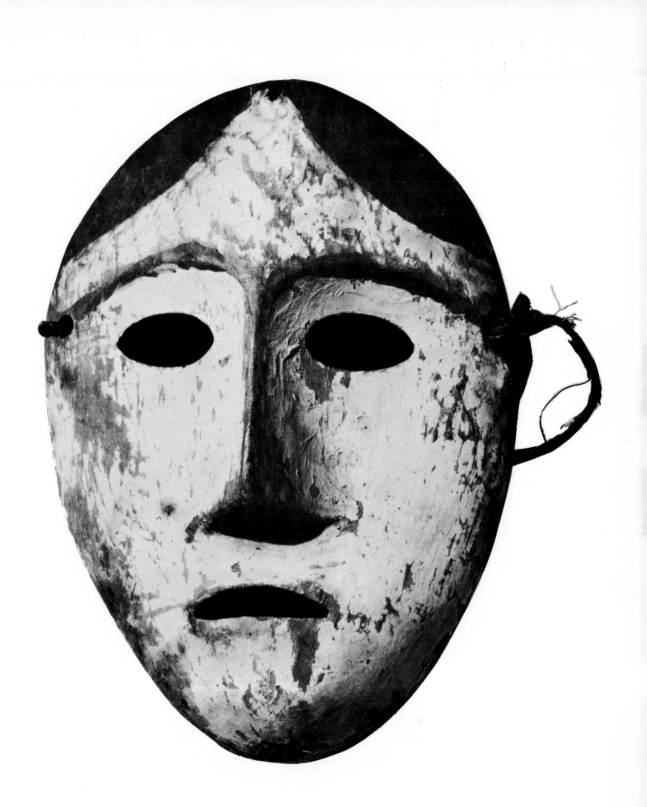

Plate 45. *Mask from the Yukon delta, similar to those from King Island in the Bering Strait*

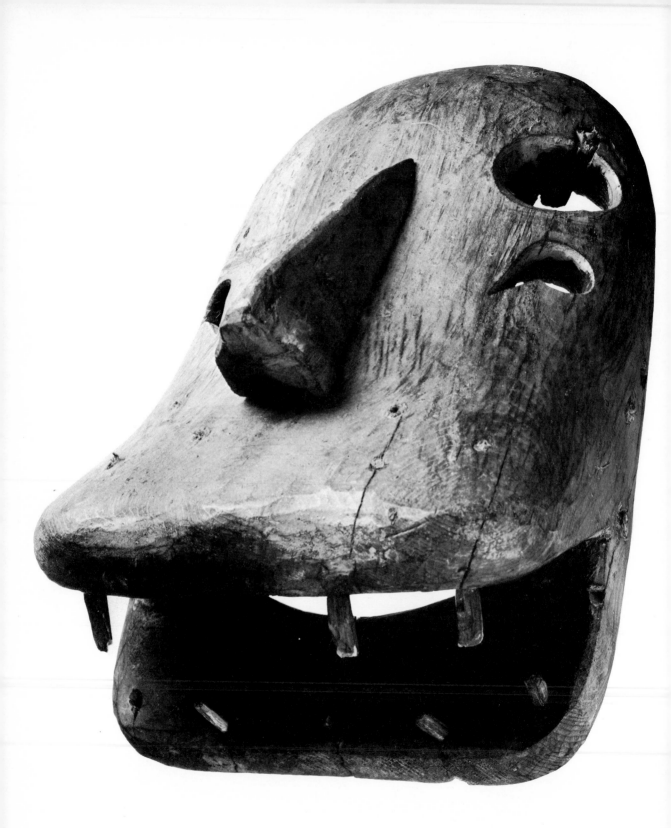

Plate 46. *Mask from Unalakleet, said to have been made for the Inviting-In Feast of 1912 in St. Michael*

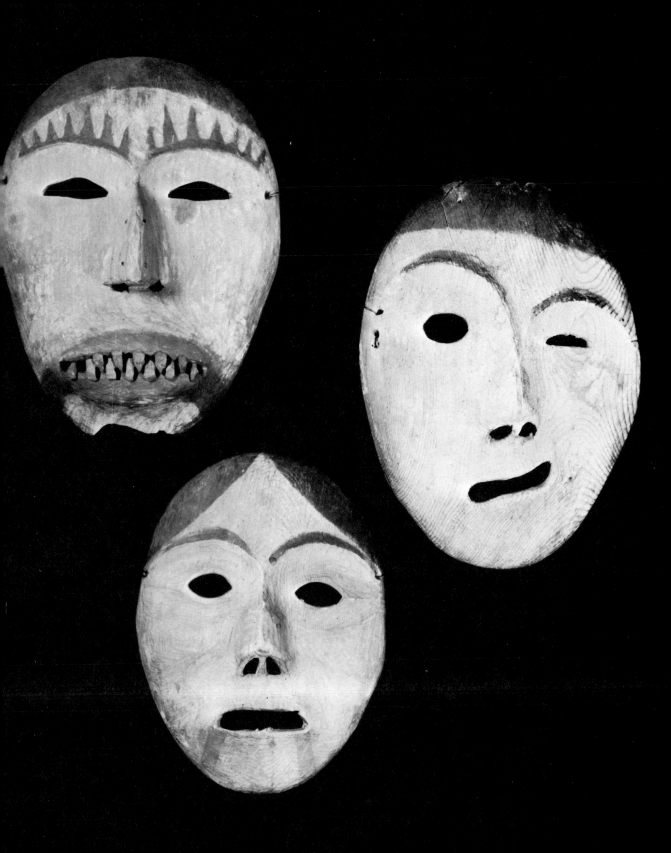

Plate 47. King Island masks from 1912

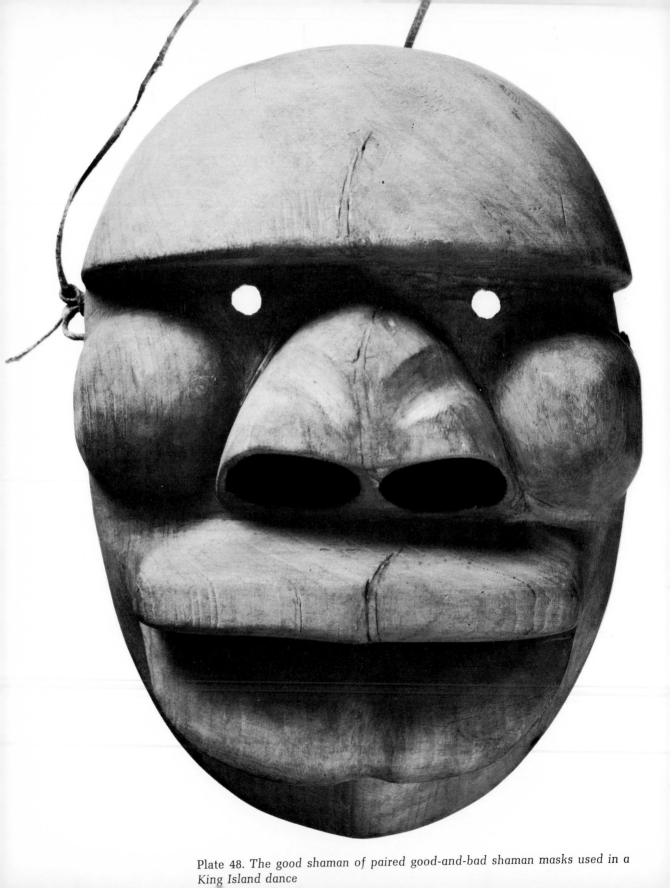

Plate 48. The good shaman of paired good-and-bad shaman masks used in a
King Island dance

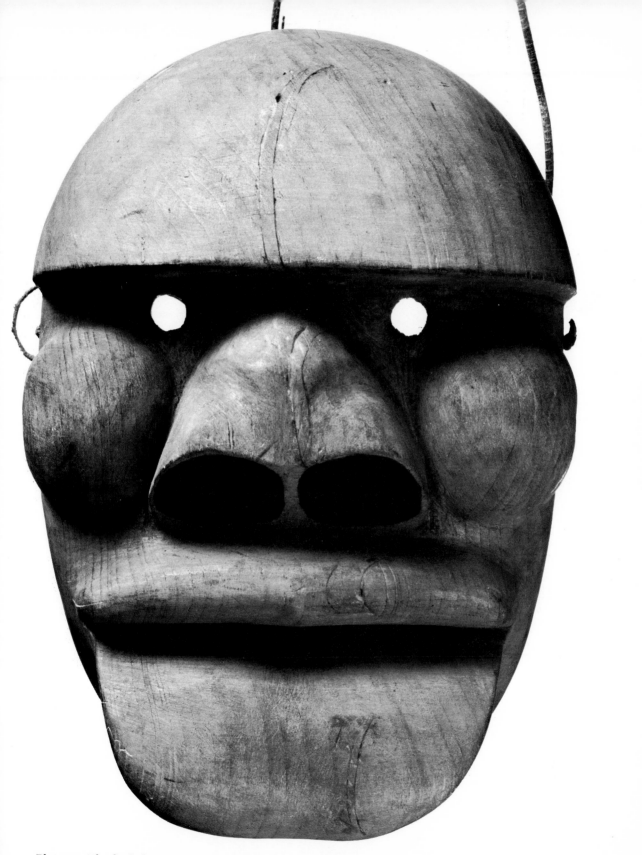

Plate 49. *The bad shaman of paired King Island masks*

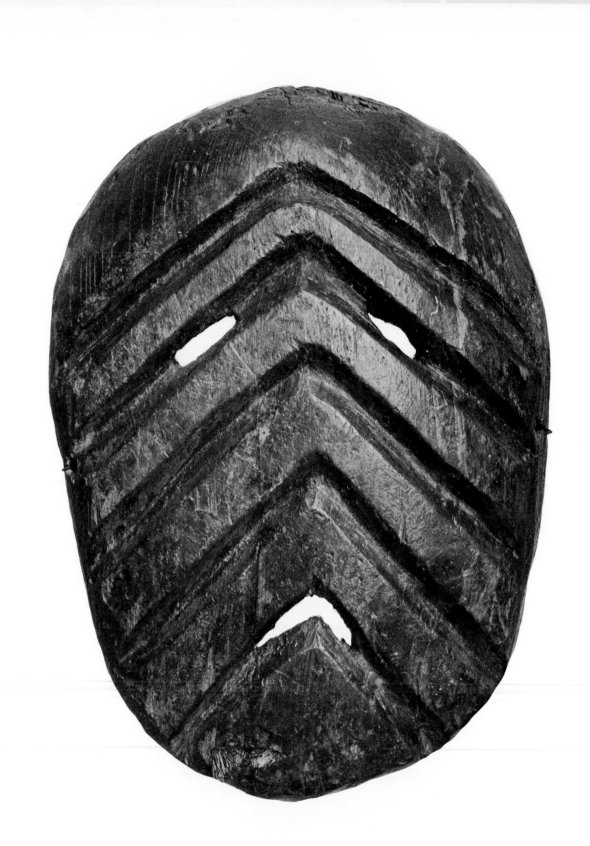

Plate 50. Point Hope mask found under the floor of an old ceremonial house

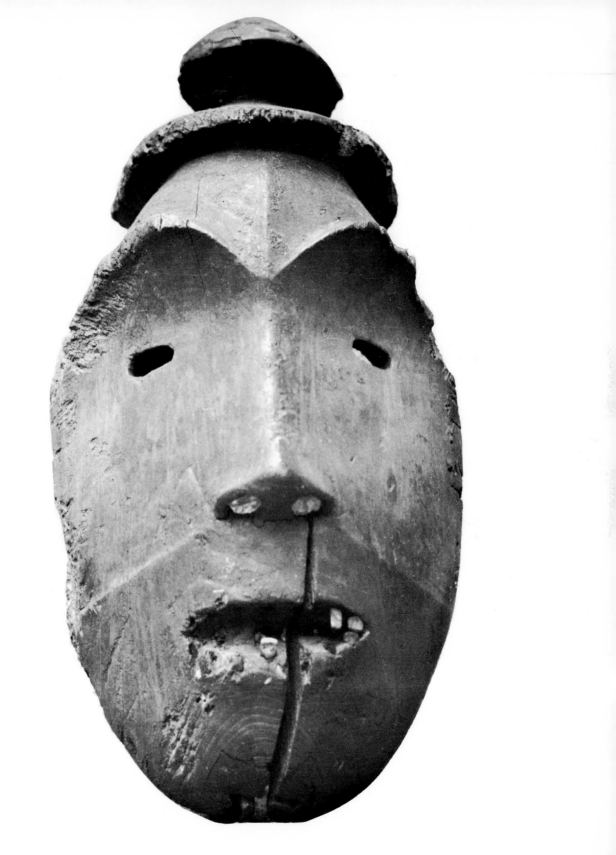

Plate 51. *A mask from Point Hope*

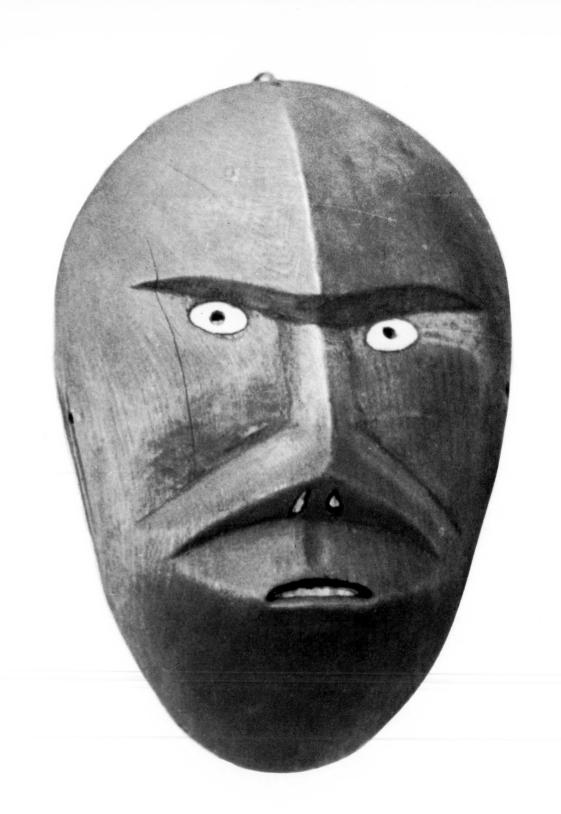

Plate 52. Point Hope mask said to be used as a protective image in the house tunnel

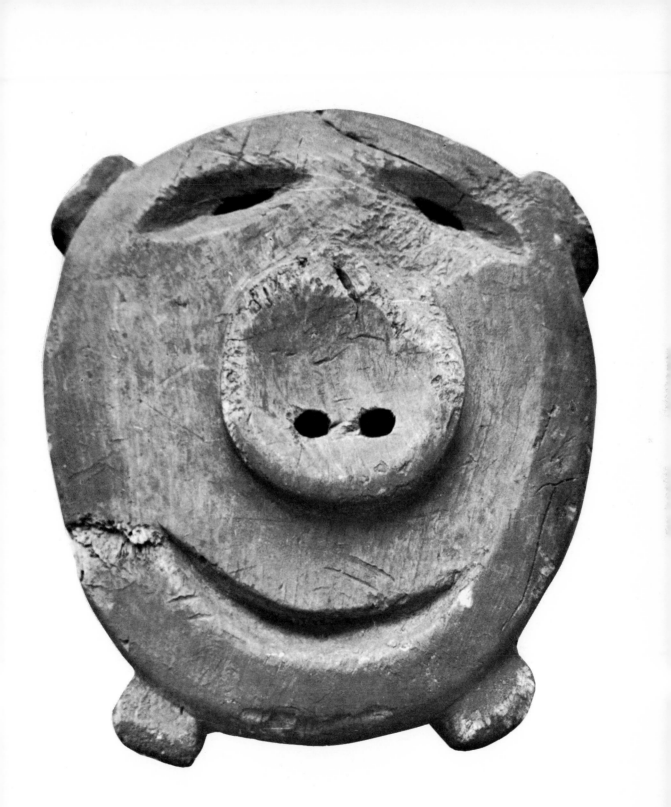

Plate 53. *Point Hope mask from the latter nineteenth century, possibly used in whaling ceremonies*

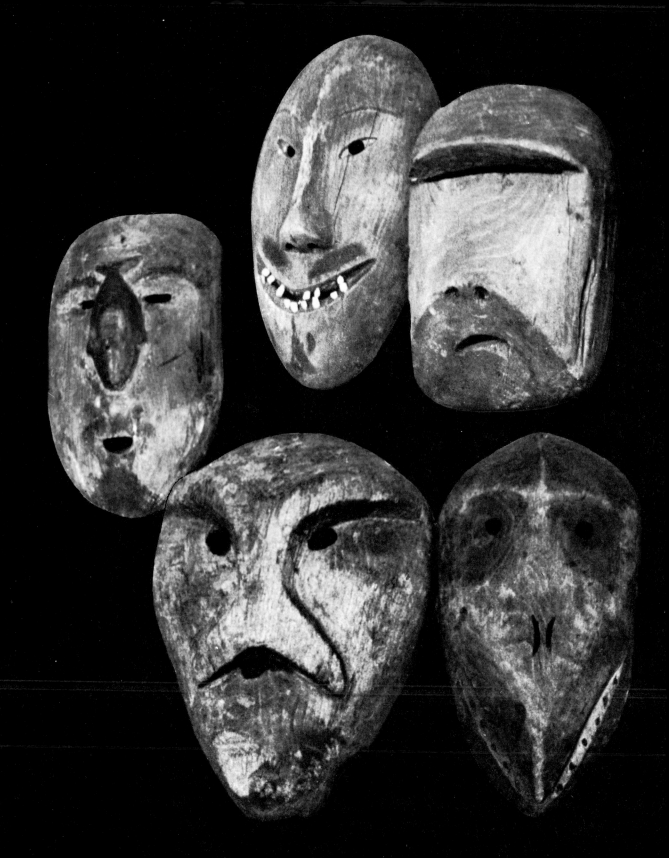

Plate 54. *Point Hope masks collected in 1891 and used in whaling ceremonies*

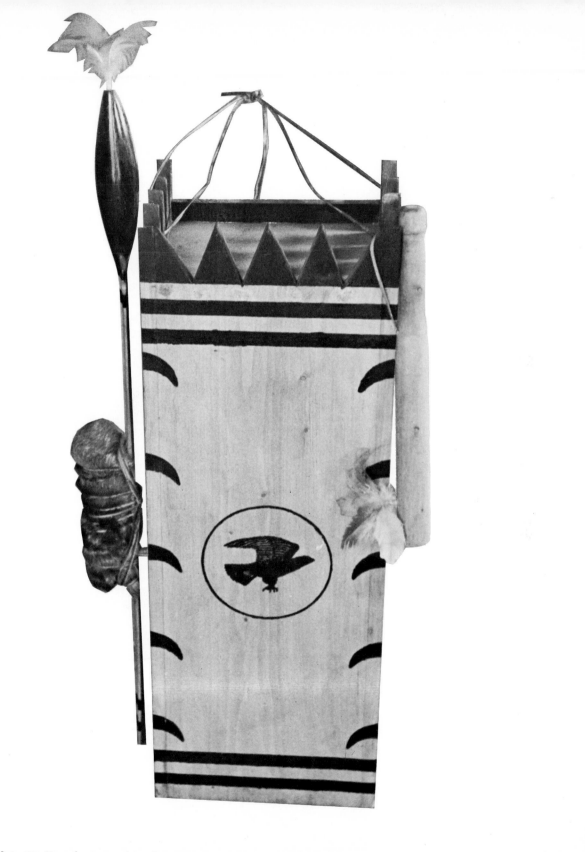

Plate 55. Box drum used in the Messenger Feast on Seward Peninsula

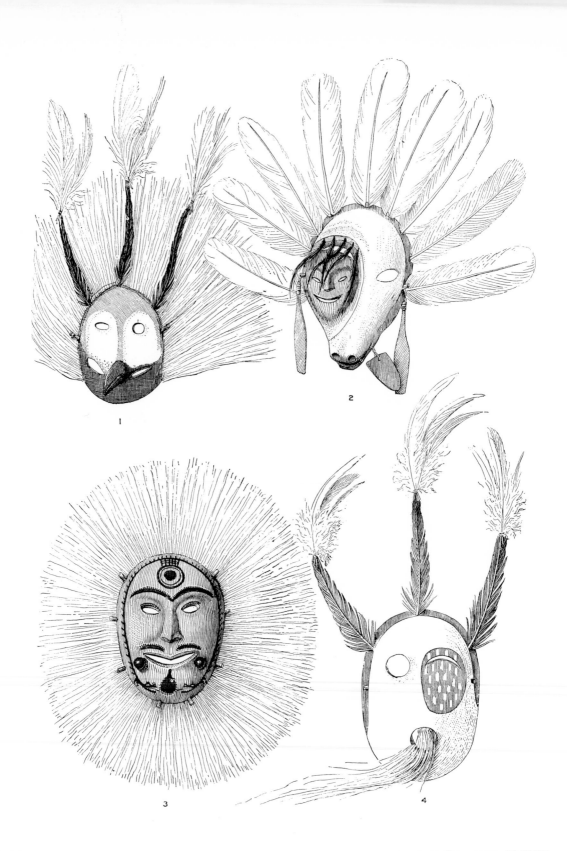

1

2

3

4

Plate 56. Nelson 1899: Pl. XCV

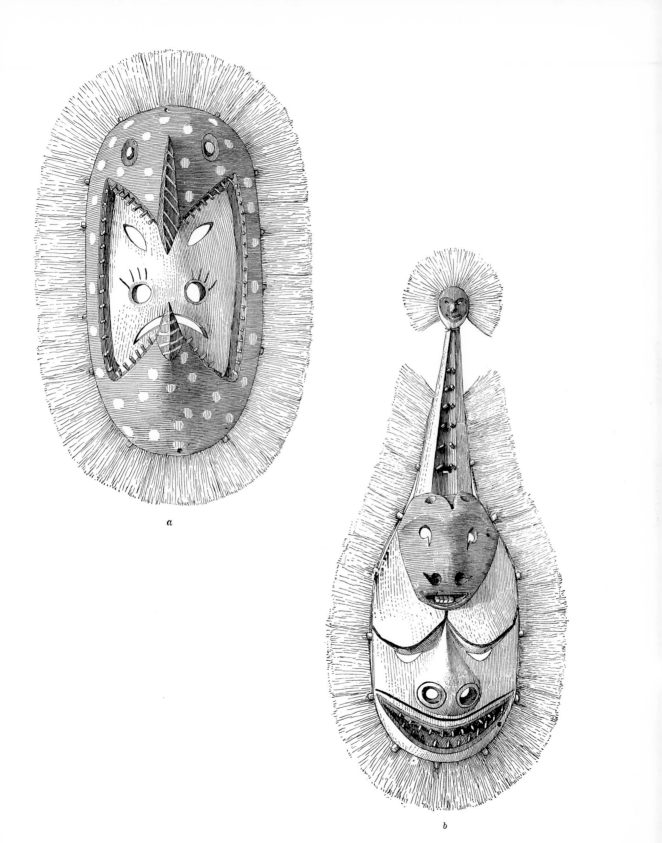

a

b

Plate 57. Nelson 1899: Pl. XCVI

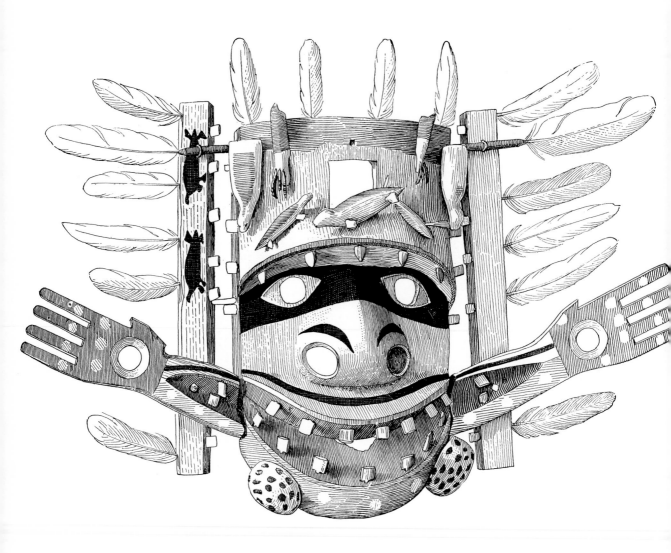

Plate 58. Nelson 1899: Pl. XCVII

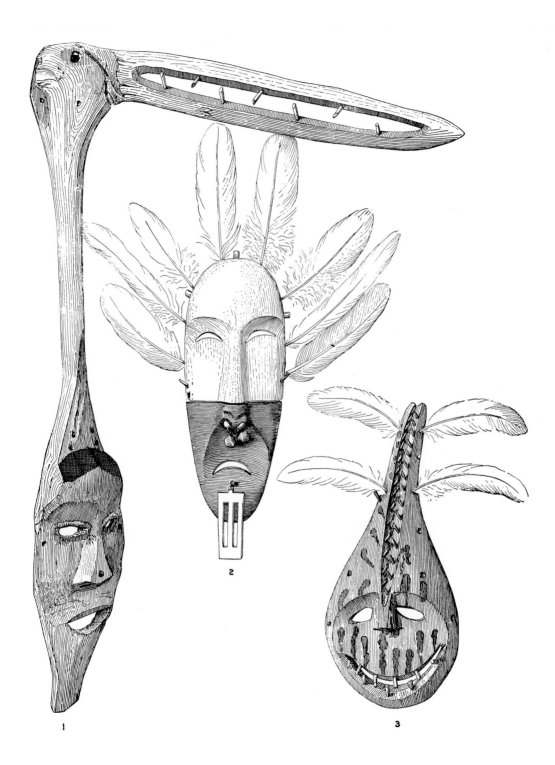

Plate 59. *Nelson 1899: Pl. XCVIII*

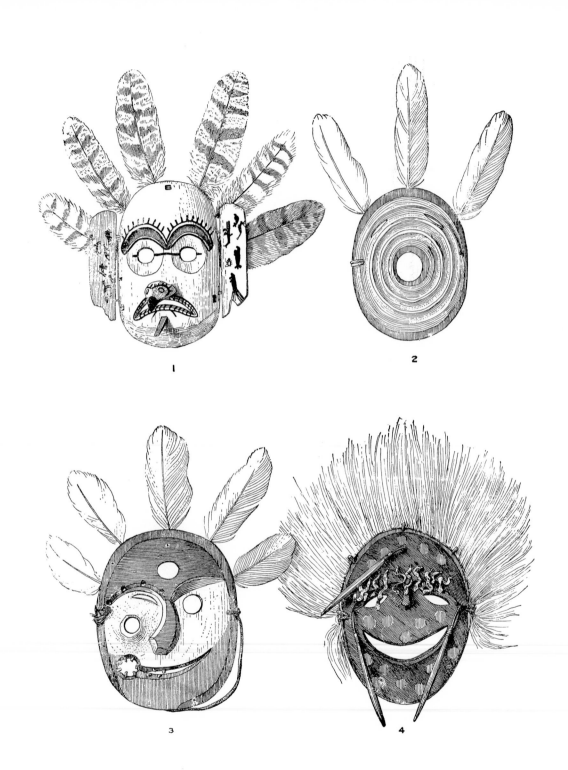

Plate 60. *Nelson 1899: Pl. XCIX*

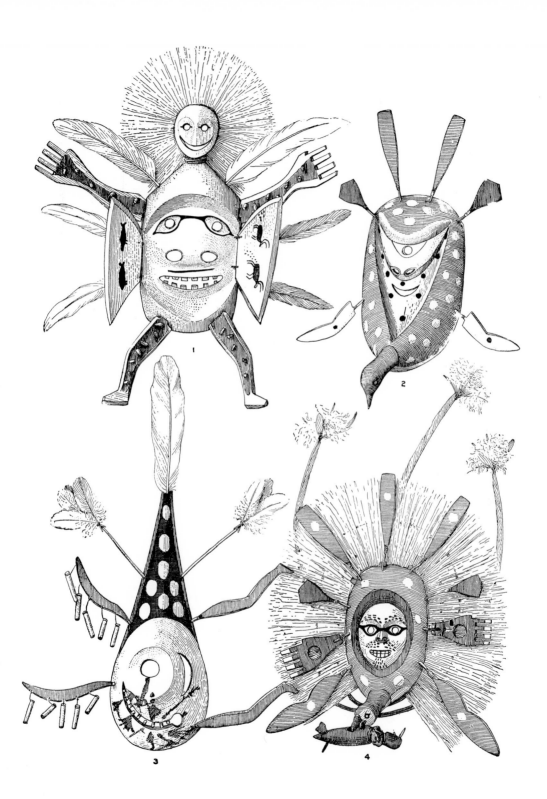

Plate 61. *Nelson 1899: Pl. C*

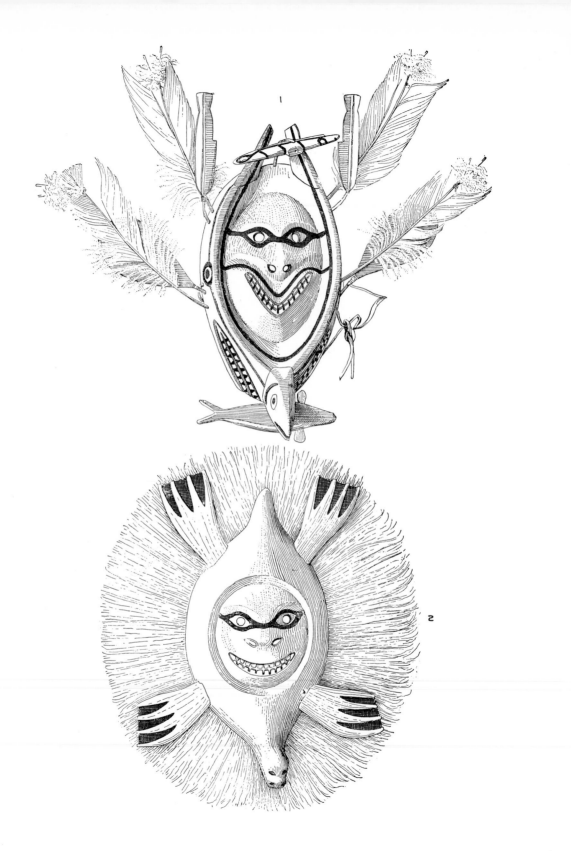

Plate 62. Nelson 1899: Pl. CI

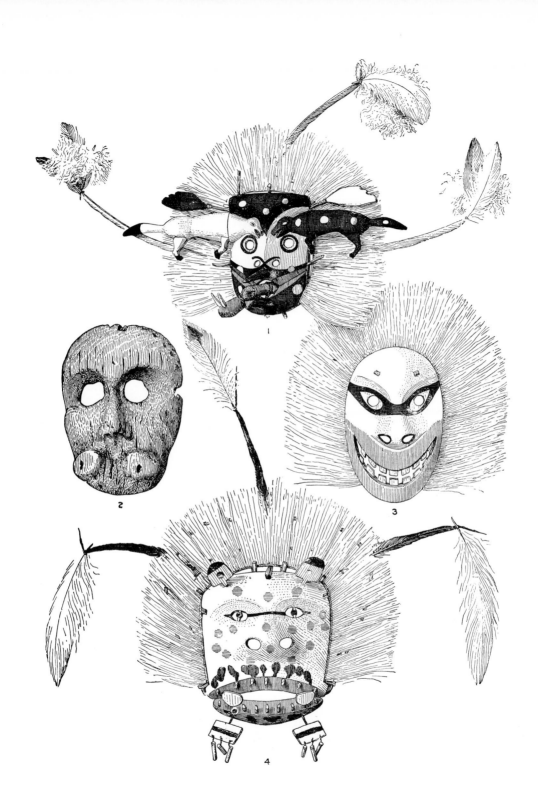

Plate 63. *Nelson 1899: Pl. CII*

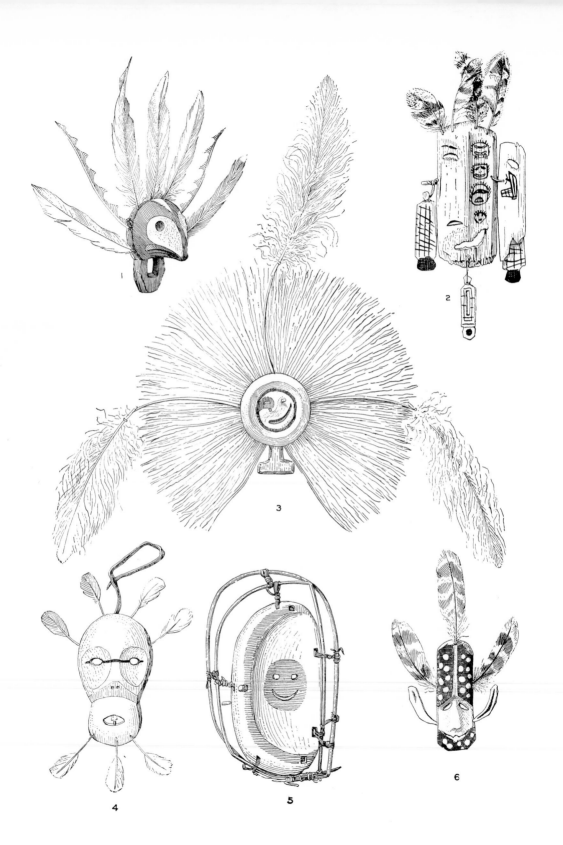

Plate 64. Nelson 1899: Pl. CIII

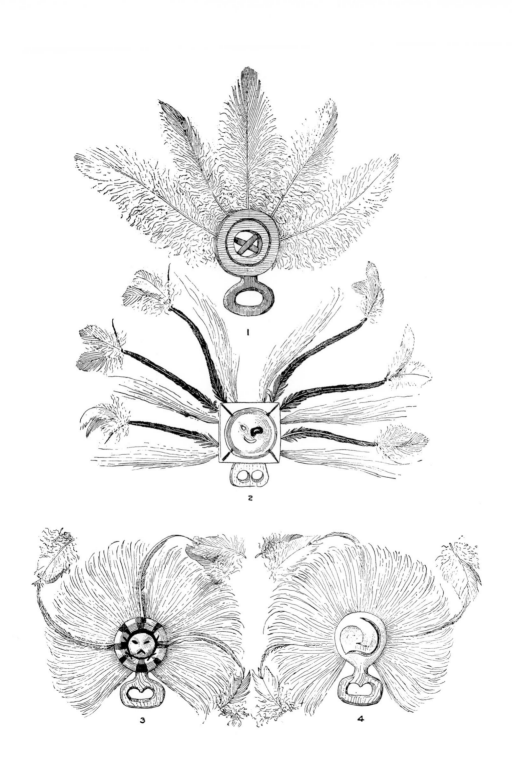

Plate 65. *Nelson 1899: Pl. CIV*

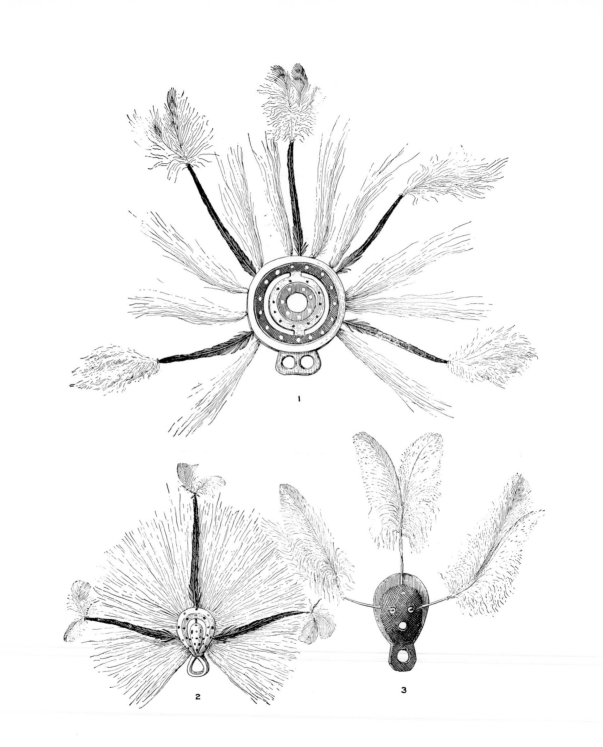

Plate 66. *Nelson 1899: Pl. CV*

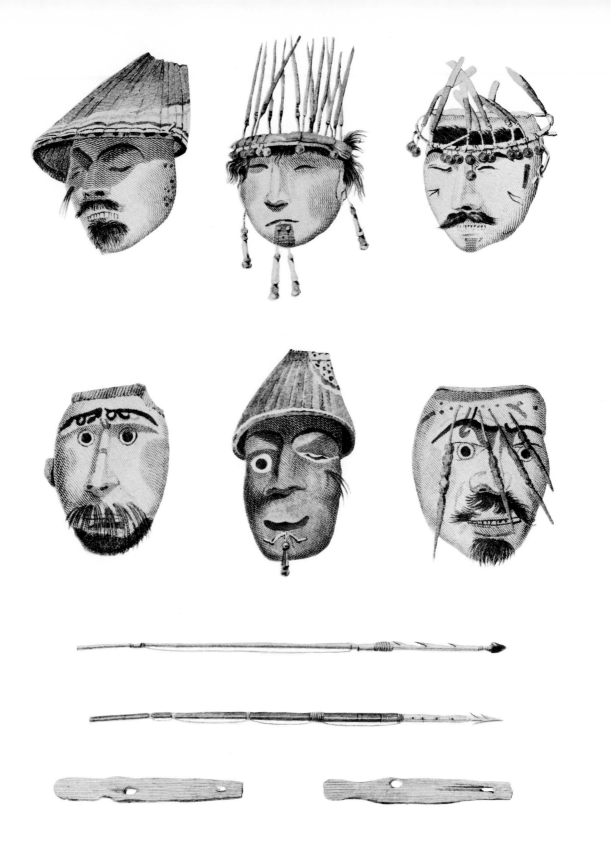

Plate 67. *Aleut masks (Sauer 1802: Pl. 11)*

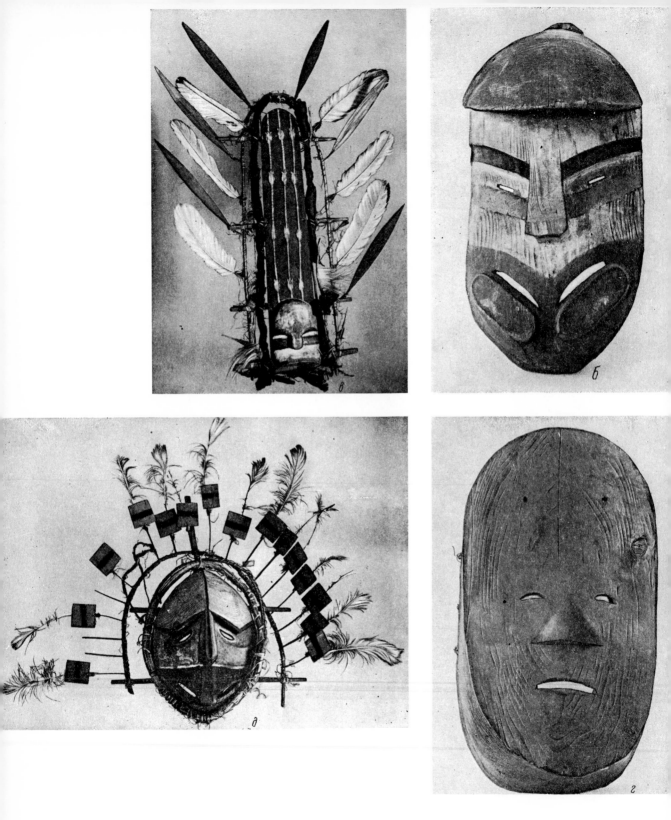

Plate 68. Kodiak masks (Lipshits 1955: Pl. 4)

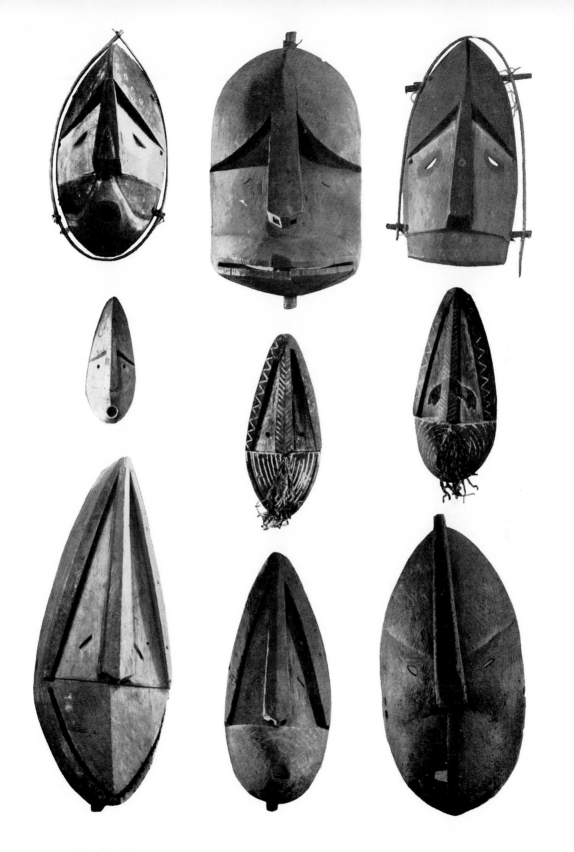

Plate 69. Prince William Sound masks (*Lot-Falck 1957: Pl. II*)

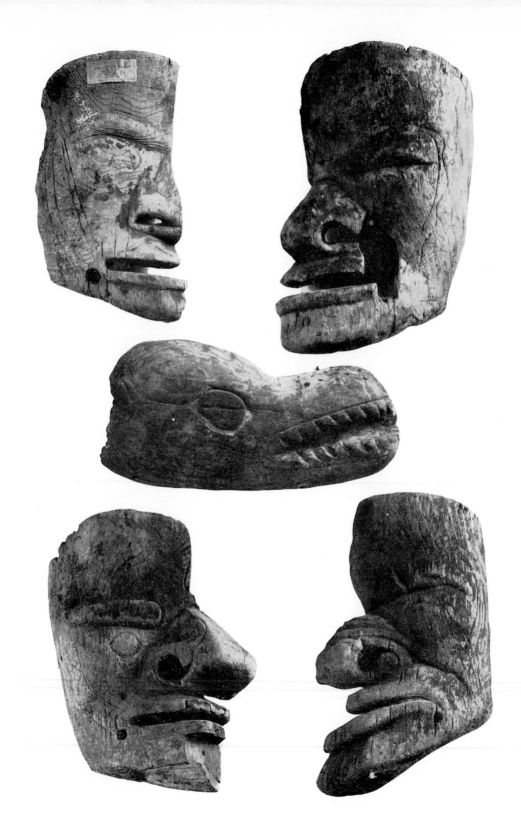

Plate 70. *Aleut masks (Lot-Falck 1957: Pl. IX)*

Description of Plates

As indicated in the first few pages of this book, admiration for Eskimo masks has been considerable, but information about them often erroneous. Material on masks gathered by a few anthropologists during the course of their Alaskan studies was tucked here and there in their writings. With this information combined with that drawn from my own field work on the subject, I returned to Alaska in 1964 with Alfred Blaker's photographs. I showed these to informants not only at St. Michael where many of the masks were collected, but also at Unalakleet, Teller, Nome, and even in Anchorage and Seattle, where a number of Eskimos now live. Migrants from all over Alaska live in the last three places—Eskimos from King Island, Kotzebue Sound, Bethel, Hooper Bay, Goodnews Bay, the Yukon—and I was gratified to find that something was still remembered about the old masks.

During the same summer I also examined the collections of masks at the Sheldon Jackson Museum at Sitka and the Alaska State Historical Museum at Juneau, (abbreviated SJM and AHM, respectively, in this section). Before this I had studied the mask collections at the following institutions: American Museum of Natural History, New York (AMNH); Burke Memorial Washington State Museum, Seattle (WSM); Museum of History and Industry, Seattle (MHI); Peabody Museum, Cambridge, Massachusetts (PM); United States National Museum, Washington, D.C. (USNM); University of Alaska Museum, College (UAM); University Museum, University of Pennsylvania, Philadelphia (UM). I also examined the Lowie Museum (LM) masks at first hand.

Many of the masks in the Lowie Museum were collected between 1875 and 1900 by agents of the Alaska Commercial Company and by H. M. W. Edmonds, a physician in the employ of the United States Coast and Geodetic Survey. One of the agents of the Alaska Commercial Company in the Lowie Museum records is R. Neumann, whose first name was

Rudolph. E. W. Nelson mentioned Rudolph Neumann as agent at St. Michael in 1879 (1899:21). Johann Adrian Jacobsen said that Rudolph was head agent at Unalaska on July 16, 1882, and that his brother, Henry, lived in St. Michael (1884:150, 232). In 1890 Henry Neumann presented several masks to Sheldon Jackson, who included them with his collections in the museum he founded. I learned from a relative of Henry Neumann in Unalakleet that three Neumann brothers—Henry, Rudolph, and William—had come to Alaska from Germany. The Catholic sisters at Holy Cross Mission on the Yukon knew about their former beautiful home, and could never understand why the brothers had left it for the rough life of Alaska. William, who did not like the new frontier, went to San Francisco where he became a dentist. His brothers remained as employees of the Alaska Commercial Company. In 1892, Rudolph was general agent in Alaska with headquarters at Unalaska; Henry was manager of the Yukon Division at St. Michael (Report of the Governor of Alaska . . . 1892:32). Rudolph also had a mine on Unalaska Island, where he was killed, according to his relatives.

Edmonds was stationed at St. Michael in 1890, 1891, and 1898. While there, he became interested in Eskimo ceremonialism and collected information and photographed artifacts. His photographs and notes eventually found their way to the University of Washington Library. Many of the masks in the faded brown prints of that manuscript are the same ones illustrated here. (See Ray 1967 for Edmonds' original photographs.)

The Alaska Commercial Company's huge collection of wooden and ivory objects was presented to the University of California. In 1954 when I was seeking information about that collection for a study of ivory carving, I was told by an official of the Northern Commercial Company, successor to the Alaskan Commercial Company, that many of the records pertaining to the collection had been lost during the San Francisco earthquake and fire of 1906. This probably accounts for the lack of provenience and other information about many of the masks collected by the agents.

Few Chugach, Kodiak Island, and Aleut masks are in any museum, and little information about ceremonials and masks of these groups has been recorded.

The Aleuts apparently had two kinds of masks, the large-nosed,

militant-featured masks illustrated by Avdeev (1958), Dall (1884), and Pinart (1875); and delicate dancing masks, similar to those of the Bering Sea Eskimos (see Pls. 67 and 68). Two bone masks excavated by E. M. Weyer at Port Moller on the Aleut-Eskimo boundary also fit easily into the northern categories of masks (see pp. 94–95).

W. H. Dall collected several Chugach masks, which he illustrated in 1884. They are now in the United States National Museum. At one time it was assumed that these were the only Chugach masks preserved, but Alphonse L. Pinart had deposited a number of masks in a French museum after his collecting journey to Alaska in 1870–72. Their existence was not widely known until 1957 when Eveline Lot-Falck illustrated them for the first time. The six Aleut masks and seventy-four Pacific Eskimo masks (both Chugach and Kodiak) are now in the Museum of Boulogne-sur-mer.

The Chugach Eskimos used wooden masks for certain festivals and shamanistic performances, but the Messenger Feast and other elaborate ceremonies of their northern kinfolk apparently were unknown to them. Chugach masks are illustrated in Birket-Smith's *Chugach Eskimo* and Lot-Falck's article.

Kodiak Island masks were similar (at least in facial style) to those of the Chugach, but had a more delicate air, and were often framed by feathers, rings, and geometric designs. Tall boards were also used behind the masks. Kodiak masks are illustrated in the articles by Lipshits and Lot-Falck.

One of the largest collections of northern Alaska masks is located in the Sheldon Jackson Museum. Jackson, the first agent for education in Alaska, made annual trips to Arctic Alaska between 1890 and 1900 on the revenue cutter, *Bear*. At the various stops he persuaded scores of Eskimos to part with their possessions, including the parkas off their backs. His largest booty of masks came from Andreafsky (now St. Mary's) on the Yukon, King Island, Nushagak, Point Hope, and St. Michael. The Sheldon Jackson Museum has one of the largest collections of King Island and Point Hope masks anywhere.

Between 1877 and 1881, E. W. Nelson collected an equal number of masks, which he deposited in the United States National Museum. The masks are from St. Michael and southward, where Nelson made numerous trips in line with his duties as United States Signal Corps observer. He made only one trip to the Arctic, on the revenue steamer *Corwin* in

1881. He disembarked infrequently and saw the Eskimos only in their summer homes during the nonfestival season; therefore, his collection contains few northern masks. About the same time, between 1881 and 1883, John Murdoch collected fourteen wooden masks at Point Barrow (P. H. Ray 1885:64).

Fortunately, both Jackson and Nelson recorded proveniences of individual masks, but neither Jackson nor Nelson provided detailed information about a mask's meaning or specific ceremonial use. Nelson, a fine observer, apparently tried his best to do so, but circumstances failed him; nevertheless he described easily observable characteristics of a selected number of masks in his *Eskimo about Bering Strait*. Reproductions of his plates, along with a few masks not ordinarily accessible to the average reader, will be found in Plates 56–70.

In 1881 and 1882 Jacobson collected a number of masks and finger masks from the Yukon River for the Berlin Museum für Völkerkunde. These are illustrated and described in two articles by Disselhoff (1935; 1936).

The Eskimo masks in the Alaska State Historical Museum cannot very well be used as illustrations because most of them were painted with bright commercial paints in 1954, destroying their original character.

Each mask in the following section is described in detail and discussed with information pertinent to the mask or similar ones. Some of the material presented in the first section is occasionally repeated for a specific mask when necessary so that this catalogue can be useful by itself. Masks of the Lowie Museum are presented first, followed by those from other collections. Permission to reproduce all of these masks has been granted. Masks in each section are listed from south to north.

Museum catalogue data are given in the first paragraph following collector's name, date of collection, and provenience. I have provided a tentative provenience for undocumented masks after comparing them with similar ones.

The colors of the masks in the Lowie Museum can be characterized as follows. All are pale and subtle. White is a chalky neutral white. Black is a dull, lusterless black or a dull blue-black, almost like slate. Green is usually an olive green or a gray-green. Reds are dull, usually brownish red.

All photographs are by Alfred A. Blaker, unless noted otherwise.

COLOR PLATES

PLATE I

Lowie Museum 2–4584. Height: 19½ inches. Collected by Alaska Commercial Company, no date, no provenience. It may have come from Nushagak since mask II.A.5 (SJM) from Nushagak is an exact duplicate with the exception of a large bird beak emerging from the top hole. A St. Michael man told me that Apaguk, the famous Nelson Island shaman, had made one similar to this once, but "I don't know its story."

The mask is white with red mouth, chin, eyes, nostrils, and flippers. The three white spiraled sticks appear to be stylized human figures. The top one, which was once paired with a fourth stick, is partly painted with red. The white forehead of the mask juts out conspicuously. Baleen fastens the appendages to the mask. The wearer held the mask to his face by grasping a horizontal bar in his teeth and looked out through the nostrils. This mask and those in Plates 2 and II (LM 2–4574 and LM 2–5852) were decorated with the same paint.

The nose is reminiscent of Aleutian Island cave masks (see p. 79). This particular combination of eye, nose, and mouth forms has been reported from the Kuskokwim (see Pls. 57b, 58, 61, No. 1, 63, No. 3; Covarrubias 1954: Pl. 5; and other masks in SJM and USNM). It is also found at Nushagak, Togiak River, and St. Michael.

The chevron-shaped forehead is similar to some of the Pacific Eskimo masks illustrated by Lot-Falck. This shape was not unknown at Point Hope (Pl. 50).

PLATE II

Lowie Museum 2–5852. Height: 17 inches. Collected by Alaska Commercial Company, no date, no provenience. It may have come from the Nushagak area. One of my St. Michael informants said that he had seen a similar one at Stebbins.

The colors are exactly like those of the masks in Plates I and 2. The background board is white. The visor and walrus are pegged on with wooden pegs. The front of the hands and paddle is painted red, but the back is unpainted. The walrus, which is red, is made of very soft wood; the tusks are wood. The teeth are carved out of the mask and painted white. The lips and nostrils are red. The broad band around

the left eye is black; the one around the right eye is red. Root is used to splice the three boards of the mask together. Heavy pieces of baleen, bound with string, are used to attach hands and flippers.

PLATE III

Lowie Museum 2–5854. Height: 16 inches. Collected by Alaska Commercial Company, no date, no provenience. The style is similar to that of many masks collected by Sheldon Jackson from the lower Yukon in the 1890's.

The paint used is identical to that of LM 2–5851 (Pl. 3). The background, the attached face at the top, and the tip of the large winglike attachment on the left are white. The area surrounding the eye is gray-green. The lips, bottom of the wing, and nostril are reddish brown. (The nostril is unpainted in Pl. 3.) Four upper and four lower wooden teeth once were inserted in the mouth, but only two remain. The bow is strung with seal thong. The face is attached to the main mask with baleen, and the wing is attached with split root. A deep groove surrounds the mask, probably to hold a halo of fur or feathers. The carved face finger masks in Plate 36 may have been used in the same dance as this mask.

This is illustrated in Covarrubias 1954:8; Covarrubias and Borbolla, 1945: Fig. 4; and in Douglas and d'Harnoncourt 1941:43.

PLATE IV

Lowie Museum 2–1303. Height: 25¼ inches. Collected by Charles L. Hall, no date. From "Lower Yukon or Northwest Behring Sea."

The face and ears of this mask are unpainted. The hair, eyebrows, lines around the eye, and tattoo marks are black. The paint line next to the face is red. The other lines, proceeding to the edge of the board, are black, red, natural, and red. The concentric root hoops are alternately black (next to the board) and red. The wooden labret is tied on with string, and the ears, pierced for earrings, are fastened to the mask with root. The mask was tied to the head with a fishskin thong fastened to the edge of the face just above the mouth, which permitted the wearer to look through the mouth. A mouth grip was also provided at the base of the mask.

The distinctive shape of the nose of this mask and that in Plate 4 (LM 2–1305) is found on many masks of the Unaluk-speaking people of Norton Sound and the Yukon River.

This mask was identified on page 17 as a woman representing

the moon, who was made to look as beautiful as possible. One of my St. Michael informants, considered to be an expert about masks and dances between St. Michael and the lower Yukon, said that he had seen a mask like this used at Stebbins about 1910. This style of face was commonly made on masks of both Indians and Eskimos of the lower Yukon. Detailed reports of its use by Indians have been made by J. Chapman, de Laguna, and Osgood.

Numerous examples of this mask have found their way to museums. An almost identical one at Sheldon Jackson Museum is attributed to "Kozeifsky" (old Kosorefsky on the Yukon near Paimiut). It has no border boards. The woman has beads in the septum of her nose instead of labrets in her chin. A USNM mask (45,503) is also almost identical. The catalogue attributes it to "Athabaskan or Eskimo, Anvik." The woman's labret is turned in the opposite direction, and the ears are held to the face with two thongs instead of one. The hair, tattoo marks, and ears are the same. The surrounding board of the mask is not as wide as this one, and it is circled by two rings instead of four.

Another mask from the National Museum (45,502) is similar in concept, but was probably made by a different carver. The hair, eyes, nose, mouth, tattoo marks, and ears are the same, but the cheeks are fat and bulging, each painted with a bright spot of red. The labret and earrings are small tubes. The face is surrounded by a heavy board and feathers, but no rings.

De Laguna describes the Berry Woman and Dog Salmon Woman masks used by the Indians of the lower Yukon, which are related in style to this mask. The Berry Woman has short black hair and looks almost like this mask. The Dog Salmon Woman wears hair down the sides of her face. Some have a large red spot on each cheek. These Indian masks were not provided with a board backing, and the concentric circles of root begin at the edge of the face. String holds the mask to the face (de Laguna 1936:576 and Pls. 17 and 18).

The Indian masks were thin and light, and the carving was crude compared to that of similar Eskimo masks. Chapman did not illustrate a mask with hoops, but the Old Woman, whose face is similar to this one, though narrower, has a fringe of reindeer hair on top. It has black, parted hair, beads in the septum, earrings, and tattoo marks, but no labret or spectacles.

Small, curved, sickle-shaped labrets were worn by women living between the Yukon and Kuskokwim rivers and on Nunivak Island during

Nelson's residence (1877–81). He said that he saw none being worn elsewhere (1899:45). One of my Unalakleet informants said that she saw a very old woman wearing a similar labret in Unalakleet about 1905, but this woman may have been a visitor from the Yukon.

PLATE V

Lowie Museum 2–4589. Height: 15 inches. Collected by Alaska Commercial Company, no date, but about 1880. Provenience unknown; possibly lower Yukon.

This mask and LM 2–4597 (Pl. VI) are unique, though the basic concepts of Eskimo masks are present in both. It is painted white and bluish-black. The wearer looks through the eyes, made of beads, which represent the spirit of the bird. The tail is a separate piece of wood. Fishskin is used to fasten it onto the head.

None of my informants had seen masks like this or Plate VI before, although a St. Michael man ventured this one to be "maybe some kind of ocean bird from around here." A Unalakleet man said that it might be the spirit of a murre. Two Yukon River informants could supply no information about either mask example.

PLATE VI

Lowie Museum 2–4597. Height: 15 inches. Collected by Alaska Commercial Company, no date, but probably around 1880. Provenience unstated. Catalogue information: "mask worn in dancing."

This mask is one of the most expressive in concept and total effect of all Eskimo masks; however, it is rather crudely made with many rough tool marks. The jagged finish apparently was deliberate, and the markings, especially on the enormous upper beak, no doubt enhanced its effectiveness when in motion on a performer. The tool marks are almost identical to those of masks from Pastolik (Pl. 11), St. Michael (Pl. X), and unstated locality (Pls. 18 and 22).

The human face and the forehead and eyes of the bird are natural wood color. The beak, mouth, spots, and back of the head are a subtle reddish-brown. On top of the beak are two strands of seal thong tightly embedded in the wood and held with wooden pegs. The wooden teeth are cut straight across the top, not beveled. The bird's bill is stationary and cannot close over the face.

Although many masks from Norton Sound to the Aleutian Islands

have a spirit of a bird or animal represented in some way by a human face, few are represented as emerging from the animal itself as in this mask. In many Eskimo folktales a mythological animal or bird had only to push up his muzzle or his beak to show his human counterpart and thus change into a person. This device of showing a face within an animal's mouth is also used on a seal mask from the lower Yukon in the Washington State Museum.

Some of the huge bird masks of the Northwest Coast Indians were constructed so that the bills would open to reveal a face inside. Few Eskimo masks were made in that fashion, but doors were occasionally made on Eskimo masks to cover a human face. Nelson obtained a few masks with doors, but none with removable jaws, although he said: "in one or more instances I saw masks having an outer or movable portion representing the muzzle of some animal which could be removed at a certain time in the festival by a single motion of the hand. These were used to represent the metamorphosis from the ordinary form of the being indicated to that of its *inua*" (1899:406).

PLATE VII

Lowie Museum 2–6920. Height: 6³/₄ inches. Collected by H. M. W. Edmonds between 1890 and 1899. St. Michael.

This mask is white. The left oval eye is red with white dots. The lining of the mouth and the right eye are red. The quills at the top of the mask are split to provide more elasticity during dancing. They are inserted directly into the mask. The original snapshot of this mask in Edmonds' manuscript shows a furlike or feathery material emerging from the mouth. He does not say what the mask represents. However, a similar one collected by Jacobsen in 1882 on the Yukon was called "the bad spirit of the mountain." No measurements are given for the mask, which apparently was held in the hand by a stick below the chin (Disselhoff 1935: Fig. 8).

Lowie Museum masks in Plates VII, 10, and 11 were used in what Edmonds describes as a Bladder Festival in the St. Michael–Pastolik area. Several informants said that they had seen masks like this used in dances, but none remembered its song. Possibly the masks were worn in pairs, since one from St. Michael in the Sheldon Jackson Museum (II.G.3, 7³/₄ inches high, collected by Henry Neumann, 1890) has the spirit's eye on the right instead of the left as this mask. Its eye is slightly

longer than this one and is painted black with white spots instead of red with white spots.

Nelson illustrates a mask 8 inches high, almost like this, with a red spotted eye on the right instead of the left (see Pl. 56, No. 4). Emerging from the mouth from a fastening behind it is a long tuft of reindeer hair. This mask, from Cape Vancouver, is said by Nelson to be "the features of a *tunghak* [spirit]" (1899:396). The one illustrated by Nelson had a wide red border around it like that in Plate 11.

The round mouth is found on masks from King Island to Prince William Sound. The same shaped mouth is found on Anvik Indian masks, for example, "Mask of the Siren" (Chapman 1907:28); "Bird Preceding Salmon Woman" (de Laguna 1936: Pl. 17); and "Cry Baby" and "Up-River People" (Osgood 1958: Fig. 8).

A large mask (20 inches high) from Andreafsky (St. Mary's), now in the Sheldon Jackson Museum (II.B.9), has a large protruding mouth similar to that of this mask. The plain heart-shaped face has a large head and a narrow chin. The large round mouth takes up almost all of the chin space. Sheldon Jackson, who collected it in 1893, reported it to be "the devil."

PLATE VIII

Lowie Museum 2–6926. Height: $9^7/_8$ inches. Collected by H. M. W. Edmonds between 1890 and 1899. St. Michael. Edmonds' manuscript says that this is the spirit of driftwood.

The face has been left unpainted and shows the carver's care in exploiting the grain of the wood. The forehead is blue-black with white spots. The top is bordered by red. Seven goose feathers are thrust into holes and self-tied. They are further held in place by a continuous string of braided sinew proceeding from quill to quill above the mask. Several strings of orange-dyed parchment (seal intestine?) with white fur tassels stream from the mouth.

In 1890 Henry Neumann gave a similar mask, 11 inches high, to the Sheldon Jackson Museum. The forehead is painted the same color; it has the same number of feathers, tied in exactly the same way; and streamers come out of the mouth. The face was painted white at one time.

This is illustrated in Blaker 1965: Pl. 12B.

PLATE IX

Lowie Museum 2–6914. Height: 7⁷/₈ inches. Obtained by H. M. W. Edmonds between 1890 and 1899. St. Michael. Edmonds calls this a sculpin in his manuscript.

The background of the mask is plain wood. The spots are blue-black, and the border is red. The lips are red with wooden peg teeth, the lower beveled part receding toward the lip. The round pupils are cut out, and the carefully carved corners of the eyes are depressed into the wood. A small wooden peg holds each split quill into the mask. Plumes of ptarmigan (?) feathers are fastened to the split quills. On the reverse side of the mask, eyes and mouth are lined with red paint.

Several species of sculpin are obtained in the shallow water of Norton Sound, and hooks were made especially for procuring them. Nelson said that the Eskimos of that region called the small sculpin "the rainmaker" and believed that if a person held one in his hands, heavy rains would result (1899:446).

PLATE X

Lowie Museum 2–6915. Height: 7³/₈ inches. Collected by H. M. W. Edmonds between 1890 and 1899. St. Michael.

The mask is painted gray-green, with red border and lips. The beveled teeth are inserted like pegs. It looks flat when viewed from the front, but the thin, long nose protrudes along all its length an inch or more from the face. The snapshot of this mask in Edmonds' manuscript shows three tufted feathers inserted into the rim: one above the nose and one opposite each eye. The knife marks are pronounced and are similar to those in Plates VI, 11, 18, and 22. Plate 11 is from Pastolik.

The mask was possibly used as a humorous one during a Messenger Feast dance. A St. Michael man said that he had seen only one that resembled this, and he thought that it was called *pugutak,* or "plate mask."

PLATE XI

Lowie Museum 2–6442. Height: 14 inches. Collector, date, and provenience unknown. This is, however, a duplicate of USNM mask 33105, which came from Pastolik (see Pl. 61, No. 3).

The round face is white, and the handle and framing of the face

are black with white spots, probably applied by fingertip. Red paint lines the mouth, eyes, and all other openings. Black designs are painted on the bottom half of the face. The pegged-in teeth are beveled, slanting to the outside.

The USNM mask, 13 inches high, is essentially the same color. It has two legs and two wings with five small dangling cylinders, which are missing from LM 2–6442. Quills and swan's feathers are illustrated on the mask. Only slight differences exist between the two: the circular end of the mouth of the USNM mask is on the right instead of the left, and the black background with white spots does not extend around the face. The markings around the mouth are so similar in the two that it seems unlikely that they are random splashings. Nelson presumed them to be blood (1899:406–7).

The long, curved mouth and single eye are in the same tradition as those of the mask in Plate 3. The use of blood and paint splashes is discussed on pages 21–22.

PLATE XII

Lowie Museum 2–9161. Height: 9 inches. Collected by R. Neumann, Alaska Commercial Company. St. Michael.

A white wash covers the entire mask. The upper lip is blue-black, the lower lip, red.

An informant at St. Michael said that one like this was used during vigorous dancing. It is like a mask illustrated by Edmonds in his manuscript, but not in the Lowie Museum.

BLACK-AND-WHITE PLATES

PLATE 1

Lowie Museum 2–4603. Height of board: 11 inches. Collected by Alaska Commercial Company, no date, no provenience. A St. Michael man told me that he saw a mask exactly like this used by the Nelson Island shaman, Apaguk, at Stebbins for "weather medicine."

The board, corner blocks, animal heads, wooden circles, and paddles are painted white. The two arms and hands are red with white fingers. The face is light blue-green over a brown base. The face has

red nostrils, red border, and white wooden teeth carved from the same piece of wood. The pupils are cut out, and the oval eyes around them are depressed. Heavy baleen strips attach the arms to the mask, and rawhide attaches the outer ring. Feathers probably were inserted on the arm next to the small paddles.

My informant told me that, when the shaman used this for weather medicine, he placed the mask face down on the floor before lying down on his back. He then sat up, leaned over to place his face into the scooped-out back, and lo! without using his hands, the mask held to his face. (This same kind of trick is discussed on page 20; usually a mouth grip was used to pull the mask to the face. Ordinary people supposedly did not know what the back of the masks looked like.)

My informant explained that the two animal heads of this mask are the shaman's helping dog spirits, and the four oblong pieces of wood on the four corners of the mask and the two radiating from each of the wooden circles are the rays of the moon and the sun. (He was not sure whether the wooden circles were the sun or the moon, but thought they were the moon.) The hands at the sides of the mask are Apaguk's own hands. Apaguk went without food and water for two days before he carved the appendages and the face (or spirit) of the mask. The rest of the carving was done by another man under Apaguk's direction.

Apaguk was the same medicine man who went under the ice to obtain good seal hunting (pp. 18–19), using a mask like that in Plate IV (LM 2–1303). His fame had spread over a large area during the early twentieth century. One of Margaret Lantis' Nunivak informants, who had also known him, told her the following tale:

The shaman was going after the eclipsed moon. He waited—did not return while they sang three songs. Then he came in very slowly. People took hold of him, brought him in. They removed his clothes. He was very stiff, hardly moved. He was named Apa'Gakh. He told the people that some other shaman had gone up before him and fixed the moon. Apa'Gakh did not reach the moon. He saw it had been fixed, so he came back, sadly. . . . People believed that if the moon was eclipsed as it rose in the east, the people to the east would get sick and wouldn't live long. If it was eclipsed in the west, the same would happen to the people in the west. An eclipse might mean starvation, too. The moon-man has a dog with no hair, smooth as if shaved. There was no explanation of the cause of an eclipse. Nunivak people didn't know how it happened. Some shamans had the moon's dog as a helping spirit [1960:118].

Both the Moon Dog and the common terrestrial dog were spirit helpers in many parts of Alaska. E. W. Nelson said that the Unalit had a shaman (about 1880) who was aided by a dog "with whom he could talk, the dog being a *tunghak* [spirit being] which had taken that form" (1899:429).

The Chugach had a secret society, members of which were called *aqdlat,* i.e., Winds. To avoid being tormented by the members, people would crouch down, "holding up their thumbs like dog ears, for the aqdlat never bothered real dogs nor people acting like dogs" (Birket-Smith 1959:144).

The Moon Man in most of southern and northern Alaska (but not on Nunivak Island) was a controller of hunting and game animals. At Point Hope he was called Alignuk (Rainey 1947:274). Nelson illustrates a large mask (2 feet high and 13 inches wide, probably from the lower Kuskokwim) of "the *tunghâk* or being that controls the supply of game. It is usually represented as living in the moon. The shamans commonly make a pretense of going to him with offerings in order to bring game into their district when the hunters have been unsuccessful for some time." The mask has a huge, open mouth, a bulbous nose, a broad band of black across the eyes, and several painted and carved figures attached to various parts of the mask (see Pl. 58). The features of this mask resemble those usually associated with the large nose discussed on pages 78–81.

Nelson was able to record a great deal of information about the shamans' involvement with the moon in the area between Norton Sound and the Kuskokwim while the beliefs were still alive and a vital part of Eskimo life. The shamans relied on the man in the moon for a number of purposes. He not only controlled the food supply, but also caused epidemics of sickness. Everywhere in that area the shamans had special ways of visiting the moon to change conditions brought about by the Moon Man (1899:430–31).

PLATE 2

Lowie Museum 2–4574. Height: 12¹/₂ inches. Collected by Alaska Commercial Company, no date, no provenience. The features and style are related to Nushagak masks. The nose and eyes are similar in shape to many in the Sheldon Jackson Museum collected from both the Nushagak and Kuskokwim rivers.

This mask and those in Plates I and II (LM 2–4584 and LM 2–5852) appear to have been painted from the same paint pot. The background color of the mask is white. The arch over the face and the wide band of color around the left eye are black. The right eye is circled with red. Between the eyes and the black arch is a projecting white wooden visor. The hands, paddle, and lips are red. The teeth are cut out of the mask and painted white. Carefully trimmed baleen strips fasten the appendages to the mask. Each baleen strip is placed between two halves of a split stick that is bound with split root.

This mask and that in Plate II are massive and, though heavy, were made to be worn directly on the face since there are no provisions for it to be hung from the ceiling. The mask was held to the face by the dual supports of a small grip for the mouth and thongs to be placed around the head opposite the eyes. The wearer looked out through the mouth.

PLATE 3

Lowie Museum 2–5851. Height: $9^{1}/_{2}$ inches. Collected by Alaska Commercial Company, no date, no provenience. The style is similar to that of a number of masks collected by Sheldon Jackson in the 1890's from Andreafsky (St. Mary's), Big Lake, Paimiut, and Pastolik, all on the lower Yukon River.

This mask and the mask in Plate III (LM 2–5854) were painted with the same paint and were undoubtedly made by the same person. The main portion of the mask is white, as is the fish attachment on top. The paint on the fish is a thin wash. The lips, hand attachments, and bottom portion of the paddlelike appendages are reddish-brown. The white wooden teeth are inserted into the mouth by a stem. The nostril is unpainted. The area that sweeps around the eye to the left side of the mask is painted gray-green. The bottom appendages are attached with baleen bound with split root; the fish is attached with plain baleen; and the paddle is attached with root. A groove was made around the thin edge of the mask, probably for the insertion of a caribou fur halo, common on Yukon River masks. Holes for attachment of a thong were even with the eye; thus, the wearer looked through the nostril. An object had been stuck into the hole in the middle of the eye.

I was unable to obtain an explanation for this mask and the one in Plate III, but all informants agreed that they were shaman's

masks. One man said, "The *angutkuk* was not supposed to tell what is meant." Another said they were used for "a medicine man's dance."

The style of features—a long mouth covering a large portion of the face from chin to forehead in conjunction with only one eye or two strangely shaped eyes—was common on the lower Yukon. A mask in the United States National Museum from Big Lake (No. 38646), sketched by Dall in *Masks, Labrets, and Certain Aboriginal Customs* (Pl. 27), was either the prototype for these masks or made simultaneously in the same village. A mask in the University Museum (Philadelphia) from the Hooper Bay region (NA 10348) has a wide pegged mouth sweeping to the left. It has a large oval nostril in the middle of the face, and an eye almost directly above it. The area around the eye is spotted. A stick protrudes from the forehead, and goose feathers are stuck directly into the mask. (This mask has mistakenly been called a moon mask—illustrated and discussed in Wardle 1937. Moon masks from that area were round human faces on background boards.)

The combination of long curving mouth and unusually shaped eyes is also seen in mask LM 2–6442 (Pl. XI).

PLATE 4

Lowie Museum 2–1305. Height: 12½ inches. Collected by C. L. Hall, no date. "Lower Yukon or Northwest Behring Sea."

The coloring is the same as that in Plate IV (LM 2–1303). The spots on the cheeks and the outside border are red. The mask was used, said one informant, for dancing because it did not have a background board behind the face as did that of Plate IV.

PLATE 5

Lowie Museum 2–1304. Height: 14¼ inches. Collected by C. L. Hall, no date. "Lower Yukon or Northwest Behring Sea."

The background board and most of the face below the eyebrows are washed with white. The bands around the face and the board, and the lip and pegged-in teeth are red. The forehead is blue-black. Root is used to lash together the two pieces of wood that make up the mask, possibly because one piece large enough could not be found. This two-part construction, however, is found on many similar masks and may have had a symbolic meaning.

The feathers are drawn through holes and self tied. Each feather is carefully held in place by an individual loop of a long sinew that extends around the mask.

On the reverse side, the eyes, nose, and mouth are rimmed with red. Diagonal red lines are painted downward from the nose, and with a V shape on the forehead.

A St. Michael man said that he had seen a mask like this used at Stebbins. He said that the name of the song for this mask was *auso-taxho,* "don't break something," which was sung to a slow dance. When the dance director commanded that this mask be taken off, a mask like that in Plate 28 (LM 2–18142), a half mask with the lower jaw gone, was put on and another dance took place. The name of the song, however, does not necessarily reveal what kind of spirit is represented in the mask. My informant did not know the spirit of this mask.

The face of this mask is almost identical with two from Andreafsky on the Yukon, collected by Sheldon Jackson in 1893 (SJM II.B.22 and II.B.42). Eyes, nose, and mouth are similarly shaped. Though the face is divided into three definite color planes, the forehead and background board and trim are the same colors as on this mask. The lower color plane of these two (from mouth to chin) is red. Real teeth, probably a dog's, are used in II.B.22. Several carved animals—whale (uncolored), walrus (red face), birds (blue)—are placed on either side of the face of mask II.B.42. Below them, on either side of the chin, are two long, red, humanlike arms. The background boards are shaped differently, but both have feathers placed in exactly the same position.

Many similar background boards were collected from St. Michael and the lower Yukon toward the end of the nineteenth century. In 1881–83, J. A. Jacobsen collected a number depicting the spirits of the caribou (or moose), the seal, the walrus, and the sun (Disselhoff 1935: Pls. 1, 3, 4, 5, 6, and 7).

D. S. Neuman of Nome presented several masks of this kind to the Alaska Historical Museum, and H. M. W. Edmonds illustrates several similar to this in his manuscript, but apparently only one found its way into the Lowie Museum (Pl. 6: LM 2–6624).

Similar ones are in the University Museum (NA 3268 and NA 4260). These are also made of two pieces of wood and ornamented on the top with feathers. The first mask has a downturned mouth and no

teeth. Two holes are bored through the mask on both sides of the face. It is called "Moon Mask" and was collected by P. H. Ray and purchased by G. B. Gordon without provenience in 1915.

The second mask, NA 4260, also without provenience, is called "The Man in the Moon." A wide smiling mouth has pegged-in wooden teeth. Four large holes are cut through the background board opposite the chin and forehead.

J. Chapman illustrates an Anvik Indian mask, the Silver Salmon Spirit, placed on a background board such as this. Small figures of silver salmon were suspended through five holes in the board. The mask was also made of two pieces of wood and was surrounded by a hoop and decorated with feathers (1907:23–24).

The symbolic meaning of these two-part background boards, if any, is unknown, although the board represented, variously, the universe, the sea, and the land. Some meaning might also have been attached to the carving of the face and board from the same piece of wood.

PLATE 6

Lowie Museum 2–6624. Height: 11¼ inches. Collected by H. M. W. Edmonds between 1890 and 1899. St. Michael.

This mask is made of very lightweight wood. The background board is now tan, as is the middle part of the face, but both might have been white at one time. A red border is painted only on the top half of the board. The upper and lower portions of the face are painted blue-black. The black animals, apparently a beaver on the left and a weasel on the right, are fastened to the mask with wooden pegs. The nostrils of the human nose are cut through, and the beveled teeth, sloping to the lips, are pegged in. Feathers are placed only on the red border. The roots of the feathers are inserted through the holes and self-tied. They are meticulously fastened into place with a long piece of sinew that winds from feather to feather.

This mask, similar to others mentioned in the discussion of the one in Plate 5 (LM 2–1304), had a generalized name, *wowatumkungia*, "chorus of song," but I could not learn what spirit the face represented.

An informant from St. Michael said that, when large masks such as these were worn, only one song without motions was sung. The mask

was taken off at the direction of the dance director, who ordered it re-placed by a smaller mask for vigorous dancing. The motions used in the second dance had been mentioned in the song that was sung while the big mask was worn. (This is similar to the performance recorded by Rainey at Point Hope—see pp. 41–42.)

PLATE 7

Lowie Museum 2–1306. Height: 6 inches. Collected by C. L. Hall, no date. From "Lower Yukon or Northwest Behring Sea."

This small, delicate mask is extremely lightweight. The wood is unpainted for the most part. The border and chin are red, and the hair and mustache are black. The many crowded feathers placed through holes at the edge of the mask give the appearance of airiness and motion, and indeed one of my informants said that the song for this mask was *ya' kaghokkuma*, "You're going to fly."

The feathers are self tied. The wearer looks through the eyes of the mask, which is held to the head by a thong attached to slits on the background board opposite the eyes. The mask is so small that the bottom of the mask (the bottom of the chin) rests on the performer's nose.

My informant, who had seen a mask like this when he was seventeen years old, unfortunately knew only the mask's name.

PLATE 8

Lowie Museum 2–4604. Height: 7³/₄ inches. Collected by the Alaska Commercial Company, probably about 1880. Provenience unknown.

This mask is almost completely flat in back, a contrast to the majority, which are scooped out. The middle part of the face is whitish, but the chin, lower lip, and border of the mask are pale reddish-brown. The forehead and nose are black, as are two lines that radiate from the eyes and the bottom of the nose to the edge of the mask. This doubtless came from the same place as LM 2–1304 and LM 2–6624 (Pls. 5 and 6).

On the reverse side, as in Plate 5, the eyes and mouth are rimmed with red.

Benjamin Atchak of St. Michael said that the dance for this mask was about a man who owned eight ravens, which he used as messengers.

He would send the raven to a person's house and take off his raven's head to show the face on this mask. The raven with the human face summoned the person to go with him to see the shaman who owned the mask. He could not refuse to go.

PLATE 9

Lowie Museum 2–5857. Width: 7¹/₄ inches. Collected by Alaska Commercial Company, probably about 1880. Provenience unknown.

This probably came from the lower Yukon–St. Michael area. One of my informants thought that it had come from Pastolik or Stebbins.

The carving is similar to LM 2–4604 (Pl. 8), but I could learn nothing about it. The mask is badly faded, and all the feathers have fallen off. It originally had a red border and a plain wood-colored face with blue-black hair and nose.

PLATE 10

Lowie Museum 2–6918. Height: 6¹/₈ inches. Collected by H. M. W. Edmonds between 1890 and 1899. St. Michael.

The oval eye is black. Feathers are inserted directly into the wood.

PLATE 11

Top: Lowie Museum 2–6478. Height: 5¹⁄₁₆ inches. Collected by R. Neumann, Alaska Commercial Company, about 1890. Pastolik. The catalogue also reads, "Mask representing people seen only by shaman."

The mask is white with a red band around the head. Eight goose feathers are stuck directly into the top border. This mask and the ivory object below were probably used in the same dance, the larger one worn on a man's face, and the smaller one held in the hand of a woman. The knife marks of this mask are similar to those in Plates VI, X, 18, and 22, as well as the figure below.

A similar mask collected by Henry Neumann in 1890 is now in the Sheldon Jackson Museum. It is 8 inches high. Seven white feathers are inserted into the top of the head, and four brown dots are painted on the reverse, left side of each feather (II.G.4).

Bottom: Lowie Museum 2–6466. Height: 1⁷/₈ inches. Collected by R. Neumann, Alaska Commercial Company, no date. Pastolik.

This delicate little ivory object (a "finger mask") was probably

intended to accompany the wooden mask above. Large face masks were never made of ivory, which was apparently not a popular material for any part of a mask. Even labrets, which in real life were usually made of ivory, were often represented by wooden counterparts on a mask.

The crowded feathers are like those in Plate 7, which probably came from another village.

PLATE 12

Lowie Museum 2–6913. Height: 8 inches. H. M. W. Edmonds, between 1890 and 1899. St. Michael.

The colors of the mask have faded, but at one time the main portion was white, liberally splattered with red. The upper and lower "mouths" are lined with red, as is the eye. The nose is only partially carved. A small mouth between the bottom one and the nose is also lined with red. The edge of the mask is painted bluish-black. The mask was apparently not worn on only half the face, but centered in the middle, since it is so constructed that both eyes of the wearer look out of the one eye. Red paint is applied around all of the openings on the reverse side.

This mask was obtained by Edmonds from what was probably a Bladder Festival, and it doubtless represents the mythical half-man. The half-man, like the half-man half-animal, is found in Eskimo territory all the way from Point Barrow to Chugach country. Half-man masks (split vertically) have been collected from the lower Kuskokwim, lower Yukon, and from the Anvik Indians, but none north of Norton Sound. This probably is an oversight since one of my Shishmaref informants said that he had seen a mask similar to this in an old igloo near Kividluk, a nineteenth-century village between Shishmaref and Cape Espenberg.

The use of pegs as teeth, and for symbolic or ornamental purposes as in this mask, was widespread north of Norton Sound. A mask supposedly from the western Canadian Arctic, now in the Hudson's Bay Company Museum, has a large smiling mouth with twenty-six acutely angled interlocking wooden pegs as teeth. The mask was unpainted and came from a shaman's grave (Fejes 1957:57). King Islanders made lavish use of pegs on masks, particularly for fierce-looking mouths (see Pl. 47).

The interlocking wooden peg motif was not used exclusively on masks. An unusual animal figure with a peg-filled mouth that extended from the tip of the muzzle to the ear was obtained by Nordenskiöld

from a Port Clarence grave in 1879. On top of the head was a man's face with a downturned mouth also filled with interlocking peg teeth. Behind the head of the face, and thus looking like a collar for the neck of the animal, was another row of interlocking pegs (Nordenskiöld 1882:580). This animal is similar to the "kikituk" reported by Rainey from Point Hope. A powerful shaman reportedly gave birth to one of these figures, which had the power to kill the tutelaries of rival shamans. The Port Clarence figure was less than one half the size of the one from Point Hope, which was 2 feet long. The Point Hope figure had ivory, instead of wooden, teeth (Rainey 1947:277–78; 1959:13).

Pegs were also used in the arms and legs of carved animals and human beings in masks from the lower Yukon and Kuskokwim rivers. Nelson said that these pegs indicated "that the being represented was supposed to be provided with mouths all along these portions of its figure" (1899:406). They may also have been purely decorative.

PLATE 13

Lowie Museum 2–6921. Height: 8 inches. Obtained by H. M. W. Edmonds between 1890 and 1899. St. Michael. A wolverine.

The cheeks at one time were painted with a thin white wash, but now they look unpainted. The forehead and nose are bluish-black. Nostrils and teeth are incised into the wood. When seen in a horizontal position, the mask looks like the wolf mask in Plate 14. It is worn as photographed, that is, lengthwise on the face, and held to the head with thong binding. Tufts of ptarmigan (?) feathers are tied to split quills.

This mask is similar to another called the "red fox mask," but the difference lies in the shape of the muzzle and eyes, and in the coloring: the red fox mask has a sharper muzzle and oval eyes, and the head is usually painted red. Edmonds also illustrated a fox mask from St. Michael in his manuscript, but this is not in the Lowie collection. Hawkes illustrates two red fox masks that were used in the Inviting-In Feast in 1912 at St.Michael (1913b: Pl. 7).

These graceful, simple masks (wolf, fox, wolverine) apparently were made only in the area between Unalakleet and Pastolik, although all three animals were made everywhere as masks. This trio was often grouped together in stories about the Messenger Feast (for example, see Rasmussen 1932:40). In 1955 an informant told me the story of the origin

of the Red Fox Dance, which was performed in the Messenger Feast from Seward Peninsula to the northern mouth of the Yukon.

PLATE 14

Lowie Museum 2–6917. Height: 8 inches. Obtained by H. M. W. Edmonds between 1890 and 1899. St. Michael. Wolf mask.

The mask is unpainted except for the forehead and nose, which are red with blue-black spots. The nostrils and mouth are red. Six goose feathers once decorated the top of its head (photograph in Edmonds' manuscript). The mask was worn vertically on the face, and the wearer looked through the eyes. The photograph here shows the nostrils and teeth, which are similar to those of the wolverine mask, Plate 13.

A duplicate of this mask was obtained by Henry Neumann at St. Michael in 1890 (SJM II.G.12). A larger one (II.G.2), also obtained at St. Michael by Neumann, is equipped with a movable jaw, inset peg teeth, and a bladder tongue that hangs from the side of its mouth.

A mask similar to LM 2–6917 is illustrated by Dockstader (Pl. 77). Called a seal mask, it is said to have been collected on the Kuskokwim by J. H. Turner in 1885. Nevertheless, one of my St. Michael informants said that without doubt it was a wolf mask like those he had worn many times in dances.

Wolf masks are common everywhere, ranging from a complex one at Point Hope as described by Rasmussen (thought it may be from Nunivak Island) to real wolf heads used at Bering Strait. Rasmussen says of the wooden wolf mask:

Belongs to a shaman who by wearing it acquired the powers and abilities of a wolf—quickness, scent, and the . . . arts of the wolf, skill at attacking animals.

The base of the mask: asks for the ability of the wolf to catch game.

A song, learned of the wolf's *inua*, is sung outside on top of qagsse [*kazgi*].

The shaman does not get the power from the animal, but from a mysterious "power" in the air; at the same time as it is near to them, it is so infinitely remote that it cannot be described. It is a power in the air, in the land, in the sea, far away and around them.

Only a shaman knows about this power; he is the medium. He works on the mind and thoughts as much as he can.

The shaman cannot force the power to come to him; it comes in the air, and he must place complete reliance in the power. It is called *tunraq*. All *torn-*

qat originate from it, it is one and many at the same time, mystic, unfathomable.

In its mouth the mask has an *apagssuk*: sea-horse. The shaman wishes, prays, that people shall be able to "catch" with the same facility as this wolf has the sea-horse in its mouth.

Between the ears is the tail.

The edge of the mask is the universe. "The whole power of the universe —sky, earth." It sticks its head through the universe, looking at mankind.

This mask is a social mask for the whole community and is used for all kinds of game, but only one kind at a time, which must be specified, e.g. walrus, salmon, etc.

It is used at the December full moon to pray for the coming year. December is the end of the old year.

When the song is sung, which begins: "They . . . on the power of the universe," it is followed repeatedly by the refrain *sla-nguamâ*: "all of our universe"

> "and all that we desire
> a good season
> is in the thoughts of all."

Then mention is made of the skill of the wolf, and they ask the Power to give them this skill, etc. [1952:133–34].

The wolf and the eagle received the greatest homage in the Messenger Feast. The wolf dance from the Igloo area on Seward Peninsula has been recorded by several persons including Kakaruk and Oquilluk (1964), E. Neuman (1914), K. Rasmussen (1932), and D. Ray (field notes).

Rasmussen's informant, Arnasungak, told him the story of the "Eagle Myth about Flying Swallows and a Wolf Dance in a Clay Bank," but not about the dance itself. Marten, the animal, who had killed the original Giant Eagle, was the first man to prepare the Messenger Feast. After Marten had visited the Eagle's mother, who had taught him the secrets of the ceremonies, he lay down near a clay bank. While there he saw beautiful swallows flitting about, but they soon changed into wolves. It was this experience, among many others, that he commemorated in a festival. Arnasungak related:

Marten got over the difficulty of the sloping banks easily enough: he made these of broad boards joined together, in which holes were bored, just like the swallows' holes in the clay slopes. The swallows he represented by dressing the dancers in feather cloaks shaped like swallows with long cleft tails. During the singing they were to dance back and forth till the moment came when they flitted away and turned into wolves. And this Marten arranged by hiding masks of wolves behind the artificial banks, which the dancers could quickly put on when they came in as swallows. The transformation was to take place

so quickly that they came out again almost instantly and continued the dance as wolves. This has since become a famous masquerade which is still danced under the name of the wolf dance [Rasmussen 1932:28].

In 1955, almost thirty years later, I obtained a description of the wolf dance from a Wales man who had attended the last festival in 1914 at Mary's Igloo. In summary: four men danced a long time with long gloves (representing birds) in front of the board with the holes, and at a signal from the box drummer all of the people in the room howled, and suddenly the men dove feet first into their holes. As each went through his hole there was quiet singing and drumming. Sometimes the men went through the holes as slick as squirrels, but sometimes their hips stuck because the hole was only as wide as the distance from the dancer's hand to his elbow, and if he should stick in the hole, the man sitting on the deerskins kicked it with his heels to crack the board so that the dancers could get through. It was said that a man who got stuck in a hole would be unlucky. Once in a while a man would have spots of paint or stripes on his face, but sweat often washed them off because of the heat behind the boards.

Deerskins were draped over the holes after the dancers disappeared through them. Behind the boards the dancers put real wolf heads on their foreheads, and short sealskin gloves with claws on their hands. The dancers then slowly began scraping their heads on the inside of the hole and thrusting out their paws to pat the board around the hole. They pawed very sleepily at first, but got more lively as they worked their way head first out of the holes. Singers sang six numbers while the dancers slowly pawed their way out of the holes, but during the seventh, and final, song, they jumped completely through. They were energetic and ferocious after they had emerged, and danced vigorously after first standing rigidly at attention in front of the holes.

PLATE 15

Lowie Museum 2–6625. Height: 6³/₄ inches. Collected by Alaska Commercial Company, no date, but probably between 1880 and 1890. Provenience unknown.

The principal part of the face is painted a light green, with a red border around the top half. The broad area between the upper lip and nose is white. The mouth is lined with red and is splashed with brownish streaks.

I have been unable to ascertain the meaning of this mask; my informants would venture no comments. In style of carving and the nose shape it resembles masks of the lower Yukon. The manner of attaching split quills was common in the area between St. Michael and Pastolik.

The splashing of paint or blood around the mouth is found on many masks from the lower Yukon around the old Russian trading post, Andreafsky (St. Mary's), examples of which are found in the Sheldon Jackson Museum. Several are illustrated by Nelson and Disselhoff. One of Nelson's is from old Sabotnisky (in the Marshall area), and the other from the lower Kuskokwim (see Pls. 61, 63). The mask collected by Jacobsen is conceptually similar to LM 2–5851 (Pl. 3), but is smaller. Jacobsen called it the "man eating spirit of the mountain" (Disselhoff 1935: Fig. 9).

The grandfather of one of my oldest informants, from the Kauwerak area of Seward Peninsula, told him that a medicine man's drum and mask were placed near his grave. The mask, tied top and bottom to a lightweight stick, was sometimes splashed with alder bark dye to simulate blood running from the mouth. The mask had the power to drive evil spirits from the grave, but my informant did not know the significance of the blood.

Reference has already been made to the divining of caribou hunting sucess from running blood on a masklike image in the same area (pp. 21–22). The amount of blood determined the degree of success.

PLATE 16

Lowie Museum 2–6916. Height: 6³/₈ inches. Collected by H. M. W. Edmonds between 1890 and 1899. An owl, probably from St. Michael.

The cheeks of the owl are white, and the remainder is black with red dots. The small black nose, or beak, has a red line on each side to represent the mouth.

The owl mask was used during the dance described on page 39.

PLATE 17

Lowie Museum 2–5848. Height 6¹/₄ inches. Collected by Alaska Commercial Company, probably between 1880 and 1890. Provenience unknown.

The original color, gray-green with a red border, is badly faded. The mask is broken. Originally, a beak fitted into the square opening at

the base of the slightly raised nose. Though faded and broken, it is still recognizable as an Eskimo mask and a fine piece of craftsmanship. The mouth indicates the spirit of the mask.

Nelson illustrates a complete mask similar to this from Sabotnisky on the lower Yukon (see Pl. 56, No. 1) which he identifies as the *"inua of the short-ear owl"* (1899:397). That mask, 5¾ inches high, has a horizontally oblong right eye and a round left eye. The sides of the face and forehead are green; the cheeks are white spotted with red. The bottom part of the face is painted black. The top is decorated with three quill feathers tipped with downy plumes. The owl's beak is fastened to the mask with a square peg.

A mask similar to Nelson's was collected at Andreafsky (St. Mary's) by Sheldon Jackson in 1893 (SJM II.B.27). It is 8 inches high, and the color scheme is essentially the same as in Nelson's mask, but the beak is different.

PLATE 18

Lowie Museum 2–4599. Height: 8³⁄₁₆ inches. Collected by Alaska Commercial Company, probably between 1880 and 1890. Provenience unknown.

This mask is unpainted with a badly faded red border. It apparently represents a bird similar to that in Plate 17 (LM 2–5848), but is larger and heavier. The mask is enhanced by heavy tool marks, which give a visual effect of weight. The knife marks are similar to those in Plates VI, 11, X, and 22 from Pastolik and St. Michael. None of my informants had seen a mask like this or the one in Plate 17.

The mask resembles one bought by Jackson in Andreafsky (St. Mary's) in 1893, but the latter has a handle and feathers on top (SJM II.B.43). The mouth is similar, but the eyes are more oval.

PLATE 19

Lowie Museum 2–4582. Height 7½ inches. Collected by Alaska Commercial Company, probably about 1880. Provenience unknown. Raven or crow mask.

The original black paint has almost disappeared from the mask. The cheeks and the area around the eyes had never been painted. The mask was not equipped to hold feathers or other objects, but the rim may have accommodated a circlet of reindeer hair or fox skin.

This mask of a raven (or crow, as the Eskimos call it now) is so

similar to those now being made by King Islanders that a superficial ex-
amination would attribute it to them. The King Islanders, themselves,
identified it as their own: "an old, old crow mask." However, the treat-
ment of the eye and the sweep and gape of the beak are decidedly dif-
ferent from contemporary King Island carving. Its carving style and
graceful air suggest that it was made by a St. Michael or Yukon carver.
This plain crow mask could easily have been made by King Island, St.
Michael, or Yukon people at any time since the early nineteenth century.

A King Island man told me that the dance for this mask, always
worn by a man, was called *tikmiagarok*. The raven or crow song goes like
this: "You, man on the ground, I see you from above, that is why I
fly over." On King Island this dance is secular, like the masked walrus
dance. The wearer of the mask attempts to imitate the crow; the wearer
of the walrus mask tries to imitate the "walrus dancers" in the middle
of the herd seen by hunters on the ice.

The only carver of King Island masks today makes several each
year for the crow dance, which is performed for tourists. The masks are
later sold.

Variations of the crow mask are made everywhere in Alaska
reflecting the universality of the raven myths. The raven was not con-
sidered to be either a trickster or a venerated mythological being. In
many dances he was an object of jest, and a dancer was free to elaborate
in that vein. Thus, some of the crow masks were garishly decorated.
Hawkes illustrates such a crow mask used in the 1912 St. Michael festiv-
ities. It is ornamented with hair, feathers, earrings, and labrets, and has
a speckled forehead. The song that accompanied this gaudy crow was
"The Crow song, I drum it. The Crow, he wishes to take a wife."

Another variation of a crow song and dance, reported by Zago-
skin, has been described on pages 4–6.

PLATE 20

Lowie Museum 2–6473. Height: 10^1/$_2$ inches. Collected by Neu-
mann, Alaska Commercial Company, no date, but presumably about
1880. Pastolik. "A mask representing a loon."

The bird is blue-black with white spots, neck, and band on the
neck. The feet and one remaining wing are black, and the wing has
white dots. The human face is red with a white line across the eye. The
bird's head has carefully carved eyes, nostrils, and mouth, all painted
red. The two feet and the wing are attached to springy quills, which set

them in motion at the slightest touch. A black dot is painted on each quill holding the appendages. The split quill with feathers is pegged into the mask. The wearer looked out through the eyes of the mask, which was bound to the head with seal thong.

This kind of mask, with the spirit of the bird carved into its back, was made over a wide area, but the varieties of birds, and the treatments of the face, bird, and composite whole were endless. This style is represented in almost every collection of Eskimo masks, but no two are alike. A sea bird was the principal animal carved; others were the salmon, the seal, and various birds. Although these masks have been collected everywhere on the coast from Goodnews Bay to St. Michael, the Hooper Bay area apparently produced the largest number and variety. Plate 42 (WSM 4539) from Goodnews Bay is a variation of this mask. To my knowledge, this style of bird with a human face on its back was not made north of St. Michael.

Wooden trinket boxes and snuffboxes shaped like a seal lying on its back often had a lid in the form of a spirit face. The Anvik Indians copied the bird mask with face from the Eskimos (J. Chapman 1907:20, 26).

PLATE 21

Lowie Museum 2–6919. Height: $8^{15}/_{16}$ inches. Collected by H. M. W. Edmonds between 1890 and 1899. St. Michael.

Several of my informants identified this as a seal mask.

The box part originally had a white wash with bluish dots. The seal is painted blue-black. Its spirit is the box at the top. The noselike object at the base of the box is a tiny head, which is pegged in. It has gouged-out eyes and a reddish mouth. The face of the seal has well-carved ears, eyes, and mouth, all of which are painted red. Split quills are stuck directly into the wood and reinforced with a peg.

A duplicate of this mask, with the same height and coloring, was collected by Henry Neumann at St. Michael in 1890 (SJM II.G.5a). The Sheldon Jackson mask is slightly wider, has a row of reindeer fur on the top (as this one probably had at one time), and has lost its tiny nose-face.

PLATE 22

Lowie Museum 2–5849, Height: $7^1/_4$ inches. Collected by Alaska Commercial Company. Provenience unstated. Catalogue: "A slightly decorated dance mask."

The mask appears to be natural wood, blackened by smoke. The knife marks suggest that this, and those in Plates VI, 11, X, and 18, were made by the same person. Feathers were probably inserted into the small holes on the top.

One of my informants said that this mask came from Pastolik. The mouth and peg stylization are similar to those in masks from Andreafsky (St. Mary's) in the Sheldon Jackson Museum.

This is illustrated in Blaker 1965: Pl. 12A.

PLATE 23

Lowie Museum 2–5855. Height: 8³/₈ inches. Collected by Alaska Commercial Company. Provenience unstated.

The top half of the face is white, and the bottom half gray-green. A thin edging of red was applied around the lips, nostrils, and eyes. The wooden labrets are white, and the hoops, natural. The labrets are plugged through the chin, and the pupils of the eye are cut out of the mask.

This mask is unusually small and lightweight for its kind. Many of the hooped masks are large and heavy; this seems a toy in comparison.

One informant thought that this mask came from Stebbins or Pastolik; another thought it was from Hooper Bay; but it could also have come from the lower Yukon or the Kuskokwim.

PLATE 24

Lowie Museum 2–6476 Height: 15¹/₄ inches. Collected by R. Neumann, Alaska Commercial Company. St. Michael.

The body of the man with its superimposed face and the separate head at the top are colored brown. The faces have black "spectacles," a black upper lip, and a red lower lip. Legs are white with black stripes and red socks. The border around the face is red, and a thinner black line circles the body.

Although this mask was obtained in St. Michael, similar ones were made on the coast between the Yukon and the Kuskokwim, and on the lower stretches of the rivers. The face is similar to many from Hooper Bay. Nelson illustrates a man mask with a spirit face (1899: Pl. 100). That mask, however, was provided with doors, which could cover the face to represent the whole body of a man. The covering of the spirit face in Eskimo masks by doors or by a beak has been mentioned often, but is actually rare.

PLATES 25, 26, and 27

PLATE 25. Lowie Museum 2–6474. Height: 7 inches. Collected by Alaska Commercial Company between 1880 and 1900. No provenience: "Eskimo."

PLATE 26. Lowie Museum 2–6475. Height: 7¹/₂ inches. Collected by Alaska Commercial Company. No provenience.

PLATE 27. Lowie Museum 2–6477. Height: 7¹/₂ inches. Collected by Alaska Commercial Company. No provenience.

All three masks have a reddish face with black eyebrows, mustache and goatee, and hairline. Red lines the eyes, nostrils, and mouth. All have hair of wolfskin, and apparently all had the feather combination popular in the St. Michael-Pastolik area: three split quill feathers topped with daintier plumes. Plate 27 has a movable jaw.

These unusual masks might have come from the Anvik Indian area, but from inquiry among Unalakleet and St. Michael Eskimos, and of a man born in Andreafsky on the Yukon, I received the unanimous consensus that these were, indeed, Eskimo masks. Some said they thought the masks had been made in the Andreafsky area, but one said, without doubt, that they were from St. Michael. Another said, "No Indian could make anything that good," a reflection of the old enmity that sometimes existed between the groups. The well-defined forehead wrinkles are unusual in either Eskimo or Yukon Indian masks.

A plain human mask obtained by Nelson from old Razbinsky (Marshall area) about 1880 could easily have been the prototype for these, especially Plate 27. It wears a caribou or fur ruff and has real ivory teeth (USNM 38,856).

Two Anvik Indian masks, the Old Man and the Dreamers, are somewhat similar to these (J. Chapman 1907:31). Chapman collected the Anvik masks about twenty-five years after those illustrated in Plates 25–27.

PLATE 28

Lowie Museum 2–18142. Height: 7¹/₂ inches. Collector, date, and provenience unknown.

This well-molded mask is of natural wood, with a red border, a reddish eyebrow ridge, and black "spectacles." Traces of white color remain on the face. A peg in the middle lip and thong ends on the mouth are indications of fastenings, and the mask undoubtedly once had a mov-

able jaw. A strip of rawhide (similar to that of LM 2–5855, Pl. 23) was placed around the edge of the mask, and pegs and an engraved rim indicate that feathers and reindeer hair formerly served as decoration.

Although this mask appears to be similar to those in Plates 25, 26, and 27, the catalogue number indicates that it was collected later. It was definitely recognized by at least six persons as having come from St. Michael or Stebbins.

A number of half-masks without chins were made in northern Alaska, particularly on King Island and at Point Hope. The old northern ones, however, usualy had a smoother finish than this. A King Island man told me that his people had masks exactly like this example long ago, but I have yet to see a King Island mask with this nose shape.

A St. Michael man told me that he had seen a similar mask used in a dance. (The one that he saw, however, was a half-mask made without a jaw.) The mask was put on following a dance that used one like that in Plate 5. Edmonds also saw one like this in a dance at St. Michael.

PLATE 29

Lowie Museum 2–6479. Height: 9 inches. Collected by R. Neumann, Alaska Commercial Company, probably between 1880 and 1890. St. Michael.

The face was once painted white with black eyebrows. This plain mask greatly resembles those used by the Malemiut Eskimos in their dances after they moved permanently to Unalit territory in the 1800's. The soft style of features, the flatness of nose, the eyebrow treatment, and the total indefinable character indicate that it was not made in the North. This is true, also, of the human mask from the lower Yukon (Pl. 45), which is almost a carbon copy of King Island masks.

The squinted eye suggests that this mask represents a spirit, and is not a portrait of a man.

PLATE 30

Lowie Museum 2–16645. Height: 8³/₄ inches. Collected by Wallace Barstow, no date, no provenience.

The mask is of natural wood with black painted above the lip and the eyebrows.

This undoubtedly is an old King Island product representing *yeyehuk*, the female version of the half-man half-animal (Pl. 44). It was identi-

fied as such by a King Island man, although it is also similar to certain Point Hope styles.

According to my informant, a woman shaman first saw this in a cumulus cloud. She then instructed a man to carve it. She wore it for the first time in a dance that simultaneously described and practiced her power. After she gave permission to have the mask copied by others, the dance was performed at any time of year. A King Island mask maker still carves a version of this. Nowadays it is red in color with black lips and eyes.

PLATE 31

Lowie Museum 2–16646. Height: 10⅝ inches. Collected by Wallace Barstow, no date, no provenience.

The upper and lower parts of the mask are blue-black; the middle part and the middle of the ears are unpainted.

This appears to be a modern mask from northern Alaska. One of my St. Michael informants said that it was a red fox, but another from Unalakleet said it was a wolf. The St. Michael man said that it had surely come from St. Michael, but another from Shishmaref said it had surely been made in Shishmaref.

A number of masks in the Sheldon Jackson Museum from Cape Prince of Wales and King Island have stylized ears in the same position. A mask with black forehead and ears almost identical to this was collected by Sheldon Jackson in 1891 at Cape Prince of Wales (SJM II.D.2).

PLATE 32

Lowie Museum 2–29415. Height: 7½ inches. Collected by Harold Heath, "pre-1925." Point Hope.

The wood is unpainted; the hair is black. The mask has been carved so that the wood grain emphasizes the relationship between the puckered mouth and the squinting eyes. This simple style of mask is made everywhere in the north—Point Barrow, Little Diomede Island, and Cape Prince of Wales. I was told that ones like this have been excavated by Eskimos at Shishmaref and at Singik, a nineteenth-century village north of Shishmaref.

PLATES 33–38 are of the so-called finger masks, which were made in human and animal face shapes and in various geometric designs. Some-

times they were copies of face masks and were worn during the same dance. They were used by women. In most cases they had elaborate trimmings of feathers and caribou hair, but many of the decorations have now fallen off. Finger masks were usually used in pairs, one in a hand. Occasionally circlets of fur or feathers, or upright wands, were used instead of the carved finger masks.

Finger masks seem to have been a local, specialized development in the area between the Yukon and Nushagak rivers. However, none was made on Nunivak Island (Lantis 1947:93). They were not found on Prince William Sound (Birket-Smith 1953:109) or south of the Nushagak River or north of Norton Sound.

In the plates, all objects are noted from left to right, and from top to bottom. The size of the upper left-hand object is given.

PLATE 33. Lowie Museum 2–4591. Height 3.5 inches (top to bottom of wooden part). Collected by Alaska Commercial Company, no date, no provenience. Colors: brownish, white, and black.

Lowie Museum 2–6445. Collector, date, and provenience unknown. Colors: brownish, white, and black.

Lowie Museum 2–2858. Collected by Charles L. Hall, no date. "Lower Yukon or Northwest Behring Sea." Colors: bluish forehead, white face, tan and red circles.

Lowie Museum 2–2857. Collected by Charles L. Hall, no date. "Lower Yukon or Northwest Behring Sea." Colors: bluish forehead, reddish face, brownish circles.

PLATE 34. Lowie Museum 2–6465. Height of wooden part: 4.5 inches. Collected by R. Neumann, Alaska Commercial Company, no date. Pastolik. "Worn by women." Colors: blue forehead, white face, gray chin, red and white background. This is similar to many face masks collected from the St. Mary's area on the Yukon.

Lowie Museum 2–6466. Collected by R. Neumann, Alaska Commercial Company, no date. Pastolik. Made of ivory, uncolored.

Lowie Museum 2–7195. Collected by Charles L. Hall, no date, no provenience. Colors: blue torso and forehead, reddish arms and hands and lower face. This human figurine may have been fastened to a larger mask.

Lowie Museum 2–6461. Collected by Alaska Commercial Company, no date, no provenience. Colors: white face, blue circle around face. Red dots are placed between the inner circle and the outer one, which is a faded red. Caribou hair encircles the wood.

Lowie Museum 2–6922. Collected by H. M. W. Edmonds, probably in 1891 at St. Michael. Colors: mostly natural wood color with blue on mouth and circle. This was held with a handle, instead of through one or two holes, as was usual.

Lowie Museum 2–6459. Collected by Alaska Commercial Company, no date, no provenience. Colors: bluish forehead and nose, faded red or natural elsewhere. Only one piece of caribou hair remains of the decorations.

PLATE 35. Lowie Museum 2–4602. Height of wooden part: 3.2 inches. Collected by Alaska Commercial Company, no date, no provenience. Colors: blue forehead, red chin, white and tan elsewhere.

Lowie Museum 2–2865 and 2–2866 (both in upper right-hand corner). Collected by Charles L. Hall, no date, "Lower Yukon or Northwest Behring Sea." Colors: (upper) red and blue dots on white; the interior piece and handhold are blue; red is painted around the main part; (lower) the same coloring except that the inside piece is red. These are similar to those illustrated by Nelson from Cape Romanof (see Pl. 66, No. 2).

Lowie Museum 2–6458. Collected by Alaska Commercial Company, no date, no provenience. Colors: bluish forehead, red chin, white inner circle, tan outer circle and handhold.

Lowie Museum 2–2859. Collected by Charles L. Hall, no date, "Lower Yukon or Northwest Behring Sea." Colors: red with a blue border.

Lowie Museum 2–4590. Collected by Alaska Commercial Company, no date, no provenience. Face of a wolf or seal? Colors: mainly reddish with blue forehead and nose.

Lowie Museum 2–6453. Collected by R. Neumann, Alaska Commercial Company, no date. Pastolik. Catalogue: "worn by girls." Colors: the right cheek, mouth area, and handhold are red; the nose and forehead are blue; the left cheek and border are white.

Lowie Museum 2–6456. Collected by Alaska Commercial Company, no date, no provenience. Colors: blue forehead and chin, white middle face, red handhold.

PLATE 36. Lowie Museum 2–6620. Height from end of box to tip of nose: 3.7 inches. Collected by H. M. W. Edmonds, St. Michael, probably in 1891. This object is a miniature of that in Plate 21, also from St. Michael. Colors: brownish and natural with a blue cast to the face end of the box.

Lowie Museum 2–6454. Collected by Alaska Commercial Company, no date, no provenience. Colors: white and faded reds.

Lowie Museum 2–2860 and 2–2861. Collected by Charles L. Hall, no date, "Lower Yukon or Northwest Behring Sea." Colors: both are badly faded, but at one time had white faces, blue foreheads, and red circles and handholds.

Lowie Museum 2–4594. Collected by Alaska Commercial Company, no date, no provenience. The circle part of this double finger mask is similar to one from Norton Sound illustrated by Nelson (see Pl. 65, No. 1). Colors: bluish, red, and white.

Lowie Museum 2–6472 and 2–6471. Collected by Alaska Commercial Company, no date, no provenience. These faces on the ends of wands probably were used in the same dance as the mask in Plate III. Color: mainly a white wash.

Lowie Museum 2–6463. Collected by Alaska Commercial Company, no date, no provenience. Colors: the animal face mostly bluish; white and red borders.

Lowie Museum 2–6455 and 2–6452. Collected by Alaska Commercial Company, no date, no provenience. Colors: bluish forehead and nose with white cheeks and red border.

Lowie Museum 2–6460. Collected by Alaska Commercial Company, no date, no provenience. Colors: blue forehead and nose with white cheeks and red border.

PLATE 37. Lowie Museum 2–4592. Height to bottom of fingerhold: 4 inches. Collected by Alaska Commercial Company, no date, no provenience. Colors: red and natural.

Lowie Museum 2–6447. Collector, date, and provenience unknown. Colors: red and natural.

Lowie Museum 2–6450. Collector, date, and provenience unknown. Colors: blue forehead, nose, and chin with a natural face. The handhold probably was once red.

Lowie Museum 2–4596. Collected by Alaska Commercial Company, no date, no provenience. Colors: natural wood color with red and blue dots.

Lowie Museum 2–2864. Collected by Charles L. Hall, no date, "Lower Yukon or Northwest Behring Sea." Colors: blue forehead, nose, and chin; natural face and handhold. Red circles the face.

PLATE 38. The top eight finger masks were collected by Charles

L. Hall, no date, "Lower Yukon or Northwest Behring Sea." The bottom three are poorly made objects, collected by H. M. W. Edmonds at St. Michael in 1891. Height of top left one, from top to bottom of fingerhold: 3.3 inches.

Lowie Museum 2–2862 and 2–2863. Colors: badly faded, but originally natural wood color with blues and reds.

Lowie Museum 2–6462. Colors: natural face, with blue on the border and around the face.

Lowie Museum 2–6457. Colors: badly faded, but originally with blue forehead, the rest natural.

Lowie Museum 2–6449. Colors: face and outer circle red, with blue inner circle and handhold.

Lowie Museum 2–6464. Colors: face red and blue, border blue, handhold red.

Lowie Museum 2–6451. Colors: natural with a blue forehead and nose.

Lowie Museum 2–6448. Colors: forehead blue to the top of the object; originally there was a reddish border and a whitish face and hand-hold.

Lowie Museum 2–6925. Colors: red, white, and natural.

Lowie Museum 2–6924. Colors: animal face red with a blue mouth; background white.

Lowie Museum 2–6923. Colors: red and white.

PLATE 39

Left: LM 2–6652A. Length 17⁵/₈ inches. *Right:* LM 2–6652B. Length 17³/₈ inches. Both collected by Alaska Commercial Company, no date, no provenience, but probably from Point Barrow.

The wood is natural color, and all figures are black except the man, which is red.

The Point Barrow Eskimos used these so-called "dancing gorgets" in whaling ceremony dances. Apparently they were worn on the chest when a certain kind of mask was worn, but according to Robert Spencer the gorget could be somehow attached to the mask (1959:294).

Murdoch collected three gorgets and illustrated two of them (1892:371). One of the gorgets was 18¹/₂ inches long, and the other 15¹/₂ inches; and both were similar in decoration to these. All had a man stand-ing on a whale, and all the boards had serrated edges. Murdoch said that

the man holding the whales was called Kikamigo, which he thought was the name of the supernatural being who controlled the whales.

Spencer reported that the gorgets were used in a dance at the close of the whaling season:

The first social event was a series of dances which involved the entire community. . . . The men in the crew put on clothes with the fur outside and donned dance masks and gorgets. The masks, made of wood, were small, just fitting over the face, and they were kept in the karigi except for this occasion [1959:348].

PLATE 40

Washington State Museum 693. Height: 17¹/₄ inches. Collected by James T. White, probably in 1894. "Arctic Alaska." This mask is without doubt from Prince William Sound.

The mask is a pinkish color with black. This nose form is seen on bear masks of the Kwakiutl and on spirit masks from Point Hope.

Photograph by Dorothy Jean Ray.

PLATE 41

Washington State Museum 4530. Height: 20³/₄ inches. Collected by Ellis Allen, 1912. Goodnews Bay.

The two birds on the sides are black. The upper head, the head of the straw man, all mouths, fingers of hands, and animal eyes are reddish. The seal's nose and ear tips are reddish.

Black is used around the human face, nostrils, and eyes; on the chin decoration; across the nose of the bird; and on the bottom stripes of the ears. The sticks are unpainted and are held on by string. The hoops of split driftwood are lashed on with root, but the major parts of the mask are nailed together.

The mask was held to the face by a mouth grip and a thong around the head inserted in holes in projecting pieces of wood inside the mask opposite the eyes. The wearer looked out through the spirit's eyes.

Photograph by Dorothy Jean Ray.

PLATE 42

Washington State Museum 4539. Width: 21¹/₂ inches. Collected by Ellis Allen, 1912. Goodnews Bay.

The stylized red winglike hands are nailed to the face with metal

nails. A stylized bird with a groove down its back is in the palm of each hand. The bird on the left is painted red with a blue gouge; the one on the right is blue with a red gouge. The main portion of the bird body is blue; the human face is white, lined with a red circle. The two finlike attachments opposite the mouth of the human face are blue, and the two three-fingered flippers above them are light yellow. The bird's tail is blue with a V-shaped gouge in red. It has a yellow beak and red eyes. The fish beneath its head is painted blue, white, and red. The outside circle of root is colored blue, and the inner one at the top is red. The appendages, including the fish, are lashed to the mask with root, but the various parts of the mask itself are nailed together.

This style of mask, i.e., a bird with a spirit face on its back and winglike hands flanking it, was popular from Goodnews Bay to Hooper Bay. One like this in the Alaska Historical Museum (II–A–144) was collected at Hooper Bay by Daniel S. Neuman about 1912. The color scheme is the same as on this example, but the mustache is big and bushy. The wing-hands hold a realistic seal and a fish, respectively, instead of stylized birds. Whole wooden fish are substituted for three-fingered flippers in the Juneau mask. The AHM specimen list reads: "Angakok's ceremonial mask 39 in. x 20 in. Used in seal and walrus dance." The AHM mask was repainted with commercial paints in 1954.

Photograph by Dorothy Jean Ray.

PLATE 43

Museum of the American Indian 9/3432. Height: 20 inches. Collected by Amos H. Twitchell, "before 1900," acquired by the museum in 1919. Kuskokwim River. Catalogue: The mask represents Walaunuk, which means "bubbles, as they rise up through the water."

The nose resembles that of Plate I (LM 2–4584). The forehead, upper part of the face, and bubbles are white. The hands are red with white spots, and the lower part of the face is blue with white spots. The wooden dangles are painted blue. All bindings are of root.

Nelson illustrates a lower Yukon wooden carving of a seal's head with similar wooden air bubbles rising from its mouth (1899: Fig. 141). The slender rod to which the five bubbles were attached at regular intervals was 9 inches long. The carving, called a "maskoid" by Nelson, also represented "bubbles rising on the surface of the water" (ibid.:415). It was 4¹/₂ inches wide and probably was attached to another mask or

worn on the forehead, although there are no holes for fastening. In 1842 Zagoskin said that, on the southern shore of Norton Sound, future success in hunting and fishing could be foretold by watching bubbles rise from sinking bladders (see p. 69).

This specimen illustrates the dangling pieces of wood often used on dancing masks for a percussion effect in dancing from the Kuskokwim to St. Michael. Sometimes the dangles were short or long hollow tubes, or solid pieces of wood, usually fastened to the mask with sinew.

Photograph courtesy of the Museum of the American Indian, Heye Foundation. Also illustrated in Dockstader 1960: Pl. 74.

PLATE 44

Washington State Museum 2–2128. Height of face: 12⅝ inches. Collected by Margaret Lantis in 1946. Nunivak Island. Catalogue information: for Messenger Feast; the left red half represents a man; the right blue half represents a fox.

The mask represents one of the most ubiquitous spirits of the Eskimo world, the half-man half-animal spirit called *excit* in the southern language and *yeyehuk* (when pertaining to a female shaman) in the northern language.

The teeth in the right, or blue, side of the mask are dog's teeth. The lashings are of root, and the quills of the feathers are stuck directly through the outer hoop, which represents the upper world. Two hands, six small wooden fish, two legs, and two cylindrical pieces of wood are inserted into this ring. The two hands and two legs belong to the spirit and, with his face, make him a complete being. Margaret Lantis says that the Nunivak Island half-man half-animal was sometimes portrayed with a human face and an animal body; or as two half-faces, one a man and the other a fox, as in this mask; or as a wolf (1960:116; personal communication). On Nunivak Island, ordinary people's masks were painted red; but those of a medicine man or a spirit were blue (Curtis 1930:38).

The half-man half-animal made a thundering sound when traveling and had its own world to which it might kidnap a human being. Fortunate was the man who was taken away by one of them, for they were friendly and always bestowed good hunting luck on the person they abducted (Lantis 1946:198). Hans Himmelheber said that these spirits could be heard rumbling and stamping through rocks. They had a men's

ceremonial house in the middle of Nunivak Island (1951:55–56, 58).

The *excit* is a male spirit. Its female counterpart, at least on King Island, is *yeyehuk* (Pl. 30 and pp. 98–99). The half-man half-animal mask at Point Hope was called *eitje,* according to Knud Rasmussen (1952:134), but *ahziagiak,* according to an informant.

The Nunivak Island half-man half-animal mask is the same kind of mask that Rasmussen describes, supposedly from Point Hope. He called it *eitje,* or "the dangerous one," an unfriendly spirit that persecuted mankind. Rasmussen says:

One side of the face is human, the other side a red fox. Eitje can change from the one to the other at will.

It can also turn into a polar bear. It is very quick in everything it does, both in pursuing and in changing form.

It is an evil spirit and very difficult for a shaman to acquire; it chases sea animals as a bear, land animals as a fox, and big animals as well as human beings as a man. As a man it is most dangerous.

When a shaman sends it out on an errand it often attacks other *torngat* and takes from them what they have obtained.

The mask is worn on the top of the qagsse. It is the Power, or the *tunraq,* who goes to the man, so that a shaman cannot himself decide which he can make use of [*ibid*].

In 1966 James A. Killigivuk of Point Hope carved a half-man half-animal mask, now in the Washington State Museum. The left side of the mask (when facing it) is the man, and the right side is the animal. The animal side has a bear in relief in the position of an eye, and a white fox in the approximate position of the mouth. The mask is called *azhiagiak,* an *angutkuk's* name.

The story of this mask is somewhat different from Rasmussen's, but is obviously related. A man who was traveling around the country looking for an eligible wife saw a sod house one day at a distance. When he got to the house after a fast walk, a woman with a half face came out.

"My father wants to see you. Come on in," she said.

Inside he was offered great hospitality and food, and, after he had eaten, the father asked him why he had come.

"I am looking for a woman to marry," he said.

"If you like my daughter, Half-face, she can be your wife," replied the father. The man looked the other way for a few minutes, thinking about the woman with half a face, but when he glanced at her again he saw a full face.

After they were married the man acquired unusual characteristics. When he was hunting and found that he needed to travel swiftly he could change into a white fox, and when he found it difficult to carry home a big land animal he became a polar bear.

The half-man half-woman figures were also carved as wooden boxes and in various ivory and wooden ornaments. (Plate 24, No. 16, in Nelson's *Eskimo about Bering Strait* shows an ivory earring from Cape Vancouver in this form.) An informant from Little Diomede Island said that the half-man half-animal was made as a small ivory or wooden amulet on his island and at Cape Prince of Wales.

Photograph by Dorothy Jean Ray.

PLATE 45

Staatliches Museum für Völkerkunde Dresden 38167. Height: 17 cm. A mask exchanged from the American Museum of Natural History in 1921: "wooden dance mask, carved to represent a man's face, and worn in general dances for the entertainment of the people, Eskimo of Yukon Delta, Alaska."

The face is painted white. The hair is red. Twine was used to fasten the mask to the head.

This is so much like the human face masks from King Island that it possibly was borrowed from there, or vice versa. These plain human masks were used on the Kuskokwim and at St. Michael as well as in the North (pp. 78–79). When we consider that the King Islanders often went to the Yukon River for trading before the establishment of St. Michael trading post in 1833, we can see that the opportunities were many for trading ideas. The mask is similar in almost every respect to one obtained from King Island about 1915 (Pl. 47, middle).

Photograph by W. Rabich, Staatliches Museum für Völkerkunde Dresden.

PLATE 46

D. J. Ray collection: Height: 9½ inches. From an unnamed donor in 1946. Unalakleet. Supposedly made for the 1912 Inviting-In Feast in St. Michael by one of the Unalakleet participants.

This mask, which has been repainted several times with commercial paint, is now gray. The nose appears to have been nailed on after the mask was carved. The inside of the huge mouth is red; the

long wooden teeth are pegged in. The mask at one time had several appendages; the stumps of quills are still stuck into the wood above the lip. The large round eye on the right is probably the eye of the spirit. Both that eye and the teardrop one below it were originally painted red inside. The left eye was unpainted.

I have included this mask not only to show unusual imagination in simple design, but because this is one of the few masks that is in existence from Unalakleet. From 1887 on, missionaries drastically curtailed ceremonials and mask making there. I suspect that some of the masks collected at St. Michael and Pastolik actually came from Unalakleet as a result of continual travel back and forth.

Photograph by Alfred A. Blaker. Another view of this mask is illustrated in Ray, *Artists of the Tundra and the Sea* (Fig. 84).

PLATE 47

University Museum (*left to right*): NA 4572, NA 4570, NA 4566. NA 4572 is 7 inches high. Collected from King Island about 1915.

The hair and eyebrows of all are black. The mask on the left represents a wolf. The interlocking teeth have red paint from hematite smeared around the mouth. The triangles on the eyebrows represent the peaks of the Kigluaik Mountains south of Teller. Several masks in the Sheldon Jackson Museum have similar designs either in paint or as cutouts on the top of the mask.

The middle mask is similar to that of the lower Yukon in Plate 45, and the one on the right is the half-man half-animal (see also Pls. 30 and 44).

Photograph by Dorothy Jean Ray.

PLATES 48 and 49

D. J. Ray collection. Made by Tony Pushruk, King Island Village (Nome), 1964. These are called the good-bad shaman masks.

PLATE 48. Height: 9^{1}/$_{4}$ inches (measured on the reverse side).

PLATE 49. Height: 9^{1}/$_{2}$ inches (measured on the reverse side).

The masks are painted with hematite mixed with water. The nostrils are painted with India ink. The small round eyes are unusual shapes in the North, where the common form is oval. The heavy forehead and eyebrow combination is also used on various Cape Prince of Wales and Point Hope masks. Though the masks are thick and fairly heavy, they fit

comfortably on the face because they are deeply excavated on the reverse side to accommodate even the most protruding nose.

The mask with the thick upper lip (Pl. 48) is the good shaman, and the mask with the thick lower lip (Pl. 49) is the bad shaman. I was told that, when these masks are used in a dance, they are the spirits of two shamans who are fighting to settle which one has the most power. Their fighting actually is a word battle, a braggart's game, but the words become so violent that the evil shaman overcomes the good one and kills him. The bad mask feels sorry for him, however, and sings a song to bring him back to life.

The shaman who originated the dance saw the spirits in the clouds and said that when they moved he could hear rattles, i.e., hailstones, in their bodies. Long gauntlet gloves with many puffin beaks to imitate the hailstones are worn by the two men dancers.

These are contemporary versions of old masks, which are supposed to date back to the nineteenth century. The earliest pair that I have seen was collected about 1914 by Daniel S. Neuman of Nome, and deposited in the Alaska State Historical Museum. Neuman obtained the following information: "This dance was originated and is still only used in King Island and St. Lawrence Island [Cape Prince of Wales?]. The wearers were always the medicine-men . . . and represent the Evil Spirit of the Thunder."

These masks have been popular with collectors as well as with King Island carvers, who have kept turning them out for sale for more than fifty years. As with other items that found a good sale, the original form has been closely followed, varying only with the idiosyncracies of the various carvers over the years. Many of these masks are scattered throughout the world. Nevertheless, this ubiquitous style has been, on the whole, badly misrepresented in different publications. For example, it has been called a caricature mask (Riley 1955:48), and a caricature mask with a medial labret (Collins 1961: Pl. 5). Riley goes so far as to say:

. . . this particular type of Eskimo mask had no religious significance. It was used in a histrionic contest between villagers. On this traditional occasion the wearers of the masks used comic gestures and vied with one another to provoke the greatest amount of laughter from the assembled audience. . . .

(Though without provenience, the mask described by Riley is a variation of the good-bad shaman mask made at Cape Prince of Wales, where a

more slanting forehead and white paint were customary. This is also illustrated by Davis 1949: Fig. 136.)

Hans Himmelheber, in the second edition of his *Eskimokünstler,* labeled a pair of these masks as Kuskokwim grave monuments. He saw and photographed them, however, at King Island Village in Nome in 1935, and a mixup in his notes and negatives resulted in an incorrect identification, which he has urged me to correct (personal communication).

A mask like this is illustrated by Wingert 1947: Pl. 76, No. 1, and wrongly identified as from the Quileute. The Museum of the American Indian, where it is located, has several others like this, also apparently incorrectly catalogued at the time of acquisition (Dockstader personal communication). The mask illustrated by Alice H. Ernst, also supposed to be Quileute, was probably made at Bering Strait (1952: Pl. X). She calls it a "Quillayute Wild Man mask," but in the text says that "the Wild Men wear no masks but black facial paintings" (*ibid.:50*).

Photographs by Alfred A. Blaker.

PLATE 50

Danish National Museum (Copenhagen) P6386. Height: $8^{1}/_{2}$ inches. Purchased by Helge Larsen and Froelich Rainey in 1939 from an old woman who found a cache of fifty masks under an old ceremonial house. Point Hope.

This imaginative mask probably dates back to the middle or the early nineteenth century, possibly before. The chevronlike forehead is also characteristic of masks from Prince William Sound (Lot-Falck 1957: illustrations). It is also similar in shape to the more realistic whales' tails found as noses on masks used in whaling ceremonies from Cape Prince of Wales and Point Hope.

An informant from Point Hope did not know the story of this mask, but suggested that the chevron-shaped lines in the lower half of the face represented the heavy black lines often drawn with graphite from the corner of the mouth to the bottom of the chin during whaling ceremonies. It is possible that the carver of this mask intended the chevrons to represent also the whale's tail as seen in Plate 52. Whatever the interpretation, the repetition and rhythm of the lines add greatly to the strength of this mask as a piece of art.

Photograph from the National Museum, Copenhagen.

PLATE 51

Washington State Museum 162/25–1. Height: $15^{15}\!/_{16}$ inches. Point Hope. Probably obtained in the 1890's.

The mask is brownish-black, probably a result of prolonged contact with animal fat in its storage place. The pegged-in teeth are shaped from walrus ivory.

The conical knob of the hat or hair was atypical of north Alaska during historic times, particularly the latter half of the nineteenth century when these masks were made. Some Aleut hats had a top similar to this. Greenland women, particularly of the Upernavik district (on the west coast) and on the east coast, once wore their hair in a fashionable high topknot. Alaskan Eskimo women wore their hair flat, and parted in the middle.

A Point Hope informant, seventy-six years old, did not know the meaning or story of this mask, but remarked that the knob resembled a whirling top of the kind once used both as toys and ceremonial objects.

Collins illustrates a tiny face with some kind of knob on the top of its head from Punuk Island (1937: Pl. 83, No. 14).

Photograph by Dorothy Jean Ray.

PLATE 52

Washington State Museum 434. Height: 9 inches. Collected by James T. White, 1894. Point Hope.

The surface of the mask is very smooth, with the blackish color characteristic of almost all Point Hope masks. The eyes are inset with ivory.

In 1891 Sheldon Jackson collected several masks with double whales' tails that served as nose and eyebrows, or with whole whales that served as a nose. According to James A. Killigivuk, a Point Hope mask maker, some masks of that kind were worn on the face, but others, like this example, were facial images to be placed in the house tunnel for protection. These were never removed from the tunnel. This particular mask, however, has holes on each side as if to be worn on the face.

This face image is called "Qakpangaq," but there is no meaning now attached to the name. A story of the Qakpanaq mask tells that a woman, sleeping by herself in a room, was visited one night by a stranger. She did not know what had happened until she discovered that she

was pregnant. When the baby was born, it looked just like the Qakpanaq mask.

Another image that was also used as a face mask had flukes growing out of its chin. Its form originated during a shaman's vision of prognostication at the beginning of the whaling season when the shaman himself grew flukes. If his assistant did not see his flukes growing during the seance, it was a sign that whale hunting would not be successful that year. This is a parallel to the Kauwerak shaman's daily visits to the caribou corral to predict hunting success from the amount of blood dripping down the mouth of a masklike image (see pp. 21–22).

The vertical ridge on the forehead is found on many Point Hope masks. This mask is similar to one collected by A. E. Nordenskiöld at Port Clarence in 1879 (1882:584) and to masks collected by Sheldon Jackson in 1891, illustrated in Plate 54.

Photograph by Dorothy Jean Ray.

PLATE 53

Washington State Museum 1962/25–2. Height: 10³/₄ inches. Probably collected in the 1890's. Point Hope. Catalogue states: "Kenawk [i.e., *kidnauk*, meaning "mask"] mask, used for invoking the assistance of good spirits for whale fishery of Eskimos of [illegible] Alaska."

This mask appears to have been made hastily, as is the case of perhaps one fourth of all Eskimo masks.

This kind of nose is rarely found on Eskimo masks. It is, therefore, unusual that masks with this feature from two widely separated areas, Prince William Sound (Pl. 40) and Point Hope (this plate) should be found in the same museum. The concept of a large nose, however, is not rare, as discussed on pages 62 and 79–80.

The four lobes on the mask's edge are not characteristic of Inupiaq carving either in wood or in ivory. Similar placement of lobes on ivory earrings and belt fasteners is found on objects from Nunivak Island and the opposite mainland: Cape Vancouver, Chalitmut, and Nulukhtulogumut (Nelson 1899: Pl. 24, Figs. 1, 2, 3, 5, and 6; Pl. 27, Fig. 20). Incised concentric circles with four lines (in the same position as the lobes) perpendicular to the outside circle were made at the above places, as well as in a wider area between St. Michael and the Kuskokwim River. Engraved circles with spurs, sometimes in groups of four and perpendicular to the circle, were also found in the St. Lawrence

Island archeological periods of Okvik, Old Bering Sea, and Punuk.
Photograph by Dorothy Jean Ray.

PLATE 54

Sheldon Jackson Museum. All were collected by Sheldon Jackson at Point Hope in 1891. The bottom middle mask is $10^7/8$ inches high.

Top, left to right: II.K.75: The mustache and goatee were probably painted with ashes or graphite mixed with oil. The face was left unpainted but is now gray-black. The teeth are made of ivory. The eye form was one used quite often in the St. Michael–Yukon area. For many years, this kind of human portrait mask was the only one illustrated for Point Hope, and this has led to the erroneous supposition that no other kinds were made.

Sheldon Jackson collected many portrait masks with black mustaches and goatees like this from the Point Hope cemetery. They were made with either upturned or downturned mouths, but all had a vertical ridge down the forehead and well-defined eyebrows painted black. Holes were drilled around the masks.

II.K.85. This mask, $8^1/2$ inches high, has a reddish forehead and mouth area. The forehead overhang is painted black. The portion between the nose and eyes was unpainted. This is presumably the mask made by Umigluk after he had experienced a vision between his summer camp and the main village (pp. 12–13).

Bottom, left to right: II.K.83: The mustache, chin, and eyebrows are painted black, but the face and the forehead are unpainted. This, and the following example, show variations in the use of a whale or whales' tails on masks which, according to informants, were always made by a shaman after a vision during whaling ceremonies.

II.K.81: Part of the whale-fluke nose still has traces of red color on it. The rest of the face is a grayish natural color. The double tail forms the nose, the nostril, and the eyebrows.

II.K.87: The mouth is painted red, and the round eyes are sunk deeply into the forehead. The mask is $10^1/4$ inches high and resembles a raven. An informant who looked at the photograph said that, though he had never seen a mask like this before, the two slits in the middle of the face by rights "belong to a whale."
Photograph by Dorothy Jean Ray.

PLATE 55

Box drum made by King Island Eskimos, 1961. Height: about 3 feet.

The triangles at the top represent the peaks of the Kigluaik (Sawtooth) Mountains north of Nome, and the pointed figures on the edge of the box represent the eagle's claws. All are painted black. A long eagle's feather protrudes from the top of the black ovate object at the top left. When in use, this drum is suspended from the ceiling and beaten on the folded skin with the wooden beater. (See the photograph of dancers and drum in the last complete Eagle and Wolf Dance of the Messenger Feast to be presented on Seward Peninsula in Ray 1964a.)

The drum is called *kallukaq;* the ordinary small tambourine drum, *soiyak.* This drum was newly made, but was not for sale. Ever since the King Islanders moved into their fine community building east of Nome for the showing of dances and ivory carvings to tourists, they have revived the making of this drum. The people from Mary's Igloo (Kauwerak), who claim it as their own, old invention, say that "the King Islanders are not making it right." Their complaints lie in the proportions of the drum and the resonance produced by the drummer.

D. S. Neuman, who wrote a description of the last dance at Mary's Igloo in 1914, presented a similar drum to the Alaska State Historical Museum.

So far there is no evidence on which to date its first use, but its peaklike motif is found on several old objects, including a kayak paddle obtained at Bering Strait in 1816 by Ludovik Choris and illustrated by him in his Plate III (1822). So far this is the oldest piece with this motif that has come to my attention. The same design was used on the top of masks collected by Sheldon Jackson from King Island about 1890, for example, mask number II.E.6 (SJM). This mask has carved wooden peaks painted black; the cheeks are white, the chin and upper lip are red, and the area between the lip and nose is black.

Photographed at King Island Village near Nome in 1961 by Dorothy Jean Ray.

PLATE 56 (Nelson 1899: Pl. XCV)

1. From Sabotnisky (on the lower Yukon River in the Marshall

area) (USNM 48989), 5³/₄ by 4³/₄ inches. Colors are white, red, and black. "*Inua* of the short-ear owl" (p. 397).

2. From Sabotnisky (USNM 48985), 6 by 9 inches. Colors are white, red, and black. Human hair hangs over the face. The mask represents the black bear, and the face is the "*inua* of the bear" (p. 396).

3. From "the tundra south of the Yukon mouth" (USNM 33131), 7¹/₄ by 5¹/₂ inches. The face is painted red, and the decorations are black. The alligatorlike animal is known as "*palraiyuk*" (p. 397).

4. From Cape Vancouver (USNM 43779), 8 by 5³/₄ inches. Painted white with red. "Features of a *tunghâk*" (p. 396).

PLATE 57 (Nelson 1899: Pl. XCVI)

a. From Cape Romanzof (USNM 33108), 22 by 12 inches, 6 inches deep. Basic color is a dull blue. The face inside the beak is white, as are the spots. "Supposed to represent the sea parrot (*Lunda cirrhata*)" (p. 397).

b. From Cape Romanzof (USNM 33104), 30 by 10 inches. The handle is more than 12 inches long. The lower face is mainly white, and the seal's face of the main portion of the mask is bluish. The black line above the large mouth of the bottom face is supposed to represent a mustache (pp. 398–99). This mask is illustrated by Rainey (1959:12).

PLATE 58 (Nelson 1899: Pl. XCVII)

Provenience unknown (USNM 33118), 2 feet by 13 inches. Painted white and blue, with black and red lines. The figurines represent five seals and two caribou (top two figures).

This image represents the *tunghâk* or being that controls the supply of game. It is usually represented as living in the moon. The shamans commonly make a pretense of going to him with offerings in order to bring game into their district when the hunters have been unsuccessful for some time.

Masks of this character are too heavy to be worn upon the face without additional support, so they are ordinarily suspended from the roof of the kashim by strong cords. The wearer stands behind with the mask bound about his head, and wags it from side to side during the dance so as to produce the ordinary motion. I was told that in all the great mask festivals several of these huge objects were usually thus suspended from the roof [pp. 399–400].

The Anvik Indians told John Chapman:

This mask represents the thinking spirit of the father of the seal tribe.

The square hole in the forehead is the place where the seals go down in the Fall. In the Spring they come up through the same hole. They then dive down through the various holes on the side toward the right, and come up through the holes on the other side and swim to the shore, where two of them are represented as lying [1907:15].

A photograph of this mask appears in Rainey (1959:12), but with the hands, side boards, and feathers missing.

PLATE 59 (Nelson 1899: Pl. XCVIII)

1. Provenience unknown (USNM 49020), 30 inches high. Natural color with the exception of red linings for the features of the bird and the face. "This mask was said to represent the *inua* of the [sandhill] crane." The top of the bird's head is

... excavated for a small lamp, with a hole in front on each side, representing the eyes for the light to shine through.... The maker was a shaman, who claimed that once, when he was alone upon the tundra, he saw a sand-hill crane standing at a distance looking at him; as he approached, the feathers on the bird's breast parted, revealing the face of the bird's *inua*, as shown in the carving [p. 402].

2. From the lower Kuskokwim River (USNM 64242), 11¹/₂ by 4¹/₂ inches. The upper half of the face is white; the lower half is bluish slate color. White swan feathers are inserted on the head (pp. 402–3).

3. From Sabotnisky (USNM 38733), 20 inches high. The mask is painted red "with the face between the mouth and the eyes splashed with blood. This represents some mythical being, but its exact signification was not learned" (p. 403).

PLATE 60 (Nelson 1899: Pl. XCIX)

1. From Sabotnisky (?) (USNM 64248), 8 by 5¹/₂ inches. White with black drawings.

This face represents the *inua* of some species of waterfowl, the name of which I did not learn; but from the drawings of the various game animals upon the flaps attached to the sides, I judge that it was used in festivals connected with obtaining success in the hunt, which I learned to be the case with similar masks in that region [p. 404].

2. From Sabotnisky (USNM 38862). White with red borders. "This mask ... represents the features of a *tunghâk*" (p. 403). According to Chapman, it "represents a bubble in the ice" (1907:15).

3. From Paimiut (USNM 38645), 8½ by 7¼ inches. The forehead and the top of the nose are dull green; the face is white; and the mouth, chin, border, and right eyebrow are red. "This represents the countenance of a *tunghâk* and is from the extreme upper border of the Eskimo territory along the Yukon" (p. 403).

4. From Sabotnisky (USNM 38811), 8½ by 6½ inches. Entire face is painted green with dull brown spots. The long red sticks are attached to the mask with baleen (whalebone). Small strips of parchment hang over the eyes. "This represents the face of a *tunghâk*" (p. 404).

PLATE 61 (Nelson 1899: Pl. C)

1. From the lower Kuskokwim River (USNM 64260), 11½ by 5 inches. When the doors are closed, the mask is white, with the exception of the arms and legs, which are red bordered with black.

Other masks of this character were seen in the region between Kuskokwim and Yukon rivers, as well as on the lower Kuskokwim, and in one or more instances I saw masks having an outer or movable portion representing the muzzle of some animal which could be removed at a certain time in the festival by a single motion of the hand. These were used to represent the metamorphosis from the ordinary form of the being indicated to that of its *inua* [p. 406].

2. From Cape Romanzof (USNM 33111), 9 by 5½ inches. The principal colors of the mask are white and dull blue. The mask is supposed to represent "a guillemot swimming on the surface of the water. . . . The face on the back of the bird represents its *inua*" (pp. 405–6).

3. From Pastolik (USNM 33105), 12¾ by 5½ inches. The main colors are black and white, with the appendages and spots around the mouth a dull red. Nelson said, "This mask represents the features of a *tunghâk*" (pp. 406–7), but Chapman said that this mask represented the spirit of a losh (1907:15). The mask is almost a duplicate of the one shown in Plate XI.

4. Provenience unknown (USNM 33107), 7½ by 4½ inches. The mask is white and dull blue. The bird's wings, neck, and tail feathers are also blue, but the walrus figurine, bird's beak and feet, hands, and border around the face are red. Nelson calls the lines drawn around the eyes "snow goggles." The mask represents the sea parrot (*Mormon arctica*) (pp. 404–5).

PLATE 62 (Nelson 1899: Pl. CI)

1. Collected from "south of the lower Yukon" (USNM 33134), 12 by 6 inches. Principal colors are white, red, and black. This mask represents a salmon, with gill openings at the bottom and pectoral fins at the top. Under the salmon's head is a wooden figurine of a hair seal, "represented as swimming crosswise to the course of the salmon," and on the top is a wooden kayak, which once probably also held a man.

2. From the lower Kuskokwim River (USNM 37654), 11 by 6 inches. The mask is black and white, and represents the hair seal (*Phoca barbata*). Nelson calls the lines around the eye "snow goggles." "The face on the back of this mask is supposed to represent the features of the seal's *inua*" (p. 408).

PLATE 63 (Nelson 1899: Pl. CII)

1. From "south of the Yukon mouth" (USNM 33126), 6 by 4¹/₂ inches. The forehead, the chin, and the right wolf are black with white spots. The middle of the face and the wolf on the left are white. Mouths and the walrus are red. "The signification of this mask is unknown, but I believe that the black and white wolves bear a symbolic reference to day and night" (pp. 409–10).

2. From Sabotnisky (USNM 48913), 8¹/₂ by 6¹/₂ inches. "It is a rudely oval representation of a death's-head and is made by using fire to char the wood into the proper shape. . . . On each side of the chin are represented huge labrets. . . . In the rear the mask is slightly excavated, with a ledge to enable the wearer to grasp it with his teeth" (pp. 408–9).

3. From the lower Kuskokwim River (USNM 37864), 7¹/₂ by 5 inches. The mask is red and white with black around the eyes. "The signification of this mask is unknown" (p. 408). A similar one, II.A.7, in the Sheldon Jackson Museum was obtained at Nushagak.

4. From the lower Kuskokwim River (USNM 64238), 6³/₄ by 7 inches. The face is white with bluish spots. Brownish splotches are placed above the lips. Other markings are black. This is "the *inua* of the Canada lynx" (p. 409). The mouth is hinged so that it can move up and down.

PLATE 64 (Nelson 1899: Pl. CIII)

1. From Razbinsky on the lower Yukon (USNM 1621), 2³/₄ by 3

inches. A human face is carved on the opposite side and painted red. The bird's head is white and slate. "This is used as a finger mask by women in ceremonial dances; the exact meaning is unknown" (p. 412).

2. From the lower Kuskokwim River (USNM 64258), 6$\frac{1}{2}$ by 2$\frac{3}{4}$ inches. The mask is painted in white and black and is very crudely made. The door on the left covers the "mythical beings" painted on the face (p. 411).

3. From the lower Kuskokwim River (USNM 37895), 3$\frac{1}{4}$ inches in diameter (pp. 411–12).

4. From the lower Kuskokwim River (USNM 64252), 5$\frac{3}{4}$ by 3$\frac{1}{2}$ inches. "Its significance is not known" (p. 410).

5. From the lower Kuskokwim River (USNM 64243), 7$\frac{3}{4}$ by 4$\frac{1}{4}$ inches. Colors are white and slatish blue. "The maskette represents a half moon and is connected with religious ceremonials held during the winter in that region, but I failed to learn its exact significance" (p. 410).

6. From the lower Kuskokwim River (USNM 64266), 5 by 1$\frac{3}{4}$ inches. Colors are white and slatish blue. "The purpose of this maskette is for use in religious observances, but the exact ceremonies in which it figured were not learned" (pp. 410–11).

PLATE 65 (Nelson 1899: Pl. CIV)

1. From Norton Sound (USNM 24746), 5 by 2$\frac{3}{4}$ inches. "This specimen was collected by Mr. L. M. Turner, who states that it was intended to represent a star, the feathers indicating the twinkling of the light. This finger mask was used by women in certain ceremonial dances" (p. 413).

2. From Big Lake (lower Yukon River) (USNM 38648). "It is used by women in ceremonial dances; otherwise its significance is unknown" (p. 412).

3. and 4. From Koñigunugumut (Kongiganak on Kuskokwim Bay) (USNM 36231). No. 3 is also described by Dall (1884:131). Nelson says about it: "The block is surrounded near its border by a ridge from which a narrow bevel extends outward to the edge and another one inward to the border of a face in relief which occupies the middle." Of No. 4 he says:

On one side . . . is a grotesque semihuman face, with the mouth commencing as a down-turned corner on the right side, thence extending over and down on the

other side, then sweeping up around the left border of the face and forehead. The eye upon the left side is absent; upon the right side is a crescentic eye with corners down-turned, and the nose is curved around toward the right [pp. 412–13].

PLATE 66 (Nelson: Pl. CV)

1. From Big Lake between the Yukon and Kuskokwim rivers (USNM 38451), 4½ inches in diameter. Colors are red, black, and white. "This mask also is used by women in ceremonial dances, but its signification is unknown" (p. 413).

2. From Cape Romanof (USNM 33125). Yellowish-white color with red and black dots. "This mask was used by the women in ceremonial dances" (p. 414).

3. From Pastolik (USNM 33121), 4¾ by 2¾ inches. Colors are black with a red border. "It is a woman's finger mask, used in ceremonial dances, but its meaning is unknown" (pp. 413–14). This image is similar to the masks shown in Plates VII, 10, and 11.

PLATE 67

Reproduction of Sauer's illustrations of Aleut masks, probably the first illustrations of Eskimo-Aleut masks (1802: Pl. 11).

PLATE 68

Kodiak masks collected at the turn of the nineteenth century by Voznesenskii, illustrated in Lipshits 1955: Pl. 4.

PLATE 69

Prince William Sound masks collected by A. Pinart in the 1870's, illustrated in Lot-Falck 1957: Pl. II.

PLATE 70

Aleut masks collected by A. Pinart in the 1870's, illustrated in Lot-Falck 1957: Pl. IX.

Bibliography

The bibliography is a list of references used directly in preparation of the text. Illustrations of Eskimo masks, as well as pertinent information about various masks or collections, are noted at the end of an entry.

Alaska Native Arts and Crafts Cooperative Association, Inc.
 1964 Catalogue. Juneau, Alaska. Masks, p. 3.
Andrews, C. L.
 1938 *The Story of Alaska.* Caxton Printers, Caldwell, Ida.
Atamian, Sarkis
 1966 "The Anaktuvuk Mask and Cultural Innovation," *Science,* Vol. CLI, No. 3716, pp. 1337–45. Five skin masks illustrated.
Avdeev, A. D.
 1958 "Aleutskie mask v sobraniiakh Muzeia antropologii i etnografii Akademii nauk SSSR" ("Aleut Masks in the Collections of the Museum of Anthropology and Ethnography of the Academy of Sciences, USSR"), Akademiia Nauk SSSR, Muzei antropologii i etnografii, *Sbornik,* Vol. XVIII, pp. 279–304. Masks, Pls. 1, 2, 4, and 5. These are views of two wooden masks from Atka, collected by L. I. Shrenk before 1857. They were discovered by Illarion Arkhimandritov, an employee of the Russian-American Company.
Bach, Cile M. See Hassrick, R. D., and Cile M. Bach.
Bancroft, Hubert Howe
 1886 History of Alaska 1730–1885. Edition used, Antiquarian Press, New York, 1959.
Bernardi, Suzanne Rognon
 1912 "Whaling with Eskimos of Cape Prince of Wales," *The Courier Journal,* October 20, pp. 1, 12, Louisville, Ky.
Birket-Smith, Kaj
 1936 *The Eskimos.* Methuen and Co., London. Copy used, 2nd ed., 1959. Masks, p. 177.

1953 *The Chugach Eskimo.* (Nationalmuseets Skrifter. Etnografisk Raekke, VI.) Copenhagen. Masks, Fig. 41.

Birket-Smith, Kaj, and Frederica de Laguna
1938 *The Eyak Indians of the Copper River Delta, Alaska.* Levin and Munksgaard, Copenhagen.

Blaker, Alfred A.
1965 *Photography for Scientific Publication.* W. H. Freeman and Company, San Francisco, Calif. Masks, Pl. 12.

Boas, Franz
1888 *The Central Eskimo.* (Bureau of Ethnology, Annual Report, Vol. VI, pp. 399–669.) Masked man, Fig. 535.
1901 *The Eskimo of Baffin Land and Hudson Bay.* (Bulletin of the Ameri-
1907 can Museum of Natural History, Vol. XV, Parts 1 and 2.) Skin masks and masked figures, Figs. 169 and 170.
1927 "Art of the North Pacific Coast of North America," in *Primitive Art,* pp. 183–298. Edition used, Capitol Publishing Company, New York, 1951.

Borden, Charles E.
1951 "Facts and Problems of Northwest Coast Prehistory," *Anthropology in British Columbia,* No. 2, pp. 35–55.
1962 "West Coast Crossties with Alaska," in *Prehistoric Cultural Relations between the Arctic and Temperate Zones of North America.* (Arctic Institute of North America Technical Paper No. 11, pp. 9–19.)

Bruce, Miner
1894 "Report of Miner Bruce, Teller Reindeer Station, June 30, 1893," in *Report on Introduction of Domesticated Reindeer into Alaska.* (U.S. Bureau of Education, Whole No. 215, pp. 25–121.)

Campbell, John M.
1963 "Current Research: Arctic," *American Antiquity,* Vol. XXVIII, No. 4, p. 579.

Chapman, John W.
1907 "Notes on the Tinneh Tribe of Anvik, Alaska," *Proceedings of the Fifteenth International Congress of Americanists, 1906,* pp. 7–38. Anvik masks, pp. 21, 22, 24, 25, 26, 28, 29, 30, 31.

Chapman, May Seely
1939–40 *The Animistic Beliefs of the Ten'a of the Lower Yukon Alaska.* (Church Missions Publishing Company, Publication 65.) Mask, p. 8.

Chard, Chester S.
1960a "First Iron Artifact from the Old Bering Sea Culture," *Anthropological Papers of the University of Alaska,* Vol. IX, No. 1, p. 57.

1960b "Northwest Coast—Northwest Asiatic Similarities: A New Hypothesis," *Selected Papers of the Fifth International Congress of Anthropological and Ethnological Sciences, 1956,* pp. 235–40.

1962 "Maritime Culture in the North Pacific: Age and Origin," *Proceedings of the Thirty-fourth Congress of Americanists, Vienna, 1960,* pp. 279–83.

Choris, Ludovik

1822 *Voyage pittoresque autour du monde.* Paris.

Christensen, Erwin O.

1955 *Primitive Art.* New York. Masks, Figs. 57–59.

Collins, Henry B.

1929 *Prehistoric Art of the Alaskan Eskimo.* (Smithsonian Miscellaneous Collections, Vol. LXXXI, No. 4.)

1937 *Archeology of St. Lawrence Island, Alaska.* (Smithsonian Miscellaneous Collections, Vol. XCVI, No. 1.)

1954 Arctic Area. *Instituto Panamericano de Geografía e Historia.* Mexico City.

1961 "Eskimo Cultures," *Encyclopedia of World Art,* Vol. V, pp. 1–27 and Pls. 1–12. Masks, Pls. 1, 5, 6, 7. See page 210 of this book for explanation of Pl. 5.

Cook, James

1784 *A Voyage to the Pacific Ocean.* 3 vols. London.

Covarrubias, Miguel

1954 *The Eagle, the Jaguar, and the Serpent.* Alfred A. Knopf, New York. Masks, Pls. 1, 2, 4, 5; pp. 8, 156, 160, 161. The last two are line drawings of Aleut masks.

Covarrubias, Miguel, and Daniel F. Rubín de la Borbolla

1945 *El arte indigena de Norteamerica.* Instituto Nacional de Antropología e Historia. Mexico City. Masks, Pls. 4–8.

Coxe, William

1784 *Account of the Russian Discoveries between Asia and America.* London.

Curtis, Edward S.

1930 *The North American Indian,* Vol. XX. Norwood, Mass. Masks, pp. 80, 82.

Dall, William H.

1870 *Alaska and Its Resources.* Lee and Shepard, Boston.

1878 *On the Remains of Later Pre-Historic Man Obtained from Caves . . . of the Aleutian Islands.* (Smithsonian Contributions to Knowledge, No. 318.)

1884 *On Masks, Labrets, and Certain Aboriginal Customs, etc.* (Bureau of Ethnology, Annual Report, Vol. III.) Masks, Pls. 23–29.

Davis, Robert Tyler

1949 *Native Arts of the Pacific Northwest.* Stanford University Press, Palo Alto, Calif. Masks, Figs. 136, 137, 138, 188, 194.

de Laguna, Frederica

1934 *The Archaeology of Cook Inlet, Alaska.* University Museum, Philadelphia.

1936 "Indian Masks from the Lower Yukon," *American Anthropologist,* Vol. XXXVIII, No. 4, pp. 569–85. Masks, Pls. 17, 18, 19, 20; pp. 574, 577, 578.

1947 *The Prehistory of Northern North America as Seen from the Yukon.* Supplement to *American Antiquity,* Vol. XII, No. 3, Part 2, *Memoirs of the Society for American Archaeology.*

1956 *Chugach Prehistory.* (University of Washington Publications in Anthropology, Vol. XIII.)

1960 *The Story of a Tlingit Community: A Problem in the Relationship between Archeological, Ethnological, and Historical Methods.* (Bureau of American Ethnology, Bulletin 172.)

de Laguna, Frederica, and Francis A. Riddel, Donald F. McGeein, Kenneth S. Lane, J. Arthur Freed, and Carolyn Osborne

1964 *Archeology of the Yakutat Bay Area, Alaska.* (Bureau of American Ethnology, Bulletin 192.)

de Laguna, Frederica. See Birket-Smith, Kaj, and Frederica de Laguna

d'Harcourt, Raoul

1950 *Primitive Art of the Americas.* Tudor Publishing Co., New York. Masks, Pls. 14, 15.

d'Harnoncourt, René. See Douglas, Frederic H., and René d'Harnoncourt.

Disselhoff, H. D.

1935 "Bemerkungen zu einigen Eskimo-masken der Sammlung Jacobsen des Berliner Museums für Völkerkunde," *Baessler-Archiv,* Vol. XVIII, pp. 130–37. Masks illustrated on every page. Jacobsen's proveniences, like E. W. Nelson's, can be relied on.

1936 "Bemerkungen zu Fingermasken der Beringmeer-Eskimo," *Baessler-Archiv,* Vol. XIX, pp. 181–87. Finger masks on pp. 182, 183, 184.

Dockstader, Frederick J.

1960 *Indian Art in America.* New York Graphic Society, Greenwich, Conn. Masks, Pls. 73, 74, 75, 76, 77, 79.

Douglas, Frederic H., and René d'Harnoncourt

1941 *Indian Art of the United States.* Museum of Modern Art, New York, 1941. Masks, pp. 43, 187, 188, 189, 190, 191, 192, 193.

Drucker, Philip
 1943 "Archaeological Survey on the Northern Northwest Coast." (Anthropological Paper No. 20, Bureau of American Ethnology, Bulletin 133, pp. 17–142.)
 1965 *Cultures of the North Pacific Coast.* Chandler Publishing Company, San Francisco, Calif.

Duff, Wilson
 1957 "Prehistoric Stone Sculpture of the Fraser River and Gulf of Georgia," *Anthropology in British Columbia,* No. 5, pp. 15–151.

Ernst, Alice H.
 1952 *The Wolf Ritual of the Northwest Coast.* The University Press, University of Oregon, Eugene. Plate X, called a "Quillayute Wild Man," from the Museum of the American Indian, is probably from the Bering Strait (see p. 211).

Fejes, Claire
 1959 "Eskimo Masks," *The Beaver,* Spring, pp. 56–57. Masks, p. 57 and cover.

Ford, J. A.
 1959 *Eskimo Prehistory in the Vicinity of Point Barrow, Alaska.* (American Museum of Natural History, Anthropological Papers, Vol. XLVII, No. 1.)

Fraser, Douglas
 1962 *Primitive Art.* Doubleday and Co., New York. Masks, Figs. 181, 183.

Geist, Otto, and Froelich Rainey
 1936 *Archeological Excavations at Kukulik.* (Miscellaneous Publications of the University of Alaska, Vol. II.)

Giddings, J. Louis
 1952 *The Arctic Woodland Culture of the Kobuk River.* (Museum Monographs, University Museum, University of Pennsylvania.)
 1964 *The Archeology of Cape Denbigh.* Brown University Press, Providence, R.I.

Gillham, C. E.
 1955 *Medicine Men of Hooper Bay.* The Bathworth Press, London.

Gordon, G. B.
 1917 *In the Alaskan Wilderness.* Philadelphia, Pa.

Green, Paul
 1959 *I Am Eskimo—Aknik My Name.* Juneau, Alas.

Gunther, Erna
 1951 *Indians of the Northwest Coast.* Taylor Museum of the Colorado Springs Fine Arts Center and Seattle Art Museum.
 1962 *Northwest Coast Indian Art.* Catalogue, Seattle World's Fair, 1962.

Hassrick, R. D., and Cile M. Bach

1960 *Indian Art of the Americas.* Denver Art Museum, Winter Quarterly, 1960. Masks, Figs. 92 and 93.

Hawkes, E. W.

1913a "The Cliff-Dwellers of the Arctic," *Wide World Magazine,* Vol. XXX, February–April.

1913b *The "Inviting-In" Feast of the Alaskan Eskimo.* (Canada Department of Mines, Geological Survey, Memoir 45, No. 3, Anthropological Series, Ottawa.) Masks, Pls. 1–3, 6–8, 10, 11.

Heizer, Robert F.

1952 "Notes on Koniag Material Culture," *Anthropological Papers of the University of Alaska,* Vol. I, No. 1, pp. 11–19.

1956 *Archaeology of the Uyak Site, Kodiak Island, Alaska.* (University of California Anthropological Records, Vol. XVII, No. 1.)

Himmelheber, Hans

1953 *Eskimokünstler.* Eisenach. Expanded, second edition. Masks, Pls. 13–21, 24, 25, 26, 36, 37. Plate 25 should read from King Island instead of Kuskokwim. See p. 211 of this book.

Hoffman, Walter James

1897 "The Graphic Art of the Eskimos," *U.S. National Museum Annual Report for 1895,* pp. 739–968. Mask, Pl. 16.

Hrdlička, Aleš

1945 *The Aleutian and Commander Islands and Their Inhabitants.* Wistar Institute of Anatomy and Biology, Philadelphia. Bone mask, p. 465.

Hudson's Bay Company

n.d. *Masks of the North West Indians.* Winnipeg, Man.

Hughes, Charles Campbell

1959 "Translation of I. K. Voblov's 'Eskimo Ceremonies,'" *Anthropological Papers of the University of Alaska,* Vol. VII, No. 2, pp. 71–90.

Inverarity, Robert Bruce

1950 *Art of the Northwest Coast Indians.* University of California Press, Berkeley and Los Angeles.

Ivanov, S. V.

1930 "Aleut Hunting Headgear and Its Ornamentation," *Proceedings of the Twenty-third International Congress of Americanists, 1928,* pp. 477–504.

Jacobsen, Johan Adrian

1884 *Capitain Jacobsen's Reise an der Nordwestküste Amerikas, 1881–1883.* Edited by A. Woldt. Disselhoff illustrates the masks collected by Jacobsen.

Jenness, Diamond

1922 *Life of the Copper Eskimos.* (Report of the Canadian Arctic Expedition 1913–1918, Vol. XII.)

1928 "Archaeological Investigations in Bering Strait," National Museum of Canada, Bulletin No. 50, *Annual Report for 1926,* pp. 71–80.

Kakaruk, John A., and William Oquilluk

1964 *The Eagle-Wolf Dance.* Mimeographed. Anchorage, 1964.

Keithahn, Edward L.

1959 *Native Alaskan Art in the State Historical Museum, Juneau, Alaska.* Catalogue. Juneau, 1959. Masks, unnumbered pp. 38, 39, 40, 41, 42.

1963 *Monuments in Cedar.* 2nd ed. Superior Publishing Company, Seattle.

n.d. *Descriptive Booklet of the Alaska Historical Museum, Juneau.* Masks, p. 55.

Kotzebue, Otto von

1821 *A Voyage of Discovery, into the South Sea and Beering's Straits . . . in the Years 1815–1818.* 3 vols. London.

Krause, Aurel

1885 *The Tlingit Indians.* (American Ethnological Society Monograph 26.) University of Washington Press, Seattle. English translation (1956) by Erna Gunther of *Die Tlinkit-Indianer,* Jena.

Langsdorff, G. H. von.

1814 *Voyages and Travels in Various Parts of the World during the Years 1803, 1804, 1805, 1806, and 1807.* Vol II. London.

Lantis, Margaret

1946 *The Social Culture of the Nunivak Eskimo.* (Transactions of the American Philosophical Society, N.S. Vol. XXXV, No. 3.) Philadelphia, Pa. Masks, Figs. 24, 30, 34.

1947 *Alaskan Eskimo Ceremonialism.* (American Ethnological Society Monograph 11.) Reissued by University of Washington Press, Seattle, 1966.

1950 "The Religion of the Eskimos," in *Forgotten Religions,* edited by Vergilius Ferm. Philosophical Library, New York, pp. 309–39.

1960 *Eskimo Childhood and Interpersonal Relationships.* (American Ethnological Society Monograph 33.) University of Washington Press, Seattle. Mask, p. 72.

Larsen, Helge

1950 "Archaeological Investigations in Southwest Alaska," *American Antiquity,* Vol. XV, pp. 177–86.

1951 "De dans-amerikanske Alaska-ekspeditioner 1949–50," *Geografisk Tidsskrift,* Vol. LI, pp. 63–93.

Larsen, Helge, and Froelich Rainey

 1948 *Ipiutak and the Arctic Whale Hunting Culture.* (Anthropological Papers, American Museum of Natural History, Vol. XLI.) Masks, Fig. 39; Pls. 54–55.

Laughlin, William S.

 1962 "Bering Strait to Puget Sound: Dichotomy and Affinity between Eskimo-Aleuts and American Indians," in *Prehistoric Cultural Relations between the Arctic and Temperate Zones of North America.* (Arctic Institute of North America, Technical Paper No. 11, pp. 113–25.)

 1963 "The Earliest Aleuts," *Anthropological Papers of the University of Alaska,* Vol. X, No. 2, pp. 73–91.

Linné, S.

 1960 "Indian and Eskimo Art in Helsingfors (Helsinki) 1960, *Ethnos,* Vol. XXV, Nos. 3–4, pp. 214–24. Masks illustrated in Nordenskiöld, 1882, are illustrated as part of an exhibit.

Lipshits, B. A.

 1955 "O kellektsiiakh Muzeia antropologii i etnografii, sobrannvkh russkimi puteshestvennikami i issledovatehami na Aliaske i v Kalifornii" ("The Collections of the Museum of Anthropology and Ethnography, Gathered by Russian Travelers and Explorers in Alaska and California"), Akademiia Nauk SSSR, Muzei antropologii i etnografii, *Sbornik,* Vol. XVI, pp. 358–69. Masks, Fig. 4.

Lopp, W. T.

 1892 Diary for 1892. Manuscript in the C. L. Andrews Collection, Sheldon Jackson Junior College, Sitka, Alaska.

Lot-Falck, Eveline

 1957 "Les masques eskimo et aléoutes de la collection Pinart," *Société des Américanistes, Journal,* N.S. Vol. XLVI, pp. 7–43. The article is about seventy-four Eskimo and six Aleut masks obtained by A. L. Pinart between the years 1870 and 1872, mostly from Kodiak Island and Prince William Sound. They are now in the Museum of Boulogne-sur-mer, France. All illustrations in the article are of these masks.

Lowie Museum of Anthropology

 1962 *Hunters of the North.* Catalogue for an exhibition, 1962. Masks are illustrated in unnumbered Pls. 5 and 6. Pl. 5 is mask 2–5854 and Pl. 6 is mask 2–5852 of this book.

McCracken, Harold

 1930 *God's Frozen Children.* New York. Masks, p. 148.

McElwaine, Eugene
 1901 *The Truth about Alaska.* Chicago. A memorial mask, p. 122.
Marsh, Gordon H.
 1954 "A Comparative Survey of Eskimo-Aleut Religion," *Anthropological Papers of the University of Alaska,* Vol. III, No. 1, pp. 21–36.
Mathiassen, Therkel
 1927 *Archaeology of the Central Eskimos.* Report of the Fifth Thule Expedition 1921–24, Vol. IV, Part I. Mask image, Fig. 35.
 1930 *Archaeological Collections from the Western Eskimos.* Report of the Fifth Thule Expedition 1921–24, Vol. X, No. 1, Copenhagen. Masks, Figs. 13 and 22.
Meldgaard, Jørgen
 1960 *Eskimo Sculpture.* Methuen and Company, London. Masks, Pls. 5–7, 19, 27, 34–36. Plate 27 should read Prince William Sound instead of Norton Sound.
Miles, Charles
 1963 *Indian and Eskimo Artifacts of North America.* Henry Regnery Co., Chicago. Masks on pp. 149, 150, 151, but undocumented.
Murdoch, John
 1892 *Ethnological Results of the Point Barrow Expedition.* (Bureau of Ethnology, Annual Report, Vol. IX.)
National Museum, Copenhagen
 1955 *Arctic Peoples and American Indians.* (Guides to the National Museum.) Masks, p. 35.
Nelson, Edward William
 1899 *The Eskimo about Bering Strait.* (Bureau of American Ethnology, Annual Report, Vol. XVIII, Part 1.) Masks, p. 414, Pls. 95–105.
Neuman, Daniel S.
 1914 *Mary's Igloo Potlatch, January 1914.* Pamphlet reprinted from the *Nome Daily Nugget,* January 20.
Neuman, Elizabeth
 1914 "Nidl-Gah-Ruit (Big Eskimo Dance)," *The Aurora* (Yearbook of the Nome High School), pp. 16–19.
Niblack, Albert P.
 1890 "The Coast Indians of Southern Alaska and Northern British Columbia," Smithsonian Institution, *Annual Report* for year ending June 30, 1888, pp. 225–386.
Nordenskiöld, A. E.
 1882 *The Voyage of the Vega round Asia and Europe.* Macmillan and Co., New York. Masks, p. 581.

Oquilluk, William. See Kakaruk, John A., and William Oquilluk

Osgood, Cornelius

 1940 *Ingalik Material Culture.* (Yale University Publications in Anthropology, No. 22.) Mask, p. 425.

 1958 *Ingalik Social Culture.* (Yale University Publications in Anthropology, No. 53.) Masks, Figs. 5–14.

 1959 *Ingalik Mental Culture.* (Yale University Publications in Anthropology, No. 56.) Masks, p. 80.

Oswalt, Wendell

 1952 "The Archaeology of Hooper Bay Village, Alaska," *Anthropological Papers of the University of Alaska,* Vol. I, No. 1, pp. 47–91. Masks, Pls. 6 and 7.

Oswalt, Wendell, and James W. VanStone

 n.d. *The Ethno-Archeology of Crow Village, Alaska.* In press, Bureau of American Ethnology. Three masks illustrated.

Petroff, Ivan

 1884 *Report on the Population, Industries, and Resources of Alaska.* U.S. Census Office, Tenth Census.

Pinart, Alphonse Louis

 1872 *Catalogue des collections rapportées de l'Amérique russe.* Paris.

 1875 *La Caverne d'Aknanh, Ile d'Ounga (Archipel Shumagin, Alaska).* Paris. Masks, Pls. 1–3.

Quimby, George I.

 1948 "Prehistoric Art of the Aleutian Islands," Chicago Natural History Museum, Anthropological Series, Vol. XXXVI, No. 4, pp. 77–92.

Rainey, Froelich G.

 1941 *Eskimo Prehistory: The Okvik Site on the Punuk Islands.* (Anthropological Papers of the American Museum of Natural History, Vol. XXXVII, Part 4.) New York.

 1947 *The Whale Hunters of Tigara.* (Anthropological Papers of the American Museum of Natural History, Vol. XLI.) New York.

 1959 "The Vanishing Art of the Arctic," *Expedition,* University Museum, Philadelphia, Vol. I, No. 2, pp. 3–13. Masks, pp. 11 and 12. Mask on p. 11 should read from Prince William Sound instead of Norton Sound.

Rainey, Froelich G., and Elizabeth Ralph

 1959 "Radiocarbon Dating in the Arctic," *American Antiquity,* Vol. XXIV, No. 4, Part 1, pp. 365–74.

Rainey, Froelich G. See Geist, Otto, and F. G. Rainey

Rainey, Froelich G. See Larsen, Helge, and F. G. Rainey

Ralph, Elizabeth. See Rainey, Froelich G., and E. Ralph

Rands, Robert L.

 1957 "Comparative Notes on the Hand-Eye and Related Motifs," *American Antiquity,* Vol. XXII, No. 3, pp. 247–57.

Rasmussen, Knud

 1927 *Across Arctic America.* G. P. Putnam's Sons, New York and London.

 1932 *The Eagle's Gift.* Doubleday, Doran and Co., New York. Drawing of Igloo Messenger Feast box drum, p. 25.

 1952 *The Alaskan Eskimos.* (Report of the Fifth Thule Expedition, 1921–24, Vol. X, No. 3, edited by H. Ostermann.) Masks, Figs. 13 and 19.

Ray, Dorothy Jean

 1961 *Artists of the Tundra and the Sea.* University of Washington Press, Seattle. Masks, Figs. 83–88. The proveniences of Figs. 85 and 88 were transposed.

 1964a "Kauwerak, Lost Village of Alaska." *The Beaver,* Autumn, 1964, Outfit 295, pp. 4–13.

 1964b "Nineteenth Century Settlement and Subsistence Patterns in Bering Strait," *Arctic Anthropology,* Vol. II, No. 2, pp. 61–94.

 1967 *H. M. W. Edmonds' Report on the Eskimos of St. Michael and Vicinity.* (Anthropological Papers of the University of Alaska.) In press. Masks are illustrated in Edmonds' photographs.

Ray, Patrick Henry

 1885 *Report of the International Polar Expedition to Point Barrow, Alaska.* House of Representatives, 48C: 2s, Exec. Doc. 44.

Report of the Cruise of the U.S. Revenue Cutter Bear and the Overland Expedition. 1899. Washington, D.C.

Report of the Governor of Alaska for the Fiscal Year 1892. 1892. Washington, D.C.

Rickard, T. A.

 1939 "The Use of Iron and Copper by the Indians of British Columbia," *British Columbia Historical Quarterly,* Vol. III, pp. 25–50.

Riley, Olive

 1955 *Masks and Magic.* Studio Publications and Thomas Y. Crowell Co., New York. Masks, Pls. 9–14. Pl. 14 has erroneous information; see information about Pls. 48 and 49 in this book.

Rousselière, Guy Mary

 1962 "Palaeo-Eskimo Remains in the Pelly Bay Region, N.W.T.," *Contributions to Anthropology,* National Museum of Canada, Bulletin 193, Part 1, 1961–62, pp. 162–83.

Royal Ontario Museum

1959 *Masks, the Many Faces of Man.* Toronto, Ont. Masks, Pls. A15–A23. A19 is the "bad shaman" of the good-bad shaman pair from King Island, erroneously said to be wearing a labret.

Rudenko, S. I.
1961 *The Ancient Culture of the Bering Sea and the Eskimo Problem.* University of Toronto Press, Toronto, Ont. (Arctic Institute of North America, Anthropology of the North: Translations from Russian Sources, No. 1.)

Sanger, David
1966 "Indian Graves Provide Clues to the Past," *The Beaver,* Spring, 1966, Outfit 296, pp. 22–27. Mask fragments, p. 27.

Sauer, Martin
1802 *An Account of a Geographical and Astronomical Expedition to the Northern Parts of Russia . . . in the Years 1785 etc. to 1794.* London. Masks, Pl. 11.

Smith, Fred M.
1866 Diary. Manuscript in the University of Washington Library, Seattle, Wash.

Speck, Frank G.
1935 "Labrador Eskimo Mask and Clown," *The General Magazine and Historical Chronicle,* University of Pennsylvania, Vol. XXXVII, No. 2, pp. 159–73.
1950 *Concerning Iconology and the Masking Complex in Eastern North America.* (University Museum Bulletin, Vol. XV, No. 1.)

Spencer, Robert F.
1959 *The North Alaskan Eskimo.* (Bureau of American Ethnology, Bulletin No. 171.)

Thalbitzer, William
1914 *Ethnological Collections from East Greenland.* (Meddelelser om Gronland, Vol. XXXIX.) Masks, Figs. 356, 357, 358.

University Museum.
1947 *Masks.* (Bulletin of the University Museum, University of Pennsylvania, Vol. XIII, No. 1.)

Vaillant, George C.
1939 *Indian Arts in North America.* Harper and Bros., New York. Masks, Pls. 93, 94.

VanStone, James W.
1955 "Archaeological Excavations at Kotzebue, Alaska," *Anthropological Papers of the University of Alaska,* Vol. III, No. 2, pp. 75–155.
1957 "An Archaeological Reconnaissance of Nunivak Island, Alaska,"

Anthropological Papers of the University of Alaska, Vol. V, No. 2, pp. 97–117.

VanStone, James W. See Oswalt, Wendell, and James W. VanStone

Wardle, H. N.

1937 *Eskimo Tun-ghat Mask.* (University Museum Bulletin, University of Pennsylvania, Vol. VI, No. 6.) The mask illustrated is similar to that shown in Pls. 3 and III of this book. The author supposes that the mask with a twisted mouth is a moon mask, but a moon mask was never made to be ugly. This is, instead, a mask depicting a bad spirit.

Weyer, Edward M., Jr.

1930 *Archaeological Material from the Village Site at Hot Springs, Port Möller, Alaska.* (American Museum of Natural History, Anthropological Papers, Vol. XXXI, Part 4.) Masks, Figs. 12 and 13.

1932 *The Eskimos.* Yale University Press, New Haven, Conn. 1962 edition used.

Wickersham, James

1902 "The Eskimo Dance House," *American Antiquarian and Oriental Journal,* Vol. XXIV, July–August.

Willoughby, Charles C.

1931 "Indian Masks," in *Introduction to American Indian Art,* edited by John Sloan and Oliver LaFarge. The Exposition of Indian Tribal Arts, Inc. Mask attributed to Eskimo, p. 7, is probably Anvik Indian.

Wingert, Paul S.

1947 *American Indian Sculpture: A Study of the Northwest Coast.* J. J. Augustin, New York. No Eskimo masks are illustrated, but the one illustrated in Pl. 76, No. 1, is wrongly identified as Quileute. It is without doubt the King Island good-bad shaman mask. See pp. 209–11 in this book.

Zagoskin, Lavrentii Aleksieevich

1847 *Peshekhodnaia opis' chasti russkikh vladienii v Amerikie. Proizvedennaia leitenantom L. Zagoskinym v 1842, 1843 i 1844 godakh* ("Description based on explorations on foot of parts of the Russian territories in America by Lieutenant L. Zagoskin in 1842, 1843, and 1844"). 1956 edition used.

Index

All of Part I has been indexed exhaustively, but the following items of Part II have not been included: collectors of the individual masks, authors of published references (unless quoted), museum locations, and details of facial features such as nose, ear, mouth, and ornamentation, unless especially discussed in Part I.